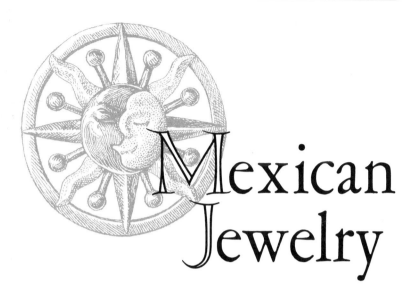

Mexican Jewelry

Mary L. Davis and Greta Pack

with drawings by Mary L. Davis

UNIVERSITY OF TEXAS PRESS AUSTIN

Library of Congress Catalog Card No. 63–7435

Manufactured in the United States of America
Type set by G&S Typesetters, Austin, Texas
Printed by Meriden Gravure Company, Meriden, Connecticut
Bound by Universal Bookbindery, Inc., San Antonio, Texas

FOR ELIZABETH DAVIS FURST

FOREWORD

At the end of a seminar conducted in Mexico by the Committee on Cultural Relations with Latin America—a seminar during which we had gone on trips, listened to lectures, and had contacts with authorities on many phases of life in Mexico—Hubert Herring said something like this, "Now that you have had a concentrated introduction to Mexico, come back next year and enjoy life here." This advice we have proceeded to follow during a number of visits.

Our interest in the beautiful creative crafts of the country grew and grew, specially our interest in the jewelry craft. From admiration for the modern work our enthusiasm came to include the jewelry worn by the country people which we saw as we traveled about. We discovered that there is a large and growing group of collectors mainly interested in regional design and craft work. And as more and more is coming to light concerning the far distant past of the Indians, our amazement at their skill and their expressive design has increased. Containing, as it does, all this inseparable material in one short volume, this book can be no more than an introduction to the subject. We have had to omit all discussion of the larger metal work which is so closely related to the jewelry, and which is being done by the same craftsmen; we have concentrated our comments on the personal ornaments and trinkets with which people instinctively adorn themselves in an attempt to be beautiful and/or attractive.

Mexico is a complicated society of many worlds. The tourist world is one, and a Yankee is always a gringo, say what you may. Each little break in the wall which separates the tourist

from the Mexicans is gratefully explored. When one has an interest in common with the Mexicans he meets—even an interest in jewelry—one can feel a little better acquainted with a people and a country one cannot help but like.

We would like to record our thanks to Mr. Frederick Davis who, before his death in 1960, helped us as we were starting our study for this book by expressing his enthusiasm for our plans, and by discussing his collection with us and allowing us to photograph many items. And our thanks also to the photographer, Sr. Antonio Garduño, who made those photographs for us, as well as many others, inasmuch as he had access to the museums, and who hunted through his forty years' accumulation of beautiful negatives for pictures which might be of use to us.

William Spratling has been especially helpful and generous, as have a number of other jewelry makers—Srs. Antonio Castillo, Salvador Terán, Antonio Pineda, Héctor Aguilar, and Enrique Ledesma, and the late Srta. Matilde Poulat. Sr. Ernesto Cervantes told us many things about the Oaxaca jewelry as did also Sr. Carlos Bustamante in Oaxaca. Mr. M. Lampell has taken time to give us an insight into the problems and point of view of the jewelry dealer.

A busy friend, Ethel Comstock, hunted up missing facts and figures for us in Mexico when we were not there. Frances Bristol, in the midst of her research on native costume, kept her eye open for items about jewelry for us. The intrepid driving of Louise Green carried us hither and yon in her car. Elizabeth Furst gave us valuable help and advice, typed for us, and fed us when we were hungry. Muchas gracias.

We must also mention the Baker Library at Dartmouth College, which, during a time when we lived in Vermont, allowed us to take home, armload by armload, dozens of books from their fine Mexican and Art shelves including some books which we had thought to be unavailable.

CONTENTS

ILLUSTRATIONS

Mexican Jewelry

THE JEWELRY OF MEXICO

The Mexican Style

THE SPANISH LOVE of rich, dramatic effects and the Indian talent for expressive decoration together have produced that unique and vigorous hybrid, the Mexican style in art. Occasionally a piece of craftwork seems almost pure Spanish or pure Indian, but one will find very few art forms completely unaffected by the four-hundred–year mingling of the two cultures.

In a small southwestern section of the United States the jewelry craft, taught to the Indians by the Mexicans about

a hundred years ago, still retains some of the Mexican character. The stamped decorations of the Navajos, the "squash blossom," the inverted crescent pendant, the stylized butterflies, all are survivals of Mexican design changed by the Southwest Indians to suit their own taste. But in Mexico Spanish-Indian is the prevailing style, taken for granted by the Mexicans, but so exotic to the visitors from the north that it excites their enthusiasm and admiration.

The temperament and the economic and cultural condition of a people are indicated by their jewelry as well as by their clothing and customs. In the United States the people, more or less classless and comparatively well off, can buy jewelry to fit every pocketbook and every kind of taste. The majority, in this machine age, are content with mass products which follow a constantly changing fashion. The production of individual pieces by hand is small and exclusive. In contrast to this, in Mexico the jewelry is practically all handmade, although some of it is mass produced by many hands with the American tourist in mind.

To many people "Mexican jewelry" suggests heavy silver decorated with so-called Aztec motifs, set with green or black stones, and ornamented with domes and balls to make it look primitive. This is the style which originated in the 1920's when the Mexicans started making silver jewelry for the tourists. The original pieces were eagerly bought by the tourists, and the designs were copied by hundreds of silversmiths who had learned the processes of jewelry making but could not design for themselves. The good pieces, set with jadeite and obsidian, retain their original beauty, but the imitations, set with dyed stones and made of thin silver, lose the harmony of design which the originals had and, like all art work which has been reproduced in thousands of copies, achieve the monotony with which we are so familiar in mass-produced "costume jewelry."

The variety which must be included in the category of Mexican jewelry is surprising if the work of four hundred

PLATE 1. The Mexican designer is surrounded by the flowery ornaments of the past. His jewelry is influenced by the designs in churches and other old buildings as well as by his own love of flowers and birds.

years is examined. The style has not developed in a steady growth and evolution, but has been influenced by many conditions. Interesting jewelry is being made in all parts of the country, in big modern workshops and in little home shops where the work is done with simple, traditional tools. And the products may be gold jewels set with precious stones or crudely worked silver set with colored glass. Students of folk-craft are not interested in the new sophisticated jewelry, and people who prefer traditional things like only the gold and filigree work. In this study we do not consider the luxury jewelry sold in the cities, jewelry which is really international in style.

With so much variety it is, perhaps, unwise to generalize in describing the Mexican style, but there are a few characteristics which occur in so much of the work that they can be said to be typical. An outstanding quality is movement, either the movement of separate parts such as pendants and fringe or movement in the design and decoration. In pre-Hispanic design this feature is very evident. In the Monte Albán jewels

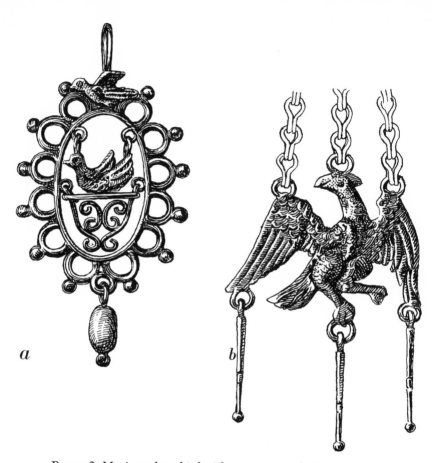

a *b*

PLATE 2. Mexicans love birds. They appear in designs for weaving, baskets, toys, and jewelry. There are horn birds, reed birds, tin birds, pottery birds. In these figures are shown (*a*) a reproduction of an old pendant from Michoacán (from Víctor Fosada); (*b*) a silver *charro* ornament; (*c*) a brooch cut from horn and painted with a brown dye, from San Juan de la Isla; (*d*) a little old silver brooch picked up by the authors in the Thieves' Market; (*e*) a copper and silver bird from a pre-Hispanic motif (by Doris).

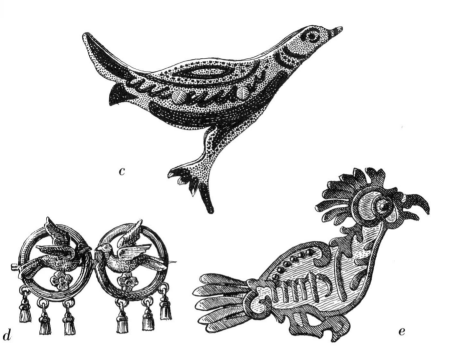

c

d e

the separate parts are suspended from each other and they
are terminated with *cascabeles* which not only move but
jingle. And the surfaces are covered with wirework in de-
signs which turn and twist. Accounts of the jewels sent back
to Spain by the *conquistadores* mention fishes that wiggled,
birds with movable tongues, monkeys with nodding heads.

The Mexican ladies have always liked dangling earrings
and pendants, filigree, and gold jewels ornamented with vines,
leaves, and flowers.

Today the designers often use a modified form of *cas-
cabeles*, or pendant drops, but the feeling for movement is
specially noticeable in many of the bracelets and necklaces
made of separate units with each unit planned to carry the

flow of the design throughout the length of the piece. Few of the designs are static.

A tendency of the Mexican designer is to construct with simple forms and then fill all the forms with ornament. Surrounded by the rich ornament in the churches and old buildings found in so many of the villages, he accepts and likes the gaiety of the surface patterns, the whirling gold scrolls, the rhythmic pattern of the ironwork, and he uses all this in his design.

In the old Churrigueresque churches the carved, gilded ornament is full of little flowers, animals and figures, cherubs, angels, and legendary beings. The village designers are pleased by these naturalistic motifs and they love to introduce the things around them into their designs. They are careful observers and many of them have great skill. Sometimes an unschooled village silversmith will produce results which are surprisingly good—and, alas, sometimes, surprisingly bad.

The Mexican is a follower of tradition. In many of the villages the way of living has not changed for generations, and in some parts of the country the styles in clothing and adornment have persisted for hundreds of years. The length of a village woman's skirt does not vary from year to year nor does the color of her *rebozo*. Her earrings are very much like those her grandmother wore, the ornament changing a little from generation to generation as the son of the jeweler takes over his father's shop. It is the village silversmith who perpetuates the old designs which persist outside of the cities and which give a continuity to Mexican design.

Many contemporary designers turn to the pre-Hispanic and early Colonial styles to refresh their work, transposing the old motifs into the scale and rhythms of today, just as the modern painters look to the art of more primitive people for inspiration. On the other hand there are jewelry makers who have broken entirely away from tradition in design but who still use the native materials in their products with the result that their work has a definitely Mexican feeling.

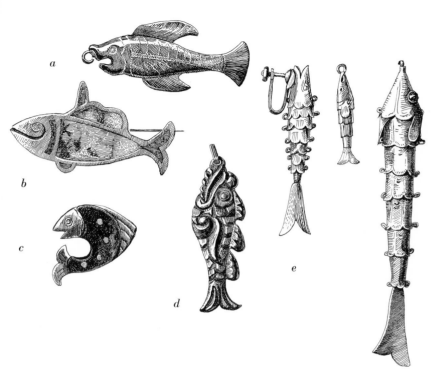

PLATE 3. Jewelry with fish motifs: (*a*) cast, carved, and chased, a fish made to hang from a key ring; (*b*) a brooch of turquoise matrix inlaid on silver; (*c*) an earring of tortoise shell riveted to silver (by William Spratling); (*d*) one of a row of silver *repoussé* fish which hang from a necklace (by Matilde Poulat); (*e*) the wiggly fish which are made in several Latin American countries (the earring and little gold charm are from Mexico, the large fish from Peru).

9

The Motifs Which the Mexicans Use

In Mexican jewelry we find not only the motifs which are used everywhere, the flowers and ribbons which have always served as adornment, but other naturalistic subjects as well. As far back as we can go in the history of Mexican art we find animals a favorite motif. In pre-Hispanic jewelry animals, serpents, fish, snails and turtles, birds, and butterflies were cast and carved with amazing skill.

Today the Tótonac women wear little gold roosters in their ears. The Yalalag necklaces are strung with small cast silver birds. In the mountains around Toluca, in parts of Michoacán and in the region around Guanajuato much of the jewelry is made of small castings of birds and butterflies superimposed on a framework of flowers and filigree. One of the best of the modern jewelry makers in Mexico City designs with one of three birds, the quetzal, the dove, and what she calls "the Mixtec bird."

Primitive-looking brooches and combs made of horn in the shape of animals, birds, and fish, decoratively painted with a brown stain which looks like iodine, come from the village of San Juan de la Isla in the state of México. They can be seen in the Regional Museum in Toluca.

The fish jewelry, old and new, shown in Plate 3 varies in design from the naturalistic to the semiabstract. The fish earrings are well-known descendants of the wiggling fish mentioned in the records of over four hundred years ago whose use has been continuous from that time until the present. They are lovely little ornaments made of funnel-like sections loosely telescoped together and held by fine wires, the scales engraved to give a glistening surface, the movement perfectly recreated by the construction.

Butterflies, once associated with the flickering fire, the soul, love, and flowers, are made into all kinds of jewelry and in all the techniques of the silversmith from the finest filigree to the heaviest engraved silver. And they are done in color with

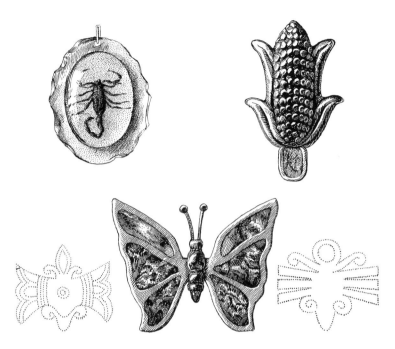

PLATE 4. Jewelry with naturalistic subjects: a scorpion pendant from Durango (the insect is a real one, dead and safely encased under plastic); maize, the life-giving food, represented in a small brooch (by Bernice Goodspeed); a butterfly brooch with iridescent *concha* inlay.

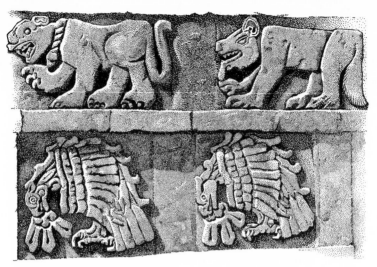

PLATE 5. One of the beautiful wall carvings at Tula.

turquoise and malachite inlay. A pair of butterflies shown on Plate 94 were made to flutter on a big *charro* sombrero.

No mention of naturalistic subject matter is complete without a word about the curious scorpion jewelry of Durango. There they collect the horrid creatures and encase them under shallow plastic domes and mount them as brooches, charms, and pendants. In hunting for jewelry of the region one encounters hundreds of these for sale in the shops. When asked about the prevalence of scorpions, the natives insist that there are very few in their fair city. Then why all the scorpion jewelry? There may be a legend about them or it may be a passing fad. In Vera Cruz they make scorpions of tortoise shell, so brown and lifelike that they would scare the daylights out of you.

The beginning of the contemporary silver jewelry industry came at a time when there was a great interest in archeological research. Fine examples of pre-Hispanic art were being added to the museums and important books on the subject were being published. Naturally the designers were impressed by the

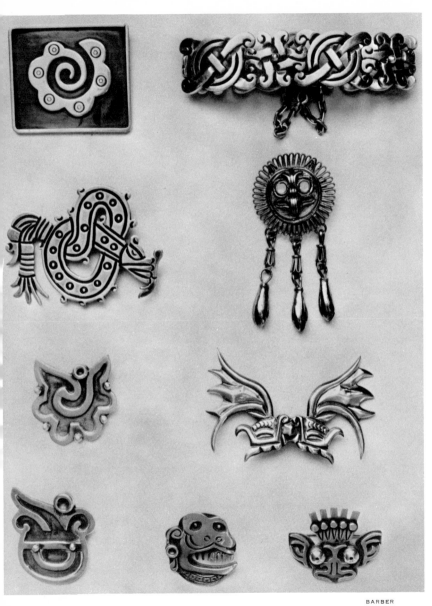

BARBER

PLATE 6. Silver jewelry from pre-Hispanic motifs (from Rafael Domínguez, José Ortiz, Doris, William Spratling, Bernice Goodspeed, and the Mitla jewelers).

beauty of the ancient Indian designs as compared with the sameness of the traditional styles in vogue at the time. The first men to make the new silver jewelry studied these Indian relics for inspiration and, with fine feeling and good taste, made some beautiful jewels, even incorporating in some of them the little stone heads and figures which were so easy to obtain at that time when the farmers were constantly digging them up as they ploughed their fields. The bracelets and necklaces attracted the tourists who were just beginning to come to Mexico in large numbers after the Revolution, and the silver jewelry proved successful commercially as well as artistically. And those designs of the 1920's set a style which is still popular after some forty years.

It seems a fine thing to perpetuate these old motifs—and the Colonial styles as well—if it is done with feeling and discrimination. Chosen from hundreds of designs based on pre-Hispanic subjects a few are shown on Plate 6. The bracelet in this group was designed by William Spratling a long time ago and has been reproduced by other craftsmen so many times that its origin has been forgotten by most of them. It is a good example of a design with Indian feeling without, as far as we can tell, being derived from any identifiable Indian motif. The undercut technique and sharp dark and light emphasis of the design is reminiscent of the ancient stone carving.

Among the pre-Hispanic motifs which have been used effectively by modern jewelers are the conch shell and the snail shell which appear as decorations on so many of the old sculptured stones; the sun and moon; turtles, birds, fish, and animals, the use of which has already been mentioned; feathers and serpents; masks, which are so dramatic when well done; hieroglyphs which, being unintelligible to us, become abstract designs.

In the museums and the archeology books there are semi-abstract plant and flower designs which might be mistaken

PLATE 7. Pre-Hispanic motifs in jewelry. The silver brooch uses a motif from the wall carving shown in Plate 5 (by Rafael Domínguez). The sun and moon, either separately or combined appear often in early carvings; here they are used in a brooch of silver and carved ivory (by Salvador Terán).

for the work of modern designers if they were not labeled as pre-Hispanic. In 1947 Sr. Jorge Enciso selected from various collections a group of small clay stamps which were used by the Indians to print their cloth and decorate their pottery. These were necessarily simple, two-dimensional designs. Sr. Enciso's book, *Sellos de Antiguo México,* has been much used by Mexican designers (which was his purpose in publishing the book) some of whom have worked directly from the book or from the original *sellos* in the museums while others have been influenced by the ·dramatic and inventive character of the designs to work in the same style.

The most hackneyed use of the ancient designs is one which confronts us on all sides—the Aztec Calendar Stone reduced in its entirety to a size small enough for jewelry and, in reduction, so changed that it remains neither authentic nor beautiful. The stone itself is monumental and is covered with intricate carved symbols, all of which are lost when it is made small. Plate 8 shows a pendant which is designed with three

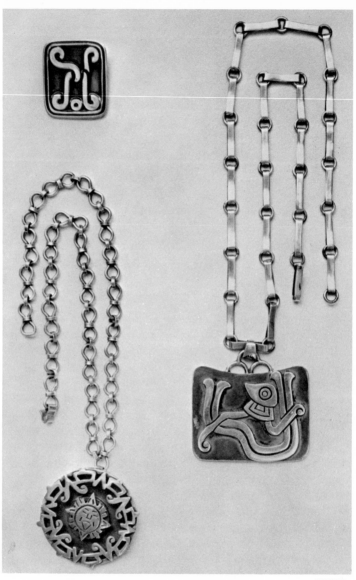

PLATE 8. Two silver pendants from pre-Hispanic motifs. For the round pendant Bernice Goodspeed has used several symbols from the Aztec Calendar Stone. The other is by a designer unknown to us and uses an unfamiliar motif, but the result is definitely pre-Hispanic.

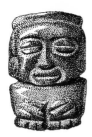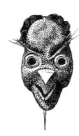

PLATE 9. The past and the present. If the man who made the little heads out of Lima beans, beads, and feathers had lived four hundred years ago, he probably would have carved his heads out of stone as his ancestors did. The little old stone figure is pierced on the back to be hung on a cord.

much simplified details selected from the many on the big stone, combined in such a way as to make an original and pleasing design.

Grotesque and distorted figures were common in pre-Hispanic art, the distortions being used for the purpose of emotional expression. Without the original meaning they seem slightly incongruous as used for personal adornment, but some jewelers make them. And some jewelers try to give their products a primitive feeling by leaving their work unfinished and crude, forgetting that the ancient jewels owe much of their beauty to their intricacy and finish.

An important feature of pre-Hispanic jewelry were the *cascabeles,* the little bells which hung either separately or in rows on many of the jewels, to give sound to the movements of the wearer. Whole necklaces were strung with them, and small ones were fastened to arm and leg bands just as today they encircle the arms and ankles of the ceremonial dancers. Larger ones were worn as pectorals or pendants. They were made in all parts of Mexico and Central America, but the style was so different in each part of the country that the origin of each can be determined by the design, the metal, and the technique used in its making. Thus the *cascabeles* of cast gold found in Yucatán where no casting was done must

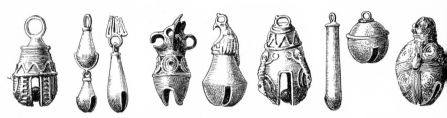

PLATE 10. Pre-Hispanic *cascabeles* from many places. The originals are not all the same size as they appear here. The first and last are of copper, from Michoacán, the three in the center came from Yucatán but were of Costa Rican origin, and the four plain, undecorated ones are from Monte Albán.

have come in trade from Costa Rica where gold casting and wirework had been brought to perfection. If we compare those bells, heavily ornamented with grotesque animal forms, with the elegant simplicity of those on the Monte Albán jewels, we have an indication of the artistic refinement of the Mixtec goldsmiths who were expert in the use of ornament but who relied on the beauty of proportion and line for their finest effects.

Cascabeles vary in shape from spherical to long thin drops, and from a quarter of an inch to four or five inches in size. Some show great ingenuity in the adaptation of natural motifs to the bell shape. Fruits and squashes, snails, turtles, birds, even human heads were stylized. Stone or metal balls tinkled inside them. As used today they are seldom real bells but only drops in the shape of bells.

In Mexico, as in all Roman Catholic countries, crosses, medals, and religious symbols are commonly worn. The most sophisticated city shops and the poorest village stands sell them. On market day in the village there will be stalls near the church with the country women crowded around to buy cheap little crosses, or medals of the locally favorite saints, hung on colored yarn with glass beads on them.

Many regions have traditional types of crosses. In Oaxaca

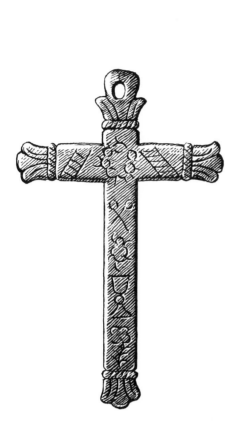

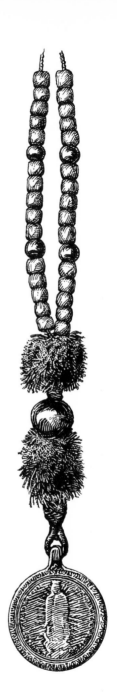

PLATE 11. Religious motifs in jewelry: an old silver cross from Oaxaca, crudely carved with the symbols of the Passion; an old Guadalupe medal on a rosary of coral and silver beads and balls of red thread (cheap imitations of this rosary are sold in the towns around Oaxaca on market day).

one often sees the Yalalag cross with the pendant crosses or medals on the arms. Another which comes from the villages around Oaxaca is of flat silver with the head of Christ and the symbols of the Passion engraved on it (Plate 11). These crosses are similar in design to the monumental ones which are seen in the churchyards in various parts of the country with the symbols carved in low relief and, in the center, the head in low relief or in the round. A famous example of the big stone crosses faces the convent of Acolman near Mexico City. The same design of wood with painted symbols is sometimes seen. But whether of wood or stone or silver the design and execution are Mexican.

The scallop shell, symbol of a pilgrimage to the Holy Land and also of baptism, often appears in religious jewelry. Aside from its religious connotation it is a familiar motif in Rococo design which was popular in Mexico for a long time. For some reason it is often used on *charro* buttons and buckles (See Plate 94). The sun symbolized, both to the Indians and to the Spaniards, the life-giving power, the God in the Heavens. We see it both in the pre-Hispanic carvings and in the decoration of the early churches and as an ornament on the apparel of the saints. Pierced or broken hearts have great importance in Catholic symbolism and are worn as medals or as the insignia of an order or a religious group.

Many other religious symbols are popular. However, some which were originally of great significance are now only familiar decorative devices which have lost their meaning except for a vague, pious relationship.

Mexicans seem to love hands in decoration, brass hands for door knockers, tin hands for paper clips, silver and gold hands for buckles and earrings, little hands holding a gold coin on a chain, clasped hands on wedding and engagement rings.

Everything which the Mexicans make is also made in miniature for the children, or for grown-up children who enjoy the delicacy and ingenious construction of very small objects. All of Mama's cooking dishes are made in small size for the *niña*

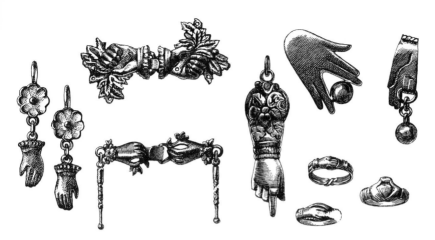

PLATE 12. Everywhere one sees hands. Bronze hands knock at the doors of the houses of Querétaro; tin hands hold one's papers together; earrings hang from hands of coral or gold; rings with clasped hands pledge a friendship or seal an engagement; buckles with hands fasten the *charro* coat.

of the family. In booths in the markets, specially in Cuernavaca and Guanajuato, these little dishes can always be found. One glass factory makes a whole orchestra of tiny green glass frogs, each one playing his minute glass instrument. In a certain curio shop in Mexico you can buy a very small revolver which actually shoots, or a complete set of workman's tools for any trade, each tool perfect in detail and not over an inch long. The same store used to carry the celebrated dressed fleas, but no longer. Probably the Society for the Prevention of Cruelty to Animals objected.

There are beautifully modeled figures of the whole bull-fight personnel about an inch high, correct in costume and posture, waving their capes and placing their *banderillas; mariachi* orchestras; dancers of all the typical dances of the country. Very small cupboards holding full sets of dishes are collectors' items. In the Toluca Museum is a complete kitchen only three inches long. Under the *portales* in Puebla one could spend

hours looking at the miniature glass chandeliers and lamps made so meticulously as to be real jewels.

The little musical instruments made by the Robles family in Ixmiquilpan are deservedly famous for they are so skillfully made. The violins, mandolins, and guitars are about two inches long, made of fine wood inlaid with other woods, tortoise shell, mother-of-pearl, and silver. They are fitted with keys and strings all ready to be played upon. One of these is included on Plate 13 with other miniature objects made into jewelry.

With this tradition is it surprising that the steel workers of Amozoc make earrings in the shape of bits or spurs of the same blue steel incrusted with silver which they use to make their famous *charro* trappings? The tortoise shell of Vera Cruz is made into brooches in the shape of combs. The lacquer workers of Quiroga make earrings of small painted *bateas* decorated with the same floral designs which they paint on the big trays. Little pitchers hang from some of the Toluca earrings.

All these motifs, some amusing, others emotional, and others traditional, add variety, interest, and individuality to the Mexican jewelry and give one a key to the character of the Mexican people.

The Jewelry Industry in Mexico

Through the centuries its mineral treasure has played an important part in the history and development of Mexico. This vast wealth is distributed throughout the country from Sonora in the north to the southmost boundary

PLATE 13. Miniatures of actual objects are often used in jewelry. The earrings with the small lacquer *bateas* come from Quiroga, those with guitars and little pitchers from Toluca; the brooch of tortoise shell in the shape of a comb is from Vera Cruz, the gold earrings with little roosters from Papantla, those representing blued steel spurs from Amozoc, and the charms from Mexico City; the little inlaid guitar is by the Robles family in Ixmiquilpan.

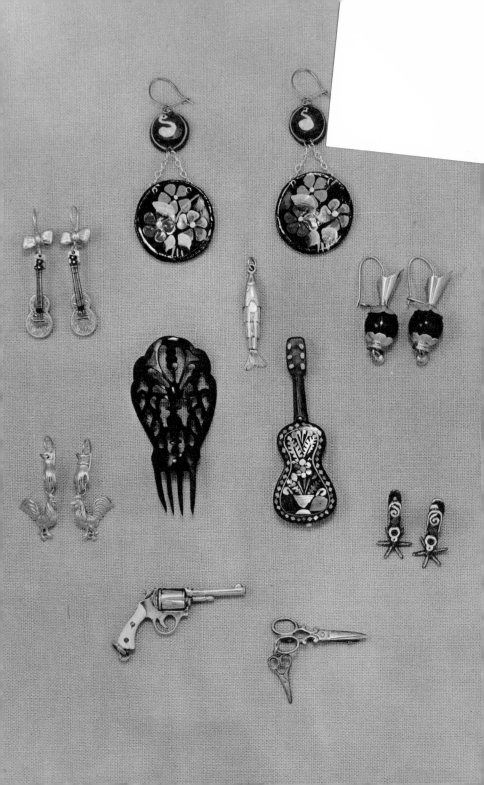

of Chiapas. Gold and silver, iron, copper, tin, lead and zinc, precious and semiprecious stones are found in the Sierra Madre range of mountains, pearls and amber on the coast. The abundance of gold and silver available to the Mexican goldsmith has made possible his pre-eminence in his craft. And it has made the jewelry industry one of the largest in the country.

The great mass of jewelry now being made comes not only from big factories but from small shops as well. In almost every village there is a *joyería*, often in the front room of a house, the jewelry being made and sold in the same room, with the doorway and window the only light. The work done in these shops is more or less stereotyped, copies of regional and traditional pieces, crosses, wedding rings, and earrings. Occasionally one of these village jewelers has the enthusiasm of a real craftsman and a natural feeling for design and then something happens. He will make changes in the old style to give it an entirely new look. In larger shops a group of craftsmen work under a maestro who is the owner and the originator of the designs, an ideal arrangement with the designer and artisan working together, the designer having control over the product until it is finished. If he designs on paper the result in metal may not be quite what he had in mind and then he can change the proportions and by coloring, polishing, or tool texturing he can emphasize the important parts.

Some dealers have their own workshops or have a contract with workshops where the jewelry is made for them to their order carrying out their ideas. In such cases, although much of the final beauty of a piece may be due to the craftsmanship or to the sensibility of the head of the workshop, the product is stamped with the mark of the dealer who ordered the work.

The big shops have their own designers and draftsmen who know all the working processes of jewelry making and constantly experiment with new designs, materials, and techniques. From the many designs which they make only a few may be

chosen for production. The work is apt to be mass produced partly by hand and partly by modern machines.

Handmade

There are two schools of thought on the subject of "handmade" jewelry. There are those who feel that an article which has in any way been constructed by the use of power machines or dies cannot be termed handmade. They would allow a polishing wheel, but no stamping, die-punching, or casting. Others think that an article may legitimately be called handmade if the machine or die is guided by hand in shaping or decorating an object, the theory being that the machine so used is no more than an efficient modern tool which should not be rejected as long as the hand can completely control the product. Many machine-made pieces have some hand work done on them and it is often hard to distinguish them from pieces made entirely by hand. However, there are some designs which, if not carried out entirely by hand, lose a subtle irregularity of surface and tone and take on a harsher and more brittle quality. The chief advantage of machine-work is precision, and this very attribute may spoil a jewelry design and destroy the quality of the original model.

The machine is an economical tool only if used to make many duplicates. Jewelry made in the comparatively small quantity which a craftsman can produce by hand will have the quality of uniqueness, which may not add to the beauty of the piece but which will gratify the desire for individuality which we all have. Whether it be a diamond bracelet or a silver brooch, it will be doubly precious if it is made or chosen to suit the personality of the wearer.

Individually made pieces are interesting to people surfeited with machine-made products and this is one of the reasons the jewelry craft in Mexico has been so successful commercially. As the country becomes more industrialized, it is to be hoped that the movement will not extend to the handcrafts and

thus destroy the quality which has given them their distinction.

In any art style there are always a few leaders and many followers, and from this condition the style emerges. This is how the present Mexican style has developed, influenced by the tradition and temperament, the environment and the religion of the Mexican people. And this is why all the Mexican art, including the jewelry, is so unmistakably Mexican.

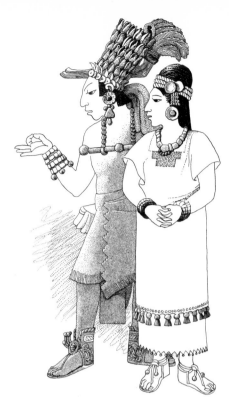

PRE-HISPANIC BACKGROUND

The Jewelry of the Pre-Hispanic Indians

FROM THE FEW REMAINING CODICES, from the manuscripts so conscientiously compiled by sixteenth-century writers, and from records of archeological discoveries, we are able to form a picture of Indian life as it was lived before the Spaniards came to Mexico. This picture shows us a people who had reached a high state of artistic achievement living a well-developed communal life centered around a religion of nature worship. They feared the destructive elements of nature and made cruel human

sacrifices to the gods of destruction. They worshipped the beneficent nature gods and they loved the beauty of the growing life around them, the flowers, birds, and animals which were part of their religion. Constantly recurring in their art are the symbols for air, rain, sun and moon, and fertility. The great god Quetzalcoatl was represented by the plumed serpent, the sea snail, and the evening star, signifying the waters, the air, and the universe. Frogs, toads, and snails were symbols of the god Tlaloc who controlled the rains and the fertility of the soil.

The walls of the temples were decorated with sculpture, and the images of the gods were carved in stone and adorned with gold and precious stones. Against the dark bodies of the priests hung pectorals of turquoise and jade and on their arms and legs were bands of the same blue and green stones, corals, and pearls, all set in gold and hung with iridescent feathers, and little bells tinkling to record their movements during the ceremonies. The background was rich with color and gleaming with golden carvings, the smoke of the incense mingling with the odor of the blood of the sacrificial victims.

The king lived in luxury and splendor with special apparel, jewelry, and ornaments for each ceremonial occasion. He was laden with necklaces and pectorals, bracelets, and anklets, ear and nose plugs, all of beautiful design and workmanship. The rare quetzal feathers were used for his adornment.

The carvings of women show them with patient and resigned expression. Their clothing was simple in design. Little jewelry was worn, usually plain strands of gold and jade beads hung with *cascabeles*. Pendant earrings of coral, pearls, jade, or jet completed the costume. Sometimes a brooch fastened the garment at the neck. Bright colored ribbons of yarn were plaited in the hair, a fashion still followed by Indian women in many parts of the country.

Craftsmen specializing in different kinds of materials were divided into groups: the sculptors of stone images, the lapidaries, the goldsmiths, the mosaic workers. Objects requiring

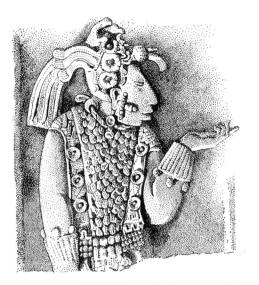
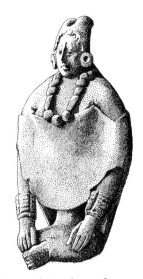

PLATE 14. The Mayas left us a record of their dress and jewelry and many of their ways of life in their beautiful stone carvings and their terra cotta figures. Here is the figure of a priest from Yaxchilán. The Maya woman, possibly the "Mother God," wears a necklace of jadeite which would weigh two pounds—at least a similar one in the collection of the authors weighs that.

the most difficult techniques were made with the simplest tools. The goldsmith was highly esteemed, not only for the beauty of his product but for his skill. He made his own tools, equipping the workshop where he created his designs, and developed his own techniques which were handed down from father to son.

Small villages became jewelry centers and many workers left less honorable work to become apprentices. Working groups developed into guilds, that of the goldsmith being outstanding at the time of the Conquest with its center at Atzcapotzalco, just north of what is now Mexico City.

The country was rich in precious stones and metals, brilliant feathers of tropical birds, rock crystal, shell, and pearls from

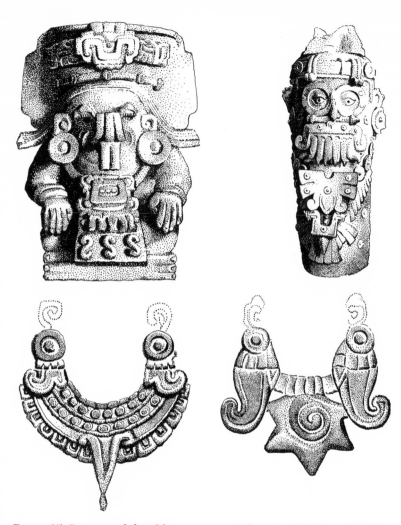

PLATE 15. In many of the old stone carvings the ornaments are so care-fully carved that one can almost discern the material from which they were supposed to be made. Here we have two stone figures: one a god in a typical Zapotec headdress and pectoral, the other the god Tlaloc with a butterfly pectoral. Below are two necklaces from stone figures of Quetzalcoatl, showing the symbols of the sun and the sea-snail shell.

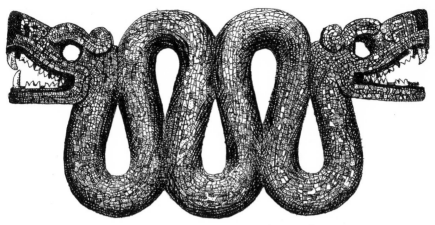

PLATE 16. A serpent of stone mosaic now in the British Museum.

the coast. The regional materials naturally influenced the kind of crafts done in different parts of the country, although some of the materials were distributed by trade or tribute. This abundance stimulated the creative genius of the Indians, and, with an inherent feeling for fine craftsmanship and unbelievable patience, they produced great works of art in various mediums.

After studying their masterpieces we cannot consider them as a primitive people whose feeling for design was purely intuitive, for the designers knew just how to plan an ornament to fit the shape it was to decorate, when to decorate and when to leave a surface plain, how to subordinate realistic detail to the main form, how to simplify and how to elaborate, how to emphasize meaning with line. So, when they used the serpent as a subject, they made it more awe-inspiring by making it more sinuous or by exaggerating the deadly fangs. They added feathers and it became a decoration of scrolls, more mystical because it was more abstract. They designed not only to beautify but to express deeper meanings, and they

31

did it so well that today's designers study their work for inspiration.

Stone mosaic was used for masks and jewelry. Turquoise, jadeite, malachite, quartz, beryl, obsidian, garnets, mother-of-pearl, and colored shell were carefully cut and fitted into complicated designs and cemented to a base of wood or stone or metal. Feather mosaics were made in the same way with many colored feathers cemented to fabrics or shields. Rock crystal was mounted over brilliant feathers for colors, or was cut and carved. Indian craftsmen explored the possibilities of every material. How surprising that they never discovered the wheel as a tool.

The metal used for jewelry was almost always gold, which was found in pure nuggets in the river beds. Although there are indications that the Indians knew the quicksilver process of extracting gold from ore and had done some mining of silver, copper, and tin, the methods of obtaining these metals were so difficult and placer mining was so simple that the river gold remained the common metal for jewelry. Some copper was also found in its pure state but was seldom used for jewelry although an alloy of gold and copper was used by the Tarascan Indians in Michoacán. Old records of the Tarascans mention gold jewelry, but what remained after the gold-hungry Spaniards had come and gone were a few copper pieces with traces of gold on the surface.

The chief ways of working the gold were casting and beating, old techniques which had spread up the Pacific coast from Peru through Panama and Costa Rica. In the gold centers of the Mixtecs and Zapotecs in Oaxaca some of the finest examples of gold jewelry were made by the cire-perdue process of casting. This process is described and illustrated in the book by Sahagún, every step having been told to him by the Indians. Further notes on this process will be found in the final chapter of this book.

The gold beaters hammered nuggets into thin sheets and from these sheets made jewelry and frames for the mosaic

pieces. They could beat the gold so thin that it could easily be decorated by punching with *repoussé* tools, or it could be applied as a coating on baser materials to gild the images and carvings. Beads have been found which were of clay and charcoal with a thin coating of the gold. In parts of the country where gold was scarce, as in Yucatán, most of the jewelry was made of the gold sheets. Small cast jewelry was acquired in trade from other parts of the country, such as Oaxaca or Costa Rica, and was beaten into sheets, an economical use of the metal.

Lacking iron tools, knowing nothing of the use of the wheel, the Indians turned out work with their crude stone hammers and chisels, their obsidian knives, their bone drills, and copper tubes and knives, which rivals in beauty and craftsmanship that of the Chinese, Egyptians, and Greeks. Some of the pieces sent by Cortés amazed the goldsmiths of Spain who were unable to figure out how they had been made. One casting which caused great admiration was a little fish, some of its scales gold and some silver, made without the use of solder. Another was a turtle necklace which must have been similar to the one found in Monte Albán. In his palace Montezuma had a replica of every animal and bird to be found in his empire, all made of gold and beautified with colored stones and the feathers of rare and brilliant birds.

The richness of some of the jewels is almost unbelievable. One piece given to Cortés, and therefore minutely described in the inventories, was a *collar* or necklace of four strands with 102 red stones, 172 green stones, 26 gold bells, and 10 large stones from which hung 142 pendants of gold. This was one of two necklaces of equal splendor given to Cortés.

A modern craftsman will know with how much loving care the ancient goldsmith must have made these precious jewels and little bibelots and how pleased he must have been with the results, and how unhappy he would have been had he known that they would soon be melted down into gold bars for the Spanish treasury.

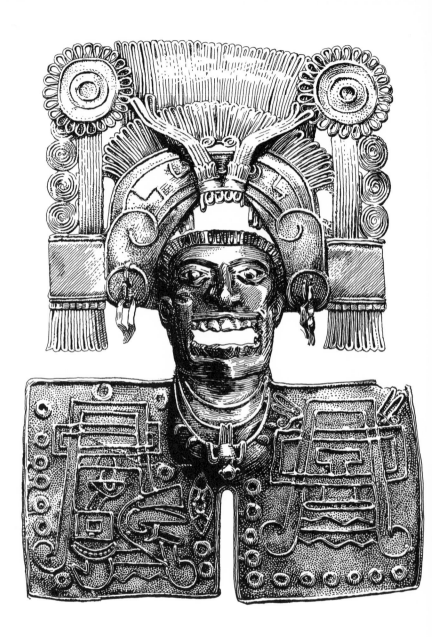

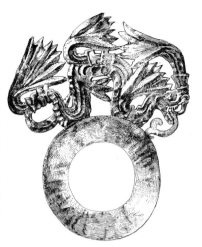

PLATE 17. The two methods most used by the Indians for working gold were casting and beating. The pectoral on the left with the head of a jaguar knight from the Monte Albán jewels is an example of the first technique. The eye-piece for a wooden mask, shown at the right, was made from gold beaten into thin sheets. It was found in the well at Chichen Itzá.

The often-told tale of the Conquest glitters with gold and color as well as with blood and bravery, and with cupidity and deceit. We read the story of the attempts of Montezuma to buy off the *conquistadores* with gifts of gold and jewels, the Spanish helmet filled with gold nuggets, the great discs of the Sun and the Moon "as large as wagon wheels," the one of gold and the other of silver (the gold disc said to weigh as much as two hundred pounds). And we read also the famous description of the Spaniards, "The Spaniards are troubled with a disease of the heart which nothing but gold can cure."

Next comes the entry of the Spaniards into Tenochtitlán where Montezuma awaited them under a canopy of brilliant green feathers bordered with gold and silver embroidery with pearls hanging from it. He was richly attired, even his sandals being of gold, trimmed with precious stones; and Cortés also must have been an impressive figure with his shining steel armor and his red beard as he dismounted from his horse and advanced to be greeted, and to present the gift he had brought, a necklace of glass beads strung on a gold cord and scented with musk. With great ceremony the necklace was placed around Montezuma's neck. A reciprocal gift to Cortés was a necklace of hand-wrought golden crabs set with rare crabshell.

Bernal Díaz del Castillo tells us of the invaders roaming the city and finding in the market the Street of the Jewelers where articles of gold and jade, filigree rings, and ornaments of pink and rose shell and tortoise shell were to be found. With the gold which they had accumulated, many of them had made for themselves the large chains which were being worn at that time in Europe by men of wealth.

When the room containing Montezuma's ancestral fortune was opened, for many days the Spaniards worked tearing off the gold from the jewelry and separating it to be melted into bars and stamped with the Spanish seal. The goldsmiths from Atzcapotzalco who had made some of the jewels were called in to melt them for shipment to Spain. A few fine pieces were saved to send to the King, but in Spain these also immediately went into the melting pot, so that the story of the treasure is all that remains.

When, later, the Spaniards were forced to leave the city they packed as much of the gold as they could on eight of the horses and on the backs of the faithful Tlaxcala Indians and the rest was apportioned among the troops. The gold which the soldiers strapped around their waists was the cause of many a death as, hotly pursued by the Aztecs, they had to plunge into the canals and could neither swim nor tear loose the heavy gold.

The information about the pre-Hispanic period in Mexican history is being constantly enlarged. There are still many gaps, but the work of digging and exploring continues. And many of the discoveries are more exciting from the artistic standpoint than from the archeological. With every discovery we are again amazed at the skill and refinement of the ancient Indian goldsmiths.

Monte Albán

From any standpoint, one of the most interesting discoveries in recent years was that of Tomb 7 in Monte Albán, the sacred mountain of the ancient Zapotecs

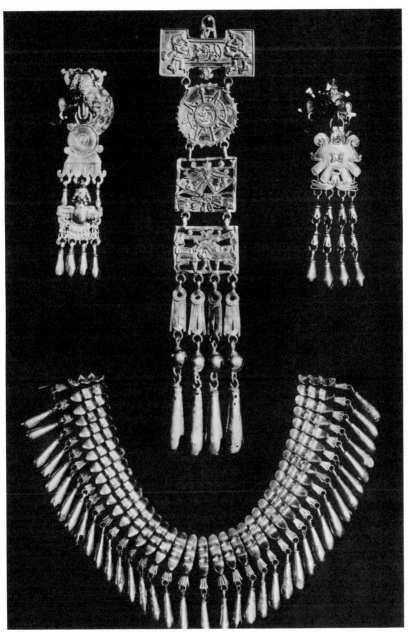

PLATE 18. Gold jewels from Monte Albán.

near the city of Oaxaca where the Zapotec and Mixtec tribes had lived for centuries. Jewelry of gold and jade, known to have come from Monte Albán, led archeologists to believe that rich treasure was hidden there, and efforts were made to raise funds for its excavation. Several institutions and individuals responded to the appeal, and the Mexican Government sanctioned an expedition which was organized and led by Dr. Alfonso Caso.

The work started in 1931. As the digging progressed many of the tombs were found to have been opened and rifled of their contents, and others to contain nothing of importance. After some time the excavators came to Tomb 7. Having removed the layers of mortar and stucco which covered the tomb, they made an entrance into the burial vault. Before them lay a treasure far beyond their hopes and expectations, the richest ever found on the American continent. Mixed with earth, dust, and skeletons, were objects of gold and jade, crystal, pearls, turquoise, and obsidian. In the following days hundreds of pieces were taken from the tomb, all proving the superb craftsmanship of the Mixtec goldsmiths who had made them.

Most of the metal objects were of gold, with a few of silver and copper. The pectorals and masks, decorated with wirework which looks like filigree, proved to have been made entirely by casting. Some pieces were beautifully modeled by *repoussé*. Gold beads were found along with the jade, pearl, and turquoise beads with which they had originally been combined. The *cascabeles* and the gold units of the elaborate necklaces had been cast by the lost-wax process.

The lapidary work was amazing. This was specially true of the goblet, and other objects of rock crystal, a material which, because of its hardness, requires great skill and patience in the working. The beauty of obsidian, which is equally hard to work because of its brittle and flaky ·quality, was shown in a pair of ear-plugs almost paper thin and so skillfully worked

that they had attained a translucence and luster seldom found in this material.

Mosaic objects must have been numerous, judging by the hundreds of small pieces of turquoise and shell found in piles on the floor of the tomb. The backing used for the mosaic masks, shields, and breastplates had been of wood which had disintegrated during the centuries it had been buried.

Among the treasures now in the Oaxaca Museum are beautiful examples of carved jade and jade inset with gold, many gold pendants, rings, and earrings. The beads are of various sizes and shapes and are of gold, amber, and jet. There are strands of small, colored shells and, in contrast, barbaric *collares* of crocodile's and wolf's teeth. Bone is so beautifully carved that it equals the finest ivory carvings from the Orient.

All this is the work of Mixtec craftsmen. It has been decided that the tomb had been used by the Mixtecs not long before the coming of the Spaniards, after having previously been used by the Zapotecs. The mystery of its use by the two tribes has not as yet been solved.

When all the treasure from the tomb was assembled it was taken to the Museo Nacional de Antropología in Mexico City for exhibition. It was also shown in the United States, but now is back in Oaxaca where one may see it, beautifully displayed, near where it was buried so many years ago.

The Yanhuitlán Brooch

A well-known jewel from pre-Hispanic times, that shown on Plate 19, is in the collection of the Museo Nacional de Antropología. It is a gold shield about two and one-eighth inches in diameter, with a filigree edge, four spears or arrows crossing it horizontally, and eleven *cascabeles*. The whole brooch is three and a quarter inches from top to bottom. The insignia in the center is turquoise mosaic on gold, the only piece of this technique known. The significance of the design, a classic emblem of the Mixtec-Zapotec culture, is not

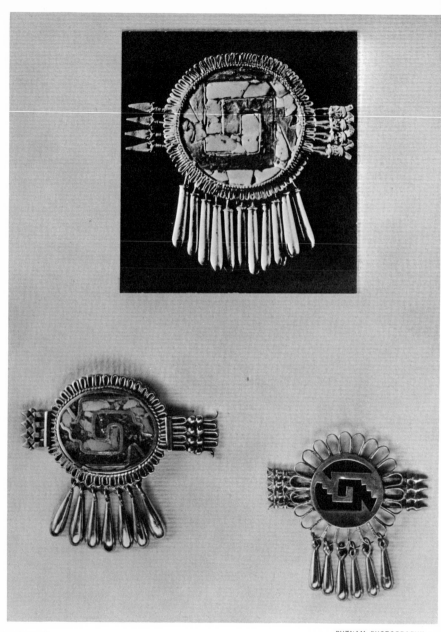

PLATE 19. The Yanhuitlán brooch, in the Museo Nacional de Antropología in Mexico City, and two modern adaptations of the design, one of turquoise inlay (from Bernice Goodspeed) and the other of black onyx and silver.

known but, inasmuch as the same emblem is found on the shields of some of Montezuma's warriors, it is thought to be a military decoration. The filigree around the edge probably represents the border of feathers which was often used to decorate the *chimali,* the shield of a warrior.

The ornament was found in a village near Yanhuitlán in Oaxaca and is known as "the Yanhuitlán Brooch." It was discovered in 1903 resting on the chest of a skeleton. The Indian who found it took off two of the *cascabeles* and pried out the turquoise. The stones were recovered and replaced but there are now only eleven of the original thirteen *cascabeles.*

On the occasion of the marriage of Queen Elizabeth of England, President Alemán had this Mexican jewel copied as a gift for her. The design, modified, has been used many times for modern brooches, often made in silver with the center design of obsidian. Modern renditions are shown on Plate 19 with the original.

Jade

In the mountain regions of southern Mexico, jade, so highly prized by the ancient Mexicans, was hidden in the ravines where the rivers flowed between steep banks. Gray boulders contained a precious core of jade; pebbles and rock fragments found in the mountain streams, when polished, revealed the beautiful green color. Natural deposits have never been found, but much of the jade may have come from what are now the states of Oaxaca and Guerrero; the Aztec records of tribute paid by the conquered tribes of that region usually mention jade. Green pebbles were found in early days on the coast of California, in a cave only accessible at low tide. Samples of these water-worn pebbles, gathered years ago and thought to be of no value, have recently been assessed as nephrite jade of gem quality. It is possible that the early Mexicans knew of such caves farther down on the coast.

For many years it was doubted that the jade was a native product of Mexico, and it was thought that both the stones

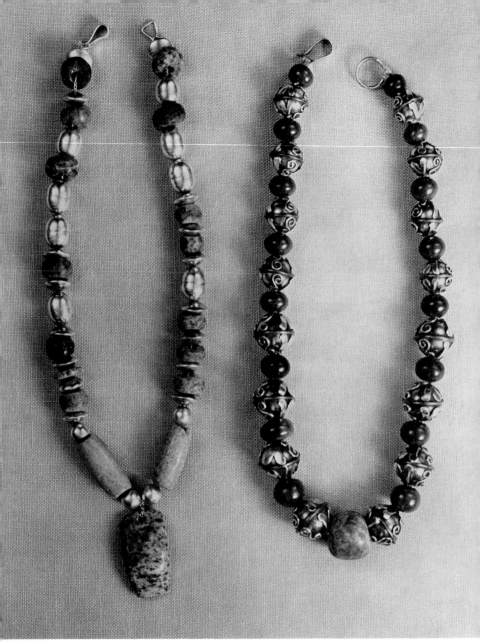

PLATE 20. Two necklaces of old jadeite beads, one strung with several kinds of old silver beads, the other with decorated silver and copper beads (by Guadalupe Castellanos).

and the technique of carving them were brought to Mexico from the Orient where the Chinese were so expert in carving the Burma jade. As there is a great similarity in the art style and working techniques in the jades from Mexico and China, this would be a logical conclusion were it not for a difference in the chemical composition of the jades found in the two countries. And, too, jade has been found in various places all over the world.

Several Indian legends concerning jade were recorded by Sahagún. The stone was supposed by the Indians to have supernatural power, and the knowledge of where to find it and how to detect the boulders with jade cores was a gift of the gods. Searchers for the stone were guided by certain manifestations, sometimes a special greenness of the vegetation caused by the damp coolness of the buried jade, or a vapor from hidden jade visible to one facing the sun in the early morning. These legends lead one to believe that the Indians did not know of any certain source of supply but depended on chance findings.

Mexican jade is less translucent and more mottled than the Chinese. Its colors include all the greens, from dark to light, blue-green and yellow-green, and all the shades from gray to white; in size it ranges from pieces weighing only a few ounces to great two-hundred–pound boulders. Without the scientific knowledge which enables one to identify stones, one might easily mistake several others for jade. Onyx, jasper, plasma, and serpentine, all have been found with the same rich color as the jades. The so-called "Mexican jade" used in much modern jewelry is dyed onyx.

The mastery of the technique of carving the stone without the use of metal tools was an outstanding achievement. The boulders were sawed through the center, the craftsman never sure of what was within, perhaps a jewel-like piece of jade, or maybe a core of poor color not worth the time and patience it had taken to saw the stone. Sawing was a slow, tedious process done with stout fiber cords or strands of rawhide,

charged with abrasives, drawn back and forth in a groove until the jade was released from the rock or the boulder was cut in half.

The water-worn pebbles were often left in their natural shape with the design fitted to the shape. The designs were either carved with simple incised lines, or modeled in high or low relief with softly rounded surfaces. Carving may have been done with flint flakes, and modeling by drilling and pecking the surface to form depressions. Bird bones were twirled rapidly to act as drills, with abrasives of finely crushed rock as a cutting agent. In the same way the jade could be pierced for beads. Hollow bones were used to form incised circles or segments of circles in carved designs. The final polishing was done with fiber pads and powdered rock, or with the bark of a tree rich in silica. The polish on jade is never brilliant but rather a soft luster with a waxy finish.

Strings of beads have been found, matching in size and color, oval and spherical alternating—the kind of beads seen on many of the Mayan stone figures. Pendants and plaques were carved in floral designs; figures were done with the expressive lines characteristic of Mayan sculpture.

One of the finest carvings of the early period, now in the British Museum, was found in a field near the great ceremonial center of San Juan Teotihuacán, a beautiful piece of blue-green stone with two figures in low relief. The elaborate ornaments on one of the figures include the jewelry worn at that time by the rulers: ear-plugs, necklace, bracelets, and leg-bands in careful miniature. The carving of the earlier periods is much finer, more sensitive and emotional, than the later work when the craft of jade carving had grown into an industry and the designs had become conventional and the execution more mechanical. The earliest dated piece of art work made on the American continent is the jade statuette in the National Museum in Washington, D.C., a figure found in a field in San Andrés Tuxtla, Vera Cruz.

Jade was prized not only for its color but for its cool, smooth

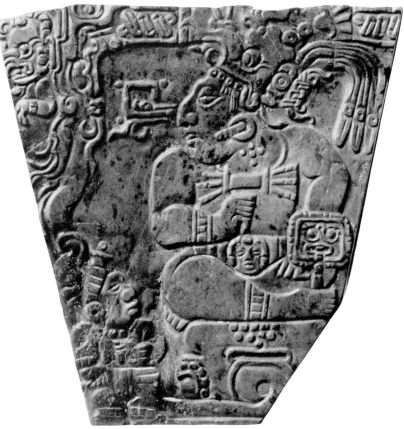

PLATE 21. A carved jade piece now in the British Museum. The actual width at the top is 5½ inches.

feel. It derives its name from the Spanish *piedra de ijada* or loin stone, so-called because of its supposed magic power to cure certain pains and to ward off evil, for which purpose jade amulets were worn. On the eve of the Spanish retreat from Tenochtitlán when the loot was being divided among the troops, Bernal Díaz del Castillo tells that, instead of gold, he chose four fine pieces of jade which, in his own words, "served me well in healing my wounds and gathering me food."

The art of jade carving was lost, the supply was exhausted. Is it any wonder that there was great excitement when, in 1952, under a pyramid at Palenque, archeologists uncovered a sarcophagus containing a skeleton wearing ten jade rings, a jade diadem set with a large pearl, a jade pectoral and other ornaments? The few fine carvings that are known are scattered in museums in many countries.

A viceroy of the seventeenth century

THE JEWELRY OF THE PAST

The Sixteenth, Seventeenth, Eighteenth, and Nineteenth Centuries

IN THE MIXTURE of Spanish and Indian customs in Mexico the Spanish features are more evident in the cities, thinning out in the remote parts of the country. The prevailing Roman Catholicism, with its belief in a visible and material display of devotion to the Church, is an inheritance from Spain; the love of gold and decoration, of pageantry and a show of power, still lend color to contemporary life. Even the *rebozo* came to Mexico with the Spaniards. The emotional spectacle of the bullfight is

pure Spanish, as are also the guitar and the rhythm of the songs which are sung with the guitar. And the language brings the Spanish culture to Mexico. On all sides we are reminded of this inheritance.

Following the *conquistadores*, drawn by the stories of great wealth in the new land, came men of all professions and trades, among them the goldsmiths and jewelry makers. The Spaniards took advantage of the abundance of gold, silver, and beautiful stones to have handsome jewelry made. Most of the jewels and luxury items were imported from Spain and Italy, but the ships from Spain were few and far between and so there were always many "made in Mexico" and the Mexican goldsmith flourished.

The early laws regulating the craft mention Indian workmen, proving that there were native craftsmen as well as Spanish goldsmiths making jewels in the first years after the Conquest. Gold work had reached a high state of beauty and craftsmanship in Spain, but the same was true of Mexico, and the Spanish craftsmen actually could teach the Indians little about the working of the metal; but they brought iron and steel tools as well as the rich Renaissance patterns for them to copy. However, they kept the Indians in inferior positions in the workshops, and some who had been the head men in their own shops became the lowly workers. After a time the Indian style was lost, but the Indian interpretations of the European models differed just enough to acquire an individual quality. There are records of jewels sent back to Spain which had been made by native craftsmen and at least one famous piece is still in existence, a piece made for Cortés by a native goldsmith.

The story is that Cortés was walking in his plantation in Yautepec where silkworms were being grown in a mulberry grove. Suddenly he cried out and clapped his hand to his leg where a large scorpion had stung him. The attendants tried to kill the insect but Cortés ordered that it be captured. The bite had the usual result and the conquistador became sick-

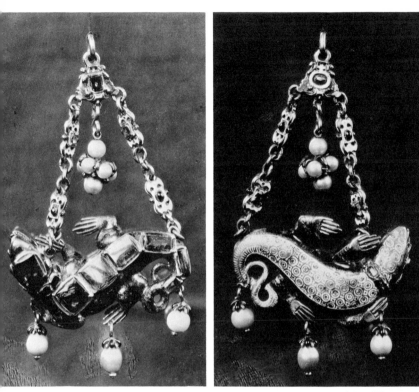

PLATE 22. Front and back views of the ex-voto sent by Cortés to the Virgin of Guadalupe in Extremadura, Spain. It is now in the Instituto de Valencia de Don Juan in Madrid.

er and sicker, his fever increasing and his talk becoming thick and unintelligible. At the point of death he turned his eyes and spirit to the Virgin of Guadalupe and promised a jewel for her shrine if she would intervene and save his life. Almost at once an Indian came with native medicines, applied a plaster to the swollen leg and gave him a bitter drink to swallow. Soon the pain eased, the fever abated, and he started to recover. True to his vow he ordered to be made an ex-voto in the shape of a scorpion, which was sent to the Virgin of Guadalupe in Extremadura. This jewel now reposes in the Institute of Valencia of Don Juan in Madrid. It is shown on Plate 22.

It is a pendant in the shape of an insect, the body covered with green, blue and yellow enamel mosaic forming scales and wrinkles through which shines a hot and continuously changing color. Forty-five emeralds are worked in a strange pattern. The creature is suspended from a chain of finely carved plates held together by delicate pearl trimmed links. From it hang three magnificent pearls in filigree drops. In this sumptuous casket is interred the dried body of the malicious insect. This piece is typical of the goldwork being done at the time, incorporating as it does realistic modeling and carving, fine goldwork, enameling, and beautiful stones in a seminaturalistic design. Enameling was unknown to the Indians before the Conquest but they were quick students and, it was said, they would silently watch a Spanish craftsman doing a complicated job and go back to their benches and do the same thing.

During the early Colonial period all phases of life were strictly governed by Spain, specially those activities which

PLATE 23. Early filigree, probably of the eighteenth or nineteenth century: a large *relicario* and a set consisting of a necklace, earrings, and a brooch, both in the Museo Nacional de Historia, Chapultepec.

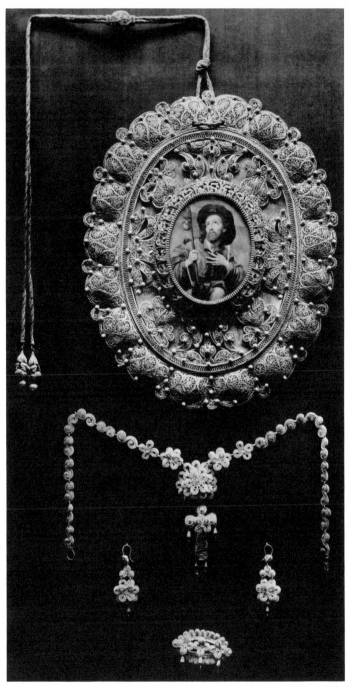

ANTONIO GARDUÑO G.

51

affected the flow of gold into the royal treasury. There were frequent changes in the laws as to who might work precious metals, how they must be worked, and who might wear jewels. In 1559 the Casa de Moneda, the Mint, had been established and all articles of gold and silver had to be taken there, weighed, assessed, and stamped, and the tax paid before they could be sold or used. But soon all licenses were suspended because it was found that silver and gold were being worked without payment of the *quinto,* the royal share of 20 per cent. When they were again allowed to work, all silversmiths had to live and work in the same district on the same street, the Calle de los Plateros, to facilitate inspection. But in spite of the attempts of Spain to control the use of precious metals —or perhaps because of the attempts—the craft flourished and, like a vigorous plant in the Mexican soil, produced jewels of great beauty.

The metal workers were divided into groups according to their ability, the most proficient group being the men who worked in gold and enamel and who set stones. The rules of the apprentice system were carefully followed and the Silversmiths' Guild had a high professional standing.

Until later, when a well-to-do mestizo class emerged, fine clothing and jewels were worn only by the Spaniards. In spite of the many laws which were made concerning the use and wearing of luxuries and even as new rules were made to enforce the sumptuary laws, the rich Spaniards bedecked themselves. Women wore jeweled hair nets and ornaments for the hair; bracelets and chains and pendants and medals; gold buttons and buckles; gold toothpicks hung on jeweled cords. Their yarn and embroidery thread was enclosed in large filigree balls which hung from gold circlets on their arms. They all had beautiful *relicarios* and fine jeweled rosaries, often with an Agnus Dei, gold embroidered and pearl embellished by the nuns in the convents. Pearls, emeralds, rubies, and diamonds are listed in the inventories which are still in existence. One pin is listed, made in 1646 by a goldsmith in

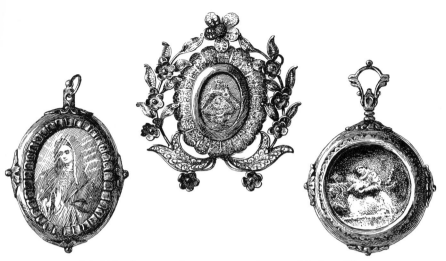

PLATE 24. Old *relicarios*. The center one is very old silver filigree.

Mexico City, which contained 121 emeralds, then as now the most precious stones after diamonds. Native flowers, fruits, and little animals naturalistically carved in gold were favorite subjects, and they were done with such skill that many found their way to Spain where they were prized as precious curios.

There are few portraits of Mexican women of early Colonial times, (in fact there were few Spanish women in Mexico at first) but, as Spain set the style for the new world, we can suppose the rich women wore jewels as nearly like those of the mother country as possible. So the portraits of the ladies of the Court in Spain give us an intimation of the ideal appearance of the Mexican women, always allowing for a lapse of time for the fashions to cross the Atlantic. As for the men's jewelry, gold buttons fastened their uniforms and gold chains were obligatory for officials. Only royalty was allowed to wear clothing decorated with gold embroidery but precious metals were permitted for sword hilts, belts, and bags and for the fine hat ornaments without which the big, soft hats were incomplete. These ornaments were often the insignia of re-

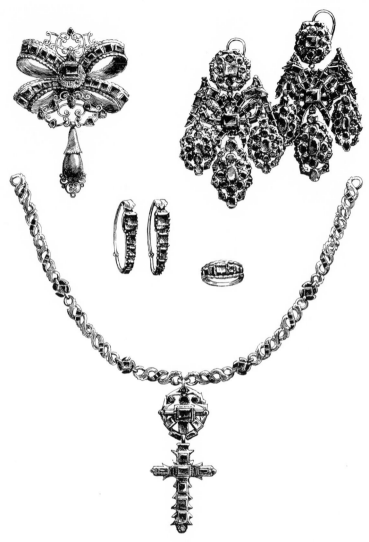

PLATE 25. An emerald set consisting of a necklace and pendant, earrings
(large and small), and a ring. This set dates from early Colonial days and
is now in the Museo Nacional de Historia, Chapultepec.

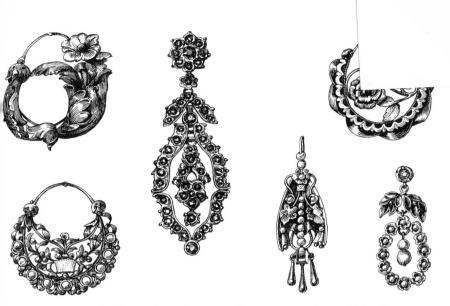

PLATE 26. Eighteenth- and nineteenth-century earrings, all in the Museo Nacional de Historia, Chapultepec, except for the two at the lower right which are from the collection of Margaritá Figueroa.

ligious or civil orders, but they were also fashioned like knots of gold cord ornamented with gems.

Gold and silver were plentiful and as soon as trade opened with the Philippines (in 1575) the gems of the whole Orient were available. The ships, after a voyage of five or six months, landed at Acapulco with ivories, diamonds, garnets, sapphires, carnelians, topaz, and rubies, carbuncles, amethysts, emeralds, and opals. Engraving, carving, and fine goldwork became secondary in importance to the color and glitter of the stones.

The settings were heavy and solid. The diamonds and emeralds were set in silver, or even lead, to add by contrast to the sparkle of the stones. Rock crystals were cut to look like diamonds and were probably the stones often mentioned as "brilliants." The transparent stones were, until 1700, all rose-

cut or table-cut and were set half buried in the metal. When the Dutch lapidaries began cutting stones "brilliant-cut" with many facets the settings became lighter.

During the eighteenth century great fortunes were being made by the men who had large grants of land from the Crown, or who had invested in silver or gold mines. The latter part of the century was a period of extreme elegance, influenced by the rich display of the French Court which dominated the styles of all Europe. Mexican women's dresses were made of Chinese gold brocades, French silks and velvets, laces ornamented with gold and silver embroidery, seed pearls, and sequins. Fine silk *rebozos* were worn, the finest being woven in Saltillo and incorporating in their pattern gold threads, ribbons, and pearls.

Pearls came to be the most prized stones and there was a never ending supply. Beautiful ones were brought from the coast in strings of 150 or more, graded as to size. Pierced, they were made into bracelets and necklaces. Almost all the portraits of Colonial ladies in the Historical Museum show them wearing bracelets of many strands of pearls, those made of large stones having two or three strands while those made of smaller pearls sometimes encircled their arms as many as fifteen times. They were worn in sets, one on each wrist, sometimes accompanied by gold bracelets as well. Even the baby girls are shown wearing bracelets and earrings and several rings on their fat little fingers.

Corals were worn in sets consisting of a necklace, earrings, brooch, and bracelets. Small corals were found along the Gulf coast but the beautiful carved ones came from Italy. In the Museo Nacional de Historia are two beautiful sets which have a story connected with them. They are said to have been the property of the Marquesa de Branciforte, wife of the viceroy from 1794 to 1798. She was, both by position and inclination, a leader of style in Mexico. Pearls were the accepted jewels of high society and the Marquesa found that some of the Mexican ladies had pearls outshining her own.

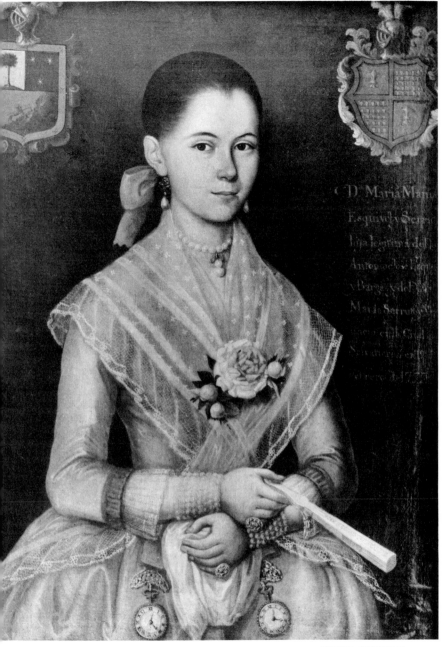

PLATE 27. A portrait of María Manuela Esquivel, painted in 1794 and now in the Museo Nacional de Historia, Chapultepec.

At one grand occasion she appeared wearing corals, announcing that pearls were no longer the vogue in Europe and that corals were now the style. Soon all the ladies of the viceroy's court were wearing corals, having sold their pearls, and the wily Marquesa was able to build up an incomparable collection by buying their former possessions from the dealers and money-lenders who had obliged the Mexican ladies.

Chinese design in textiles, embroidery, and jewelry had a decided influence on Mexican style, specially in the southern part of the country where the ports were full of ships bringing luxuries from the Orient. The *China-poblana* dress, which originated in Puebla as an imitation of a Chinese dress, is still the national costume for gala occasions, and the dresses of the Tehuanas are embroidered with designs which are typically Chinese. The Chinese use of seed pearls strung on white horse hair and combined with filigree and enamel was copied by the jewelers of Puebla and Oaxaca. Seed pearls were used in combination with baroque pearls and mother-of-pearl in the Chinese fashion. Many exquisite carved mother-of-pearl pieces came from China, at first only in the form of religious medallions which were made for the convents, but later for jewelry and bibelots.

As an illustration of the eighteenth-century style, on Plate 27 is the portrait of a young girl, Doña María Manuela Esquivel, painted in 1794. She wears a pink dress with lace fichu and ruffles caught with a bunch of pink roses. A blue bow is tied in her hair. She wears pearl earrings with large pearl drops, a pearl choker from which hangs a pendant of gold and pearls. On the little finger of each hand is a large, circular diamond ring, on each wrist eight strands of pearls, and at each side of her waist a jeweled watch suspended from a diamond clasp.

By this time the men also were adorned with jewels. They had diamond-decorated buttons as a matter of course. They carried jeweled snuffboxes, and swords and canes with jeweled handles; they wore jeweled ornaments in their hats, and on

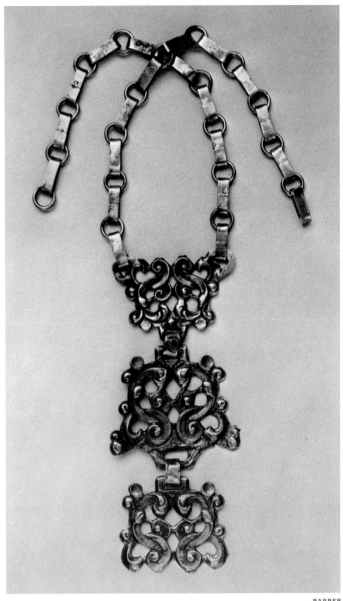

PLATE 28. A necklace made recently, by a jewelry maker unknown to us, from scraps of old carved silver, probably decorations from a velvet-covered book.

their uniforms a great deal of gold embroidery. Their badges of military and civil orders were diamond-incrusted. Their saddles, stirrups, and spurs were decorated with gold and silver.

Silver was so plentiful that it was common for table use to save the imported porcelains from the carelessness of servants. Dining services and large trays, collars for lap dogs, candelabras, locks and hinges, picture frames, cuspidors, desk sets, chamber pots, vases, and hundreds of other silver articles were to be found in the houses of the rich and the not-so-rich. No wonder the rich people preferred gold for their personal jewelry, leaving silver for the common people, a preference which lasted from that time until the twentieth century when the Revolution leveled some of the class distinctions and many of the fortunes, and when modern designers discovered the beauty of the white metal for fine jewelry.

In the early nineteenth century, with increased communication with the rest of the world and the growth of a middle class, a great deal of the splendor of the previous life disappeared. The jewels were much the same as those worn in England and France, in fact most of them were derivative in design. Until recently the influence of the United States on Mexican styles has been negligible. In the memoirs of the tourists who started visiting Mexico in the last century, the jewelry shops on the Calle de los Plateros—later Calle San Francisco and, since the Revolution, Avenida Francisco Madero—were said to equal any to be found in Europe.

Madam Calderón de la Barca, wife of the first Spanish minister to Mexico after the Independence, writing in 1839, commented on the taste of the wives of the officials who called upon her when she arrived in their midst.

Sra. B——a, the wife of a general, extremely rich and who has the handsomest house in Mexico; dress of purple velvet embroidered all over with flowers of white silk, short sleeves and embroidered corsage; white satin shoes and *bas a jour;* a deep flounce of Mechlin appearing below the velvet dress, which was short. A mantilla of black blonde, fastened by three diamond aigrettes. Diamond

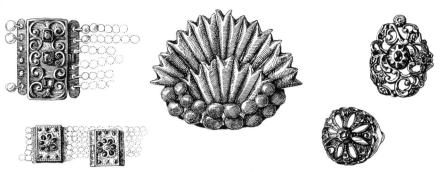

PLATE 29. Examples of nineteenth-century jewelry which the authors have been fortunate enough to find, none of any great value but all typical of the period: at the left two clasps for pearl bracelets, the larger of gilt and emeralds, the smaller of gold and enamel; in the center a coral brooch, perhaps from Italy, in a style very popular during the first half of the century; on the right two rings, the upper of carved silver set with eight small diamond chips and a larger rose-cut diamond and mounted on a gold backing, the lower made from an old silver button set with nine small diamonds and mounted on gold by a modern jeweler.

earrings of extraordinary size. A diamond necklace of immense value and beautifully set. A necklace of pear pearls valued at twenty thousand dollars. A diamond *sevigne*. A gold chain going three times around the neck, and touching the knees. On every finger two diamond rings like little watches. As no other dress was equally magnificent, with her I conclude my description, only observing that no Mexican lady has yet paid me her first morning visit without diamonds.

Madam Calderón de la Barca was interested in all phases of life around her and she gives us a fine picture of Mexico in her lively letters. She observes that ". . . no man above the rank of *lépero* marries in this country without presenting his bride with at least a pair of diamond earrings, or a pearl necklace with a diamond clasp." She further comments that noth-

ing but pearls and diamonds were worn by the Mexican women as they considered colored stones cheap and trashy. "The ladies of the diplomatic corps tried to make up in elegance what they lacked in magnificence, for in jewels no foreign lady could attempt to compete with those of the country."

During the French occupation there was an attempt to revive the aristocracy and splendor of the Court. Maximilian, in his trips about the country, was always accompanied by his secretary carrying (so he says in his memoirs), ". . . a valise containing insignia of the orders of Guadalupe and of the Mexican Eagle: gold, silver, and bronze medals of civil and military merit, and articles of jewelry, for the most part gold watches with covers enameled in blue with the imperial monogram, to be bestowed on persons the Emperor encountered on his journeys who he thought should be rewarded for good service or merit."

After the Revolution old jewels appeared for sale in the dealers' shops, brought in by impoverished patricians or by old family servants who wouldn't, or couldn't, tell anything about them. These jewels rapidly disappeared as the tourists arrived. A problem of the antiquarian in Mexico is to establish the origin of such jewelry as still remains from more than a hundred years ago. The Mexican goldsmiths could duplicate any object which came from Europe and there are few records to authenticate the source of the jewels which come to light as the old fortunes vanish. Most of the fabulous ornaments which we read about have been dispersed over the years when Mexico was torn by war and revolution, when homes and churches were pillaged and burned. Gold and diamonds could be converted into money. Much of the old treasure was melted down, some of it reset with the changing styles. The more valuable the stones, the more apt they were to have been reset.

In the Museo Nacional de Historia there is a comparatively small collection of eighteenth- and nineteenth-century jewelry both Mexican and foreign. The jewels made in Mexico com-

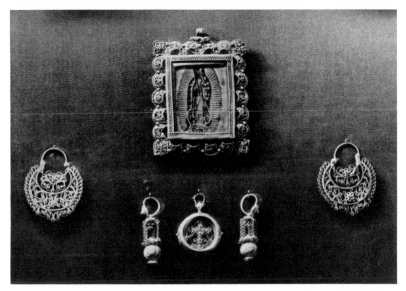

PLATE 30. Eighteenth-century filigree jewelry in the Museo Nacional de Historia, Chapultepec.

pare well with those of foreign origin and, examining them, we are again impressed by the unmistakable individuality of the Mexican style. The richness and beauty of the Mexican jewelry made at a time when the United States was in its infancy fills us with respect and admiration for the Mexican craftsman.

The Monte de Piedad

Closely associated with the Mexican jewelry of the past is the Monte de Piedad, the National Pawn Shop, privately owned but under Government supervision. In this institution people in need of money can borrow on their possessions under just terms and at low interest rates. It was started in 1775 by the Conde de Regla, who had amassed a large fortune from silver mining, as a charitable act to rescue people from the rapacious money lenders of that time, and

it still has that character although interest is now charged. Ever since the beginning a Conde de Regla has been on the Board.

A great deal of jewelry eventually gravitates to the show-cases where the unclaimed pieces are displayed. There one sees gold filigree, strings of baroque pearls, beautiful rosaries, diamond rings, gold-coin jewelry, rings made from the old diamond buttons, all kinds of pieces from many periods and from many parts of the country. The jewelry is appraised by experts and the prices are said to be right. All day people hang over the cases, admiring, searching, or longing for something they see.

Many of the larger cities have their own Montes de Piedad where, from time to time, old jewels and regional pieces appear.

RELIGIOUS JEWELRY

As in many other countries the craft of
the goldsmith in Mexico was developed and
encouraged through the patronage of the Church. Although
at first the laws of Spain restricted the use of precious metals
for personal or home adornment, their use for the Church
was permitted. As people grew wealthy their gold accumu-
lated faster than they could spend it and there were no banks
where it could be kept, so they were led to bestow jewels and
devotional pieces on the churches and monasteries, and they
competed in fitting out beautiful shrines and private chapels.

The churches which were being built in great numbers

were awe-inspiring with the richness of gold and color, and must have seemed like Paradise itself to the Indians. The interiors were covered with gold leaf, the altars rich with embroidery and lace, and against this shining background were lamps and bells, vases, candle holders, incense burners, plates, chalices, and other sacred vessels, all of gold and silver blazing with the color of stones and enamel. On many altars were vases holding *ramilletes,* branches of golden flowers done in a seminaturalistic manner and set with colored stones. All the skills and all the materials known to the goldsmith were employed in making the crucifixes, some of the most beautiful having a cross of rock crystal with the corpus of modeled or carved gold. Many pieces which give one an idea of the great beauty of these devotional jewels of the past can be seen in the Museo de Arte Religioso adjoining the Cathedral of Mexico City.

One has only to look at the splendor of the old churches as they are today, remembering how many times they have been despoiled of their treasures, to imagine how they must have looked when the Church was so powerful and owned so much of the wealth of the country. From 1810 to 1910 Mexico suffered from two revolutions, from wars and invasions. Wave after wave of anti-Catholic feeling swept the country, and each time the civil government confiscated Church property to finance the army and the bankrupt Treasury. Churches which had a wealth of gold and jewels, altar rails and pavements of silver, and gold leaf on the carvings, lost it all to the government which needed the actual metal to melt into money.

The Virgin is the chief patroness of all Mexicans and many of the ceremonies of the Church center around her shrine. In the chapel of Our Lady of the Rosary in the church of Santo Domingo in Puebla, a chapel glowing and shimmering with gold leaf, is the image of the Virgin which for nearly three hundred years has been specially venerated by fishermen and sailors who brought pearls to make possible the building of the shrine. The chapel was finished in 1690, and writers of

PLATE 31.—A *ramillete,* an altar decoration. These are usually seen in pairs in gilt vases. The flowers are of gold and silver, sometimes with jeweled centers. The tradition of flowers beautifully wrought in metal goes back to the sixteenth century, and this type of metalcraft is still liked today both for jewelry and for larger pieces.

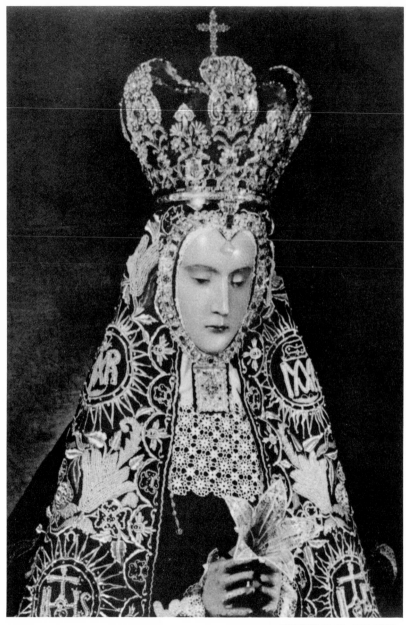

PLATE 32. The Virgin of Soledad wearing a crown of gold set with emeralds and diamonds made by Sr. José Ortiz and carrying a filigree lily made by Rosita.

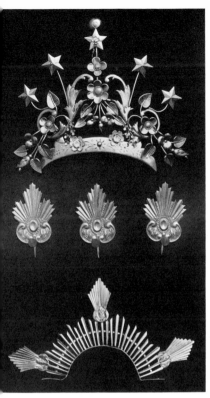
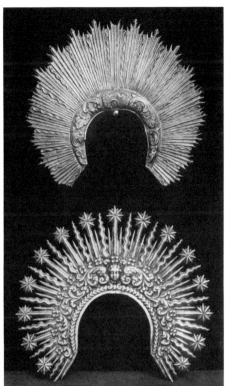

PLATE 33. On the left a silver crown and *potencias*, on the right two halos for figures of the Virgin; all are in the Museo de Arte Religioso in Mexico City.

that period have left us glowing accounts of the silver throne, lamps, and altar service, and the blue robe of the Virgin incrusted with pearls of great value. In the wardrobe of the little Virgin of Los Remedios were three robes, one embroidered with pearls, one with emeralds and one with diamonds worth three million pesos.

In Oaxaca the lovely, pale Soledad has dresses and jewels worth a fortune. She has a wealth of pearls, and always carries a lily, white with pearls. She also is a patroness of the sailors

who claimed to have seen her in time of danger as she came to save them from shipwreck, and who brought her pearls as they journeyed overland from Acapulco to Vera Cruz. On the occasion of the fiftieth anniversary of her Coronation a beautiful new crown was made for her by Sr. José Ortiz who is probably the finest of the Oaxaca goldsmiths. It is of lacy gold incrusted with pearls and set with diamonds and emeralds.

The crowns, halos, and jewels made for these figures are the finest work of the Mexican goldsmiths of all periods. Little Saints wear small rosaries and rings no more than a quarter of an inch in diameter set with precious stones, and crosses half an inch wide decorated with fine engraving. Several years ago, in the comprehensive exhibition of Mexican art was one figure of the Virgin about seven inches high with earrings and pendant of delicate wrought gold and three strands of minute seed pearls on each wrist. The little golden shoes made for the *Santos* and for the Child have become collectors' items as they find their way into the antique stores.

Gold and silver ex-votos, commonly called *milagros,* are a truly Mexican contribution to devotional silver work. They are expressions of thanks for the intervention of the Saints and sometimes the entire robe of a popular *Santo* is covered with these little replicas of the various parts of the body which have been cured through prayer: eyes, ears, hands, breasts, legs. There are animals of every kind from cows and burros to scorpions, and in Pátzcuaro many fish in gratitude for large catches. There are babies and children, hundreds of broken hearts, devout kneeling figures. Cast or carved, stamped or modeled, they are a very sincere folk art, on sale throughout the country in city shops and in the sidewalk stands outside the poorest churches. The little figures, sometimes very primitive when done by the village silversmith, are often real emotional works of art.

Plate 34 shows a San Antonio which is in the collection of Mr. Frederick Davis, who gave us permission to tell its story.

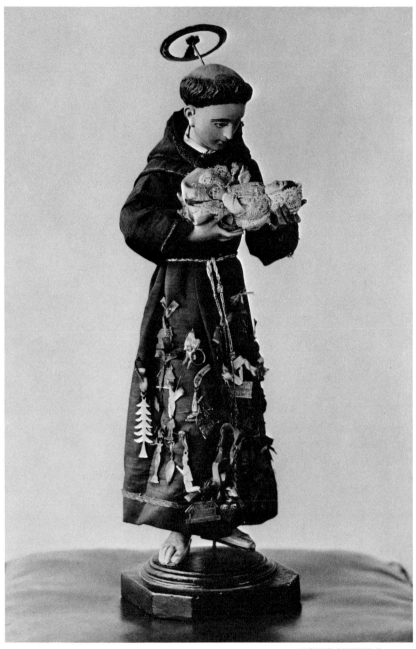

PLATE 34. San Antonio, with *milagros*. This figure, about 18 to 20 inches high, is in the Frederick Davis Collection.

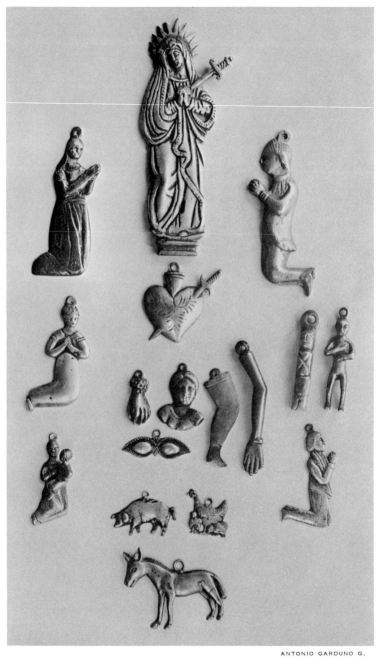

ANTONIO GARDUNO G.

PLATE 35. Silver *milagros* in the Frederick Davis Collection.

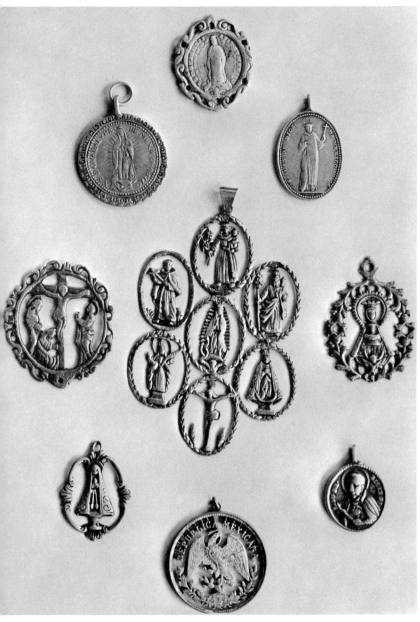

Plate 36. Old religious medals in the Frederick Davis Collection.

Years ago, when Mr. Davis had his shop in the Iturbide Hotel, a woman came with this very nice *Santo* (about fourteen inches high), a San Antonio which had been in her house for so many years that it had become a neighborhood Saint. Now she needed money but would sell the precious figure only to someone who would appreciate it and cherish it as she had done. Mr. Davis bought the *Santo* and as long as he had his shop the former neighbors came to pin their ex-votos on it. One series which tells its own story consists of a heart, a little ring, a baby, and a house, all placed on it by one young man as his prayers were answered. During Mr. Davis's last illness, at a time when he seemed to be recovering, friends added grateful ex-votos to this same household *Santo*.

In Mr. Davis's fabulous collection of folk art there is a group of silver *matracas,* rattles used during Holy Week when no bells ring. The imagination of the silversmith ran riot as he fashioned these little objects, fantastic with figures and flowers, buildings and animals, carved and decorated. A writer in 1844 tells us,

On Thursday before Good Friday no bells ring, no horses or carriages, everybody is on foot. The women in their finest clothes make pilgrimages to seven churches. Everyone carries a *matraca* of wood or bone surmounted by a wax figure of a bird, a baby, a nude Venus. The rich carry ornamented silver ones, and it is the custom to give them as presents on that day. . . . all was quiet but the hum of the crowd and the crack of a thousand rattles that filled the air like a meadow full of grasshoppers.

As in every Catholic country, medals are worn for personal saints, for saints specially venerated in the community, for the local Virgin—La Salud, Soledad, Zapopan. The most generally worn medal is that of La Virgen de Guadalupe on which the goldsmiths expend their most devoted efforts, producing some beautiful examples.

The cross is a form capable of infinite variety in its ornamentation, and it has been the inspiration for some of the

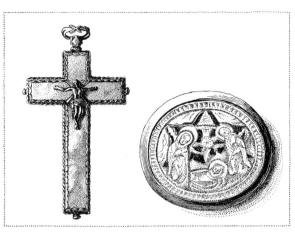
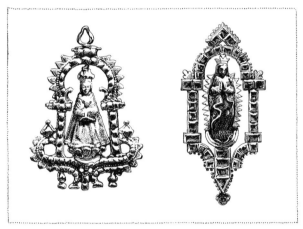

PLATE 37. Old religious pieces: above, a gilt sun similar to some we have seen on the robes of the saints in sixteenth-century paintings; a cross and brooch of mother-of-pearl and gold (the latter, not in its original frame) showing a nativity scene which was carved either in Italy or in the Philippines; below, two pendants in the Spanish style, which could have been made either in Spain or in Mexico (now in the Museo Nacional de Historia, Chapultepec), and an old bronze figure of San Cristóbal with traces of gilt (it is smooth with wear and we would like to know who wore it for so long a time).

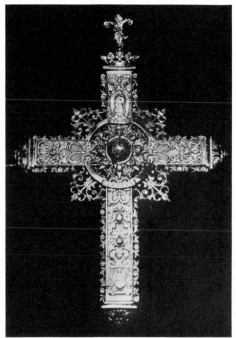
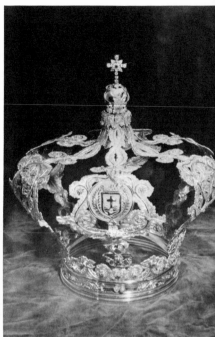

PLATE 38. A pectoral cross made for Cardinal Piazza and presented to him by the Carmelite Order of Mexico, and a crown of red, yellow, and green gold for the Virgin of Carmen in San Angel. The crown at the widest part measures a little over 11 inches in diameter. (The cross was made by Sr. Carlos López González and the crown was made under his direction.)

most beautiful jewels since the early days of Christianity. In Mexico many regions have favorite styles of crosses for personal wear: filigree and pearls in Oaxaca, the foliated filigree from Yucatán, large silver crosses with pendant crosses from Yalalag, the engraved silver crosses which have already been mentioned. And every modern jewelry designer has his own version.

The tradition of fine handmade work for the churches is carried on today with the center of the industry in Puebla. In

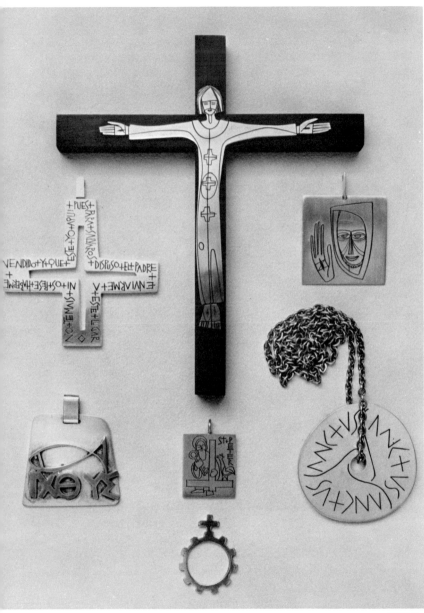

PLATE 39. Silver crucifixes and medals made by the Benedictine brothers in the monastery in Cuernavaca. At the bottom is a "rosary for the road" used by travelers, boy scouts, and other wanderers.

PLATE 40. Hearts are a favorite religious symbol. The heart on the left is of *repoussé* silver and is finished with hand carving (in the Museo de Arte Religioso in Mexico City); the two on the right are hollow, of silver and gilt, cast and carved; the fourth is in crudely done filigree with the cipher of the name *María*.

addition to the crosses and crowns, altar silver, *relicarios,* and *custodias* are finely modeled figures which are afterwards cast in silver and gold plated. The samples of this work which we are showing on Plate 38 are from Orfebrería López & Ortíz, one of the best of the Puebla shops doing this highly specialized work. Sr. Carlos López is one of a line of fine silversmiths who have been producing such work for over a hundred years. He designs within the traditional style and uses all the processes and materials available. Technically his products equal those of the finest periods of the art.

The crown shown is one made for the Virgin of Carmen in San Angel. It is about twenty inches high, of yellow, red, and green gold, set with one hundred and ninety-six stones, diamonds, emeralds, rubies, and garnets. A crown was also made for the Child in the arms of the Virgin. It is of yellow gold embellished with brilliants, emeralds, and pearls. Both crowns were dedicated in 1951.

A recent development in the art of devotional jewelry is the work being done in the Benedictine Monastery in Cuerna-

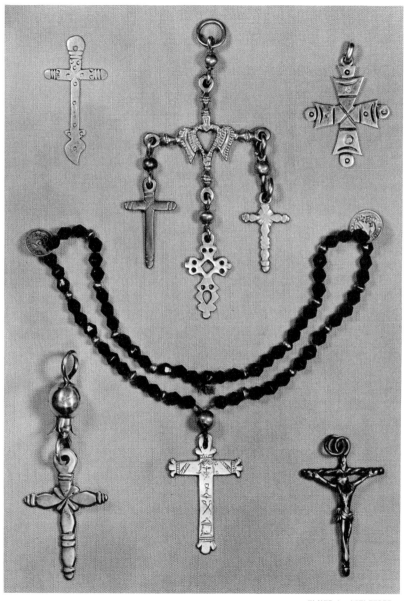

PLATE 41. Silver crucifixes and crosses. The large one at the top and the one suspended from a pomegranate are from Yalalag. The one on the jet beads is from Oaxaca. In the lower right is an old one so worn that the detail has disappeared and it resembles modern sculpture.

vaca. In contrast to the elaborate traditional design common to this class of metal work, the Benedictine designer, Fray Gabriel, has turned for inspiration to the simple Byzantine designs of early Christian art. The crosses and medals are cut from heavy, flat silver on which line designs are incised. The figures in the designs are highly stylized for dramatic effect and lettering is used as decoration. The fact that the designer is an architect probably gives the work its special quality. The beauty of the silver is enhanced by the clean, simple lines and lettering, and the designs are more beautiful because of the softly burnished silver background (See Plate 39).

The designer of religious jewelry and metal work has a special problem. Each piece, to be successful, must do more than decorate an altar or adorn a person; it must express an emotion. Sometimes, as in some of the great works of the past, this quality is obtained by a lavish use of precious materials worked with great care and labor. But often the impression given by such work is only one of ostentation.

With today's concepts of design, the simplifying of ornament, and the search for novelty, the difficulty is to avoid designs so abstract as to have little devotional content. The architects of the new churches which are being built in Mexico are setting an example of the use of new materials, and of old materials used in new ways, which the jewelers are beginning to follow.

JEWELRY OF THE PEOPLE

Regional Styles

IN THE UNITED STATES there have been several kinds of "regional design" which, upon being recognized as having individual style, have been quickly commercialized. Pennsylvania Dutch is an instance, a naive type of design created for their own use by farmers with European peasant tradition. It was appropriated by antique dealers and interior decorators, and now there are books about Pennsylvania Dutch design, Pennsylvania Dutch wall papers and textiles, stencils for furniture, and pseudo-Pennsylvania

Dutch articles in gift shops from New York to Hollywood. Certainly it is no longer a regional style. Navajo jewelry, so handsome in its own environment, now is worn in flimsy imitations all over the country.

In New England a clever village woman figures out some new crochet patterns. She does not take her lace to the crossroads store for her neighbors to buy. No, she sells her patterns to a national women's magazine and within a month thousands of women, from Maine to Oregon, are busy with their crochet hooks turning out identical pieces.

In Mexico each town and village has its own crafts and its own style of decoration, influenced by the materials available and the traditions of the place. So, if you want the kind of necklace made in Pátzcuaro, for instance, you will have to go to Pátzcuaro and find the local silversmith because he is the only man in Mexico who makes that kind of a necklace. (An exception is The Museo Nacional de Artes e Industrias Populares which gathers the best work from all over the country for sale in its shop.)

This regional individuality has several causes. Some of the Indian villages were craft centers when the Spaniards found them and their crafts were fostered by the missionary fathers, the most notable of whom was Don Vasco de Quiroga, Bishop of Michoacán, who left an indelible mark on Mexican culture by establishing, in 1540, the first college on the American continent, the College of San Nicolás in Pátzcuaro, still a flourishing institution in Morelia, to which city it was later moved. Don Vasco recognized the artistic skills of the Indians and started schools to teach and improve the crafts, designating one craft for each village in his diocese: lacquer for Uruapan, the making of musical instruments for Paracho, copper working for Santa Clara, and a different kind of pottery for each village. In many of these villages the same crafts are being produced after more than four hundred years. Among the first subjects taught in the College of San Nicolás were painting and sculpture, the casting of bells and mak-

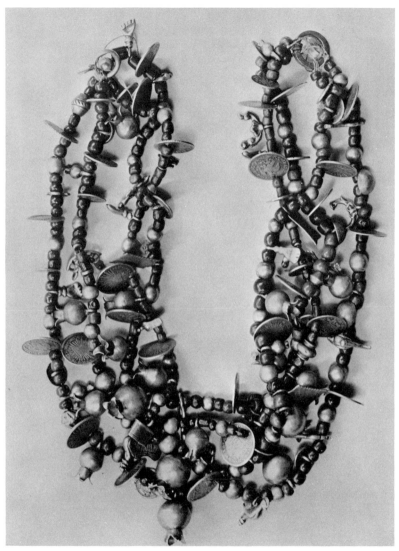

PLATE 42. A necklace of old red trade beads, silver beads, cast ornaments, and old coins. The typical castings, the Guatemalan coins, and the use of trade beads all suggest that the necklace came from the Oaxaca mountains. It is in the Frederick Davis Collection.

PLATE 43. The Huichol Indians weave small beads into ornaments and string them for necklaces or use them as earrings. They also make fine woven bead bracelets which are usually worn by the men.

ing of organs for the churches, which gave the Tarascan Indians a good artistic training.

The lack of communication between different parts of the country until recent years has been a large factor in preserving regional design, but an even stronger contributor has been the strong sense of tradition which is characteristic of the rural Mexicans. They are content with little change. In some places the style of dress has been the same for centuries. Now that roads are being built into far-off parts of the country this condition may not last. However, in some regions where the tourists have been coming for a hundred years the dress and jewelry of the natives have remained unchanged. The Tehuanas have always traveled about the country wearing their typical dress and jewelry with pride. They are sometimes seen in Mexico City in their unique costumes, unaffected by the city styles around them and apparently unselfconscious. (But lately at the dances in the plaza in Tehuantepec many of the young women wear modern city dresses, and there are two orchestras, one playing traditional music and one "la jazz.")

The crafts are not only village crafts but family crafts handed down for generations. The village jeweler has learned his

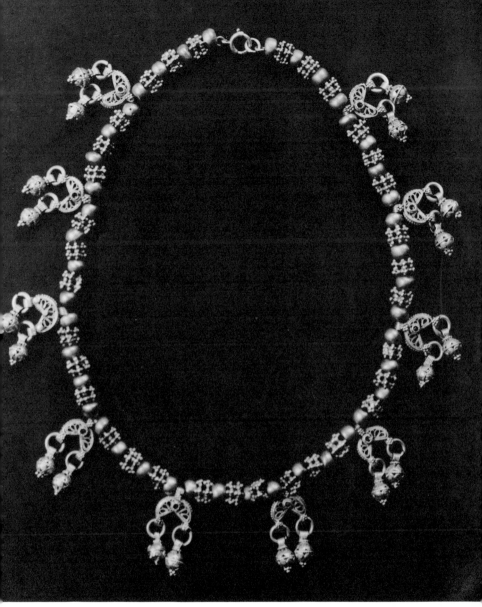

PLATE 44. A silver necklace—old and probably village-made. Its origin is unknown. From the collection of Dr. Espinosa.

trade at his father's workbench and, at the same bench following the same designs, he makes jewelry for the village women, while beside him sits his seven-year-old son tempering a little piece of silver, learning to be his father's helper. A village jeweler has a small group to please and his customers all want the same sort of things their mothers have worn with perhaps, occasionally, a little change. City craftsmen have a larger, more varied group to please and their work may not have the individual quality so often seen in the village product.

One is baffled in trying to trace the origin and development of some of the regional styles. A piece may look Moorish, Chinese, or Indian, but as far as the villagers know it has always been like that. It may have originated from a little detail in a church ornament or on a Spanish saddle, or from the lock on an old box which has long since disappeared.

Beads

Among the more isolated and primitive Indians practically the only ornaments are strands of dried berries and seed pods, small shells, or the cheap glass beads brought in by the traders. Even so a great variety of personal and regional taste exists. Often among the beads are little old coins, small silver figures of animals, birds, or people, flowers, religious symbols, bells or thimbles which look like bells, shells, buttons, anything that appeals to the wearer as ornamental or sentimental.

The Huicholes of the western mountains wear many strands of small beads twisted into fat ropes, their favorite colors being white and light sky blue. They are famous weavers, are

PLATE 45. The kind of necklaces worn by the country people. The two shorter ones are from near Puebla; the center one is a Tarascan Indian design from Michoacán.

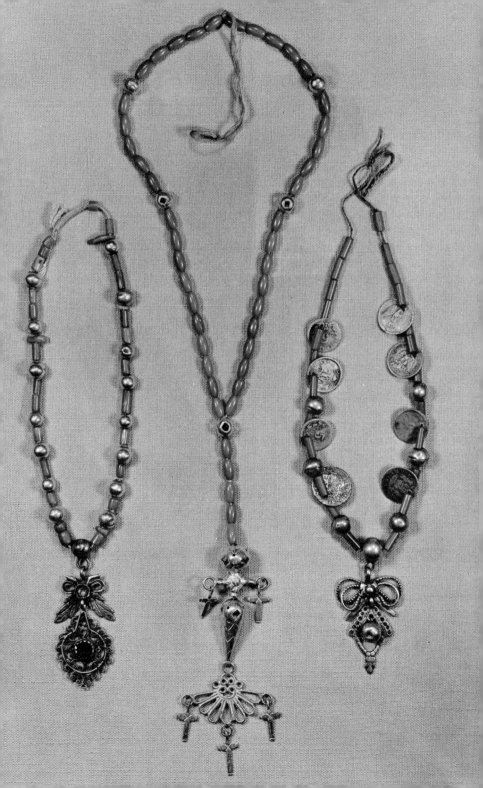

very inventive, and have fine taste in color and design. They weave little squares of black (or dark blue) and white beads in lively geometric patterns which they make into earrings or necklaces by stringing them on yarn. For these woven squares they use the small beads from France. Their fanciest ornaments are for the men, small woven bags to hang around their belts, bracelets, anklets, and head-bands. The Tarascans of Michoacán, who used to wear red branch coral, now wear plastic imitation corals. The Zoques of Chiapas wear either coral or amber, often interspersed with gold beads. And everywhere one sees the little old coins on the bead necklaces, many of them several hundred years old, which must have been passed along as ornaments for generations.

Ever since the country was opened to foreigners, from Cortés to the present day, beads have been a standard article of trade. In remote parts of the country the Indians wear beads from Germany and Czechoslovakia, and the plastic, imitation coral has almost altogether replaced real coral. Many of the very old necklaces were made of red glass beads with clear or white glass centers, made in Italy in the 16th century and brought to Mexico by the early traders. These red beads as well as the "star beads" from Venice have been found from Guatemala to as far north as Oklahoma, but in Mexico they are seen mostly in the southern part of the country.

In San Pedro Quiatoni, a small town south of Oaxaca, the women wear unusual beads of 16th century glass, rods about two and a half inches long, looped at one end so that they can be strung with other beads to radiate from the neck. Quiatoni had no road until recently and the beads stayed in the town and were handed down for generations until the daughters of this generation began to travel to the larger towns and to sell the old necklaces, which are now occasionally seen in Oaxaca. The one on Plate 46 is of alternating green and white rods with a few other old Venetian beads between them.

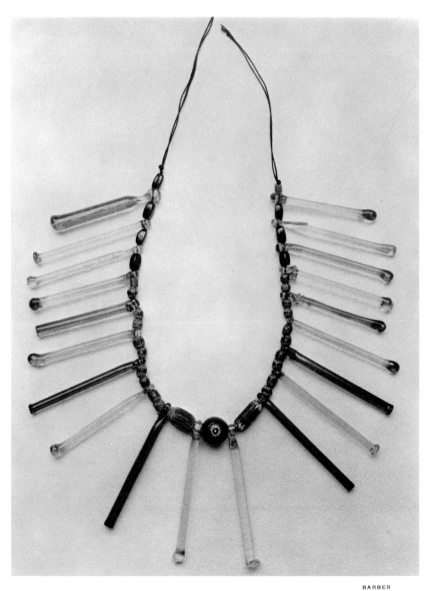

PLATE 46. A necklace of sixteenth-century trade beads from San Pedro Quiatoni, Oaxaca.

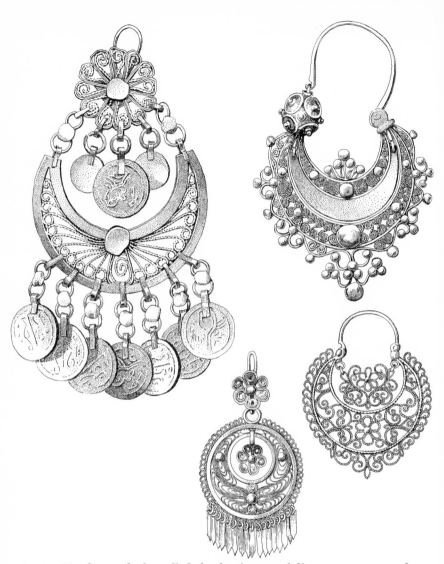

PLATE 47. This might be called the family tree of filigree earrings: at the upper left is a large star and crescent earring from Morocco; at the upper right is a piece of Spanish filigree now in the Hispanic Museum in New York; below are two examples of Mexican filigree, an old one on the right and a new one on the left.

Earrings and Filigree

Mexican women, old or young, rich or poor, wear earrings. Practically every girl baby's ears are pierced and have little gold rings in them, and from then on she is never really dressed without her *aretes*. Earrings for pierced ears can be quite different in design from those made to be screwed on, and many of the most beautiful ones, the old and heavy ones, cannot be fitted with screws.

Every market where the country women come to trade has a jewelry stand selling cheap, pressed, gold-colored earrings with brilliant glass sets. Factory made and flimsy, they are so light in weight that some of the Indian women wear two or three on each ear.

One sees everywhere the crescent-shaped earrings, the originals of which probably came to Mexico from Spain, a design inherited by the Spaniards from the Moors, or from the gypsies. The most interesting ones are of filigree fringed with little balls or drops. These earrings are usually made in one of the centers where gold work is done and are either of gold or silver or of copper plated with gold or silver. Many of the cheaper ones come from Juchitán in Oaxaca where they are turned out by the hundreds in small "factories." The workshop, or factory, which we visited, that of Sr. Pedro Gallegos called "El Alambre de Oro," the golden wire, was an outdoor shelter facing on a large patio which had a number of other buildings around it. There were places for six or eight workers at the benches and they were turning out a very good grade of filigree in copper wire which was afterwards to be electroplated in gold or silver. All the work is done carefully by hand. These earrings can be bought in any Mexican city for a small price.

We had been told that a great deal of the best filigree was made in Guadalajara, and this may be true. On repeated visits to the factory where it was said to be made we found the place closed, and no one could tell us whether it was for a

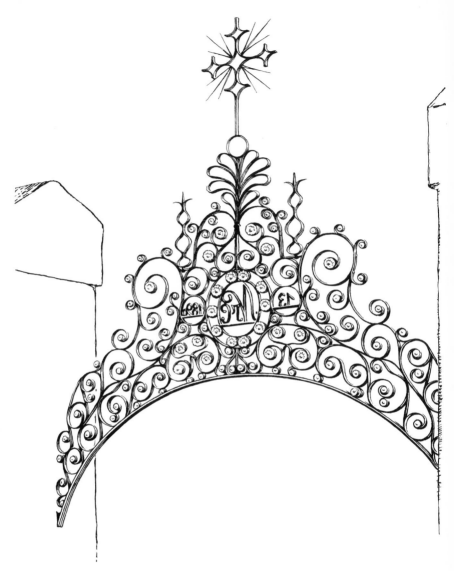

PLATE 48. Filigree is everywhere, not only in gold and silver but also in iron. This is the gate at the entrance to the Church of Valenciana in Guanajuato.

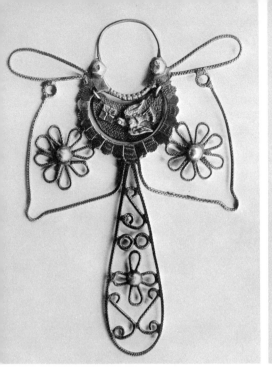

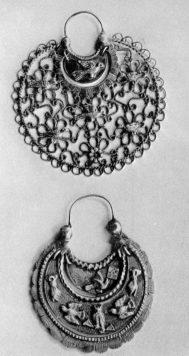

PLATE 49. Earrings from near Súltapec. The larger crescent is 3 inches wide; the butterfly measures about 3½ inches in length. From the Frederick Davis Collection.

week or forever, whether because the owner was celebrating his Saint's Day or because he was bankrupt. We were told that the tourist demand for modern jewelry had caused a slump in the market for filigree so that the larger factories could no longer afford to make it. But the style has lasted for hundreds of years and will no doubt be carried on by the regional jewelers to satisfy the Mexican taste.

There is a question of the origin of filigree work in Mexico. We have read that it started when the Chinese influence was so strong; and we have heard that it stems directly from Italy, or from Spain. The designs of the early Mexican work are so like the Spanish that it seems logical to conclude that it is part of the Spanish heritage. Much of the filigree being

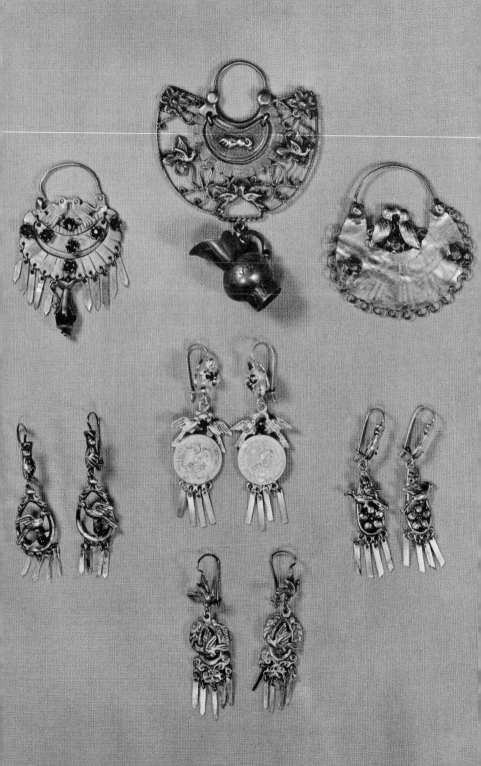

done in China and Italy before 1500 was wirework soldered as a decoration to a solid background but that in Spain was lacy and open, as was also the Mexican.

Filigree is a very old way of working gold which has been done in all parts of the world during many different periods. The technique is reminiscent of the lace and embroidery, the illuminated manuscripts and printing of the sixteenth and seventeenth centuries, and it gives us the same pleasure we derive from the intricate design of that period. We either like it very much or it bores us very much.

The eighteenth-century Mexican silversmiths not only made filigree jewelry; they built up vases and frames, cup holders for their chocolate cups, crosses, and many other accessories of the finest, most delicate wirework.

The archeology books often mention the filigree of the pre-Conquest Indians. Their goldwork had the appearance of true filigree but it was done the hard way, with wirelike threads of wax cast in a solid piece.

Some twenty or thirty years ago, in the mountains south of Toluca, there was an imaginative silversmith whose earrings reached an incredible size, sometimes three inches in diameter. It seems possible that he may have been inspired by old wrought iron work, or that he may have been an ironworker himself as his designs of heavy wirework adorned with castings of animals, birds, hands and flowers, remind one of the Colonial ironwork. But that is only a guess for we were unable to find out even his name. Although there is considerable variety in the way he used the wire and the flat silver shapes on which he mounted the castings, his style is unmistakable, always large and always original. He has long since left his native village and his work has not been on sale for a number of years (but not long ago we saw some new shiny

PLATE 50. Silver earrings from Toluca and the nearby mountains.

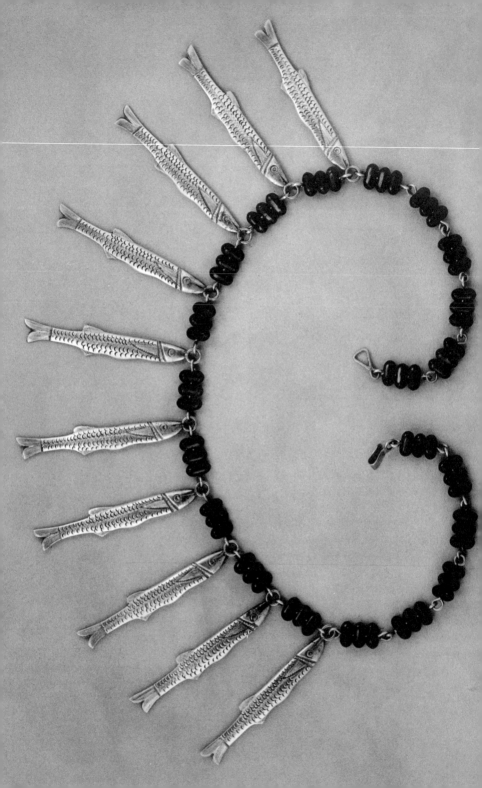

copies). Known as "Súltapec" earrings, his creations are shown in the Museum of Regional Art in Toluca, and once in a while there is a pair in an antique shop. However, the only real collection is that of Mr. Frederick Davis who, realizing their originality, bought them from the maker.

Interested, after seeing Mr. Davis's collection, we decided to go to Súltapec. After slipping, sliding, and bumping over the mountains for fifty miles on what is called a *regular* road, without passing any car but the daily bus, on up past the snow fields of the Nevada de Toluca, we arrived at Súltapec. It was once an important silver-mining town which now has much the appearance that Taxco must have had in the early days, with its tiled roofs and steep, cobbled streets. No one there had ever heard of the famous earrings. For two days we canvassed the town, talked to the women in the market, visited homes where there was old jewelry, looked at jewelry which people brought to us on the street when they found out what we were interested in, but we found no trace of the earrings. We had hoped, tradition being so strong in the regions off the highways, that we would find someone making the daughters or granddaughters of the big earrings, but there was no jewelry maker in the town. A year later we found that the so-called Súltapec earrings had been made in a small village not far from Súltapec called Barrados. We leave these notes to anyone who wants to go on with the research on the subject.

Comparatively large silver earrings with cast ornaments and filigree, set with colored glass, are common in the mountains around Toluca. Some have small pitchers hanging from them. Over a period of twenty-five years we have been interested in the earrings made by Sr. A. Quiroz in Toluca. They have not changed much in that time except that the new ones are a

PLATE 51. A necklace of silver fish and imitation coral, from Pátzcuaro (made by Jesús Cazares).

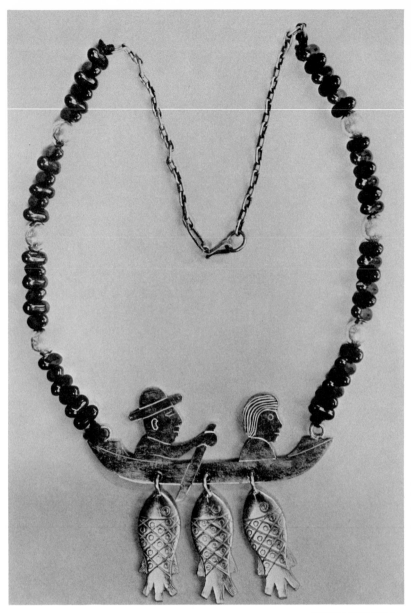

PLATE 52. A necklace of imitation coral and silver, designed by Miguel Covarrubias (made by Jesús Cazares). From the Frederick Davis Collection.

little lighter in weight. He makes castings of birds, flowers, and hands which he combines on various frames, adding filigree and glass beads to make the earrings which are very popular in Toluca. He also mounts small silver coins with filigree. The light, shiny silver looks well against the dark skin of the Mexican women.

The Jewelry of Pátzcuaro

The fish necklaces from Pátzcuaro are well known as they have been shown in museums and exhibitions of folk art and have appeared in several books on Mexican crafts. These designs originated a number of years ago with Sr. Herminio Cazares and are specially interesting because of their Tarascan derivation and feeling. And one necklace is inspired by the little white fish which have always been so important to the people who live in the villages around the lake.

There have never been more than a few designs in the Pátzcuaro jewelry. The most elaborate is the marriage necklace or rosary made of bright red beads combined with large openwork silver beads and supporting a lacy, silver cross. There are two kinds of fish necklaces, one of thin fish about two inches long (the same size as the actual little silvery fish which the natives dry and smoke), the other a fat, stylized fish. The fish are cast in silver, finished with a little carving and strung with the imitation coral beads. Miguel Covarrubias designed another unit for the Pátzcuaro jewelers to use, a fisherman and his lady in a dugout canoe with fish suspended from it, to be used either as a brooch or a pendant.

This group of designs is now being made by Sr. Jesús Cazares, the son of the designer, a genial young man willing to stop work and talk shop—or maybe just polite to visitors. The shop is dark, the only light coming from the door and the door often blocked by women waiting for orders to be finished, or for repairs to be made on a broken earring, for Sr. Cazares is the village silversmith as well as the maker of a famous line

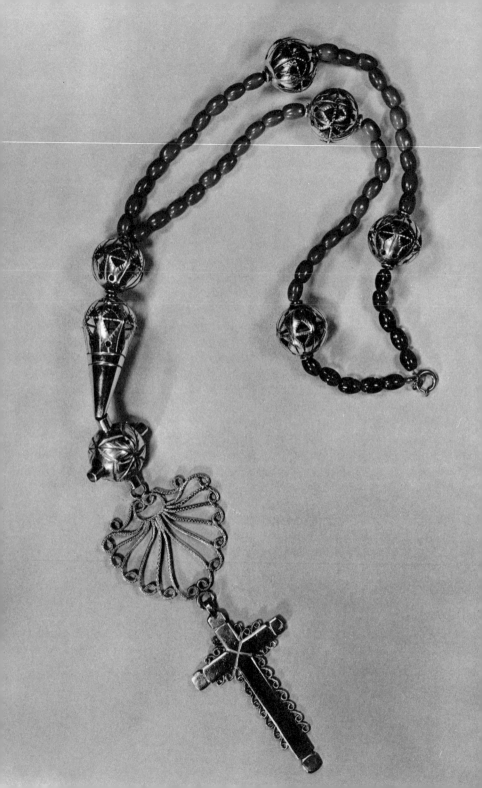

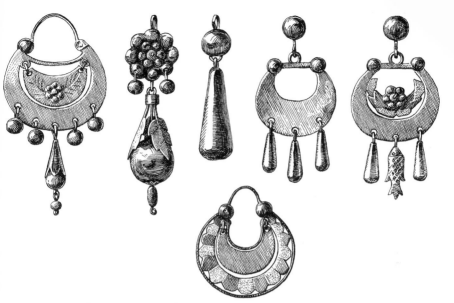

PLATE 54. Earrings made in Pátzcuaro. Six popular styles distinguish the women of the different villages around the lake.

of jewelry. On his workbench are many envelopes containing jewelry to be repaired, scraps of paper on which are written notes to himself, molds and casts and silver scrap, rags and waste for polishing, tools, and finished articles. He does gold jewelry to order but most of his work is in silver.

Pátzcuaro is the commercial center of the villages around the lake and until recently each village had its own distinctive design for earrings. As they gathered in the market in Pátzcuaro, one could tell by her earrings from which village each woman hailed.

PLATE 53. A wedding necklace of silver and imitation coral, from Pátzcuaro (made by Jesús Cazares).

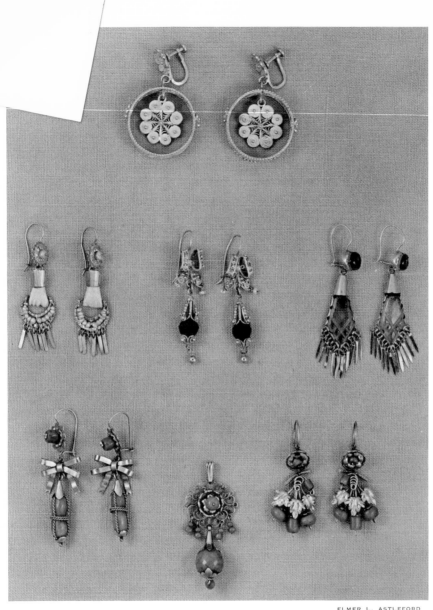

PLATE 55. Gold earrings: at the top, filigree from Yucatán; in the center, white coral and pearls from Puebla, jet from Iguala, amber from Chiapas; at the bottom, red coral, all from Puebla.

The Yalalag Cross

Up in the high mountains east of Oaxaca is the town of San Juan Yalalag. It is said to be a beautiful old town with a sixteenth-century church. The trip of two hundred kilometers from Yalalag to Oaxaca with a load of chilis to sell in the market takes four days as, for most of the distance, there is no automobile road and if one rides it is on a burro. Yet the Yalaltecas are often seen in the Oaxaca market. We did not go to Yalalag but we talked with a number of the women and with people who had made the long journey.

Our interest in the place is in the cross which is made there and only there. It is of heavy, dark coin silver with crosses or medals hanging from the terminals. There are many variations of the basic design. Sometimes the pendants are larger than the cross from which they hang. Very often the center of the cross is a winged heart. They vary from two to five or six inches in width, and the large ones must weigh a quarter of a pound.

The Yalalag women wear their crosses on strings of beads, silver beads with jet, coral, polished seeds, or the very rare old trade beads. Among these beads are added, hit or miss, little castings of birds, or pomegranates, which are a favorite Yalalag motif.

This cross is said to have been made in Yalalag since the sixteenth century but, as with so many of the crafts in Mexico, the origin is lost and one can only guess why this design is made only in one remote Indian town. Similar crosses are worn in some parts of Spain, and back in 1540 or thereabouts, when that part of Mexico was being converted to Christianity by the Dominican missionaries, one of them may have brought with him from Spain a cross which has been copied ever since by the Indians of Yalalag, losing in time its Spanish character and becoming Mexican. The Dominicans brought many crafts to the Indians, and they may also have brought the pomegranate motif, the symbol of Granada.

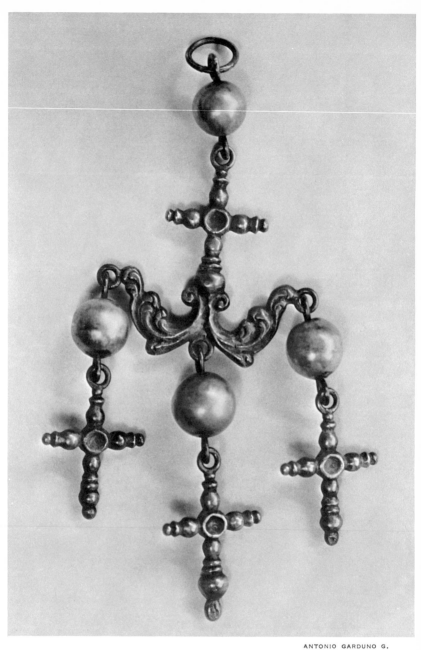

PLATE 56. A large Yalalag cross, in the Frederick Davis Collection.

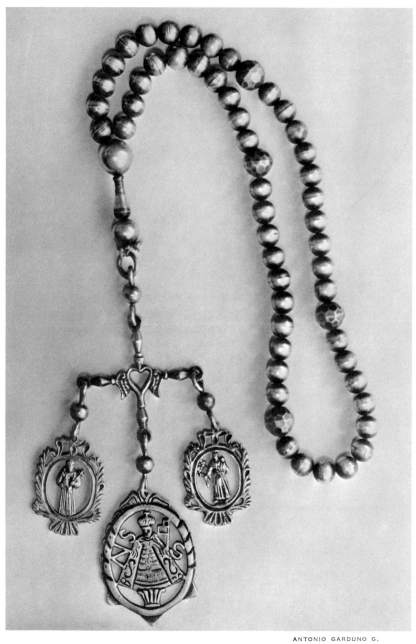

PLATE 57. A rosary and an unusual Yalalag cross in the Frederick Davis Collection.

105

PLATE 58. The little cast birds peculiar to the jewelry of Yalalag. These were all on one necklace together with many other little ornaments.

The old crosses are much sought after and are hard to find as they are gradually acquired by collectors. There is one store in Oaxaca where the people bring them when they are in need of money. And there are jewelers in Oaxaca who make reproductions cast from the old crosses, but without the color and patina of the old silver. The two crosses shown on Plates 56 and 57 are from the collection of Mr. Frederick Davis. Another interesting small collection is that of Mr. Donald Cordry who has some unusual variations which he found during his research in the vicinity of Yalalag.

The Yalaltecas seen in the markets around Oaxaca do not often wear the big crosses, explaining that the crosses are heavy and that they catch on their baskets and so, when they are working, they wear small ones. Many of them must have sold their old ones, for the dignified little Yalalteca who acts as an agent for her fellow villagers who do not come to Oaxaca can usually find one for her regular customers. It was from her we obtained the earrings shown in Plate 59. She said they came from a town near Yalalag and the owner thought they were gold, and they look to be about 10 Karat gold. She also told us that only the unmarried girls wear earrings and that when they marry "*se quitan*" the earrings and wear the "*collar*," the necklace.

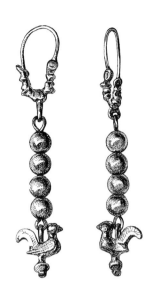

PLATE 59. Earrings from
a town near Yalalag.

Gold

The country along the southern coast has
always been rich with gold. Most of Montezuma's ancestral
treasure was in the form of gold and precious stones which
had been paid in tribute—some from the tribes from the
southern part of what is now the state of Guerrero, from the
country around Vera Cruz, but mostly from the land of the
Zapotecs which is now the state of Oaxaca. The records speak
of tribute paid by the towns of Ocotlán, Etla, Tlacachahuaya,
Oaxaca and Teotitlán, all towns well known to the present-
day visitor to Oaxaca. In the little town of Etla we were ap-
proached by an old man with a sample of mica who wanted
to find a "mining man" who could tell him about its value. He
said he knew where to find gold, which is possibly true as
there are still rich gold mines in the vicinity. They say that
almost everyone in Mexico has at one time or another, often

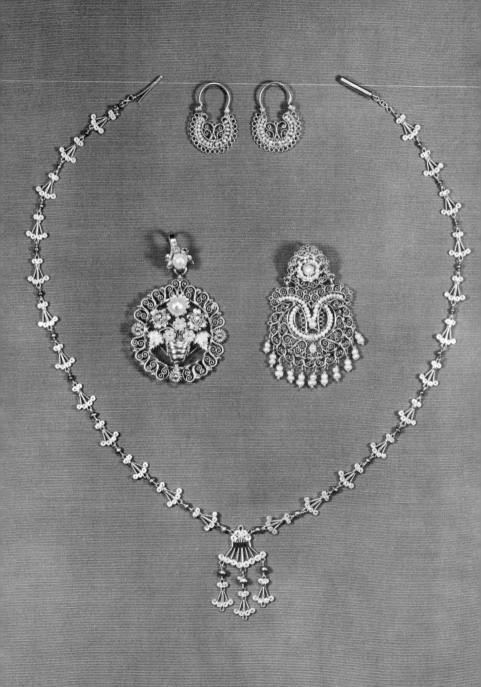

to his sorrow, sunk money in Oaxaca gold mines, for there are many legends of lost mines and buried treasure in that part of the country.

In pre-Spanish days the gold was found in the form of nuggets and dust in the river beds, washed down from the mountains. It was stored in cane tubes or in quills, or it was melted down into bars and disks. The record of tribute from Oaxaca describes one item of twenty disks the size of an average plate and as thick as a thumb.

It is said that the love of gold is instinctive, and after seeing the shining yellow metal in the Monte Albán jewels and the lacy gold filigree in the shops in Oaxaca, it is not hard to understand why the Spaniards went gold crazy. Figueroa, the officer sent by Cortés to subdue the Zapotecs, gave up his mission when he reached Oaxaca and devoted himself to opening the graves of the caciques to get the gold jewels and vessels which had been buried with the dead. He is said to have taken out five thousand pesos worth of gold jewels which were melted down into bars according to the Spanish custom, for no matter how much they might admire the beauty of the jewels, still more they loved the gold itself.

Even now ancient gold jewels are occasionally found in the fields around Oaxaca. We heard a story told by a well-known collector. Rumors had reached him of some beads found by a farmer digging in a field and he started a search for the man who, when traced, said that he had sold the necklace the day before. "To whom had it been sold?" "To the dentist." Hurrying to the dentist the collector was told that the gold had already been pried off and melted. The dentist said the beads had been like little animals and birds, and now all that remained was a lump of gold and the cores of the beads made

PLATE 60. Typical gold filigree and pearls from Oaxaca. The necklace is of black pearls.

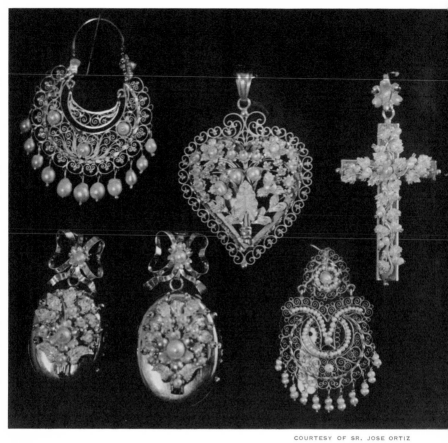

PLATE 61. Gold filigree with pearls (made by Sr. José Ortiz).

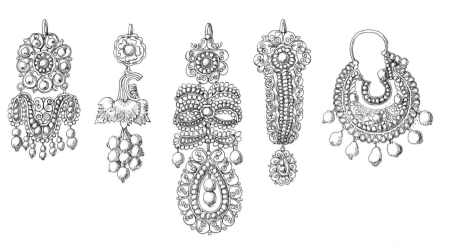

PLATE 62. The five classic designs of Oaxaca filigree earrings: *El Eme, El Ramo, El Jardín, El Gusano,* and *El Arracada.*

of charcoal and clay, proving that they had been cast by the ancient process.

The finest of the pre-Spanish goldwork came from the Mixtec goldsmiths and much of it was made not long before the Conquest. The tradition of fine craftsmanship still exists in the city of Oaxaca where there are a number of men making gold jewelry of beautiful design and workmanship, usually filigree, in designs derived from the eighteenth-century Spanish and French style. At this writing the best of them, in our opinion, is Sr. Ortiz of the Platería Ortiz, who made the beautiful crown for Soledad, which was mentioned earlier.

For the filigree 14 Karat gold is used with 22 Karat for the carved leaves and flowers which distinguish the Oaxaca jewelry. The use of different alloys of gold gives an interesting variation of color, and still more variety is obtained by chasing, picking, and carving the leaves to give a different texture to contrast with the shiny wire of the tendrils and the filigree. Seed pearls or corals are strung and used in lines or

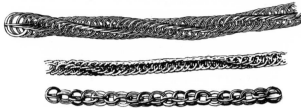

PLATE 63. The typical Oaxaca chain: the separate link and the chains made from it.

curves in the design, and larger pearls are used for the centers of the flowers and for drops.

There are five traditional designs for earrings. The most elaborate is called *El Jardín* (the garden) and is nearest in style to the eighteenth-century jewels. It is an intricate series of pearl and filigree loops, like a bow-knot, with an oval drop. Another is the *Arracada*, a crescent-shaped hoop, similar to those made all over Mexico but specially beautiful done as it is in Oaxaca of gold filigree and pearls. The design of *El Gusano* (the worm) is a vertical, undulating curve with seed pearls down the center. *El Eme* takes its name from the letter "M" which is evident in the line of pearls forming the design. *El Ramo* (the branch) is a leafy grapevine with grapes made of small pearls or coral, leaves of *repoussé* gold, branch and tendrils of wire. These five designs are seen over and over again.

Old earrings in one of the traditional styles, set with rose-cut diamonds in silver mountings, occasionally are seen. Cut with few facets and embedded in the silver, the diamonds do not have the glitter we are accustomed to associate with the stones. The stones point up the design rather than the design being made to show off the stones. Rosaries, pendants, lockets, and brooches are made to match the earrings. Bracelets are not much worn by the women of Oaxaca.

There is a special Oaxaca chain, a rope of intricate links made of flat wire. Different effects are obtained either by

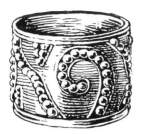
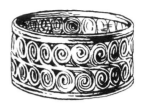

PLATE 64. Rings by Jorge Cortés Domingues of Oaxaca, copies of the bands of the Monte Albán rings, made of the same yellow gold.

(About twice actual size)

putting each link through two others for a rope effect, or through only one for a lighter, lacier chain. The long marriage chains from Guatemala are of the same construction and may well have been the model for the Oaxaca chain. In Oaxaca the chains are always of gold and we were surprised when we saw some of heavy silver in a shop in Mexico City, but found that they were being made by a silversmith from Oaxaca who was working in the capital.

The goldsmiths make very good reproductions of the Monte Albán jewels, the originals of which are in the Oaxaca Museum. Often made of gold-washed silver, they can also be ordered in pure gold. From time to time we have watched a young craftsman, Sr. Jorge Cortés Domingues doing casting from wax models he has made of the old jewels, and have admired the precision and feeling of his work done with simple casting tools which he has made in his own shop. His copies are among the best being done at the present time. While not being rampant feminists, we were interested to observe that the fine precision work of making the wax models was being done by three young girls, while the more mechanical part of the casting was done by young men, all, of course, under the watchful eye of Sr. Cortés himself.

In the Museo Nacional de Historia, Chapultepec, are a

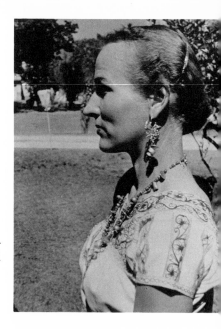

PLATE 65. Anita Jones in the regional costume of Oaxaca and wearing the regional jewelry.

number of pieces of old Oaxaca filigree as well as some fine old jewels of French origin which may have served as models and inspiration for the Oaxaca goldsmiths of the eighteenth and nineteenth centuries.

The Coin Jewelry of the Isthmus

In Tehuantepec and Juchitán, not more than 150 miles south of Oaxaca, the jewelry is quite different, less intricate and less varied in design, and planned to display the largest amount of gold *moneda* its owner can accumulate. It is seen at its best worn by a handsome Tehuana or Juchiteca.

The *moneda,* the gold coins, vary in size from the Mexican 2-peso pieces to the big Mexican 50 pesos or the U.S. 20-dollar pieces. The U.S. coins are highly prized. The gold is not

PLATE 66. On New Year's day in Juchitán there are many little stands where clay figures are sold, figures of saints and other favorites. This is a bride and groom, the bride complete with her coin necklace.

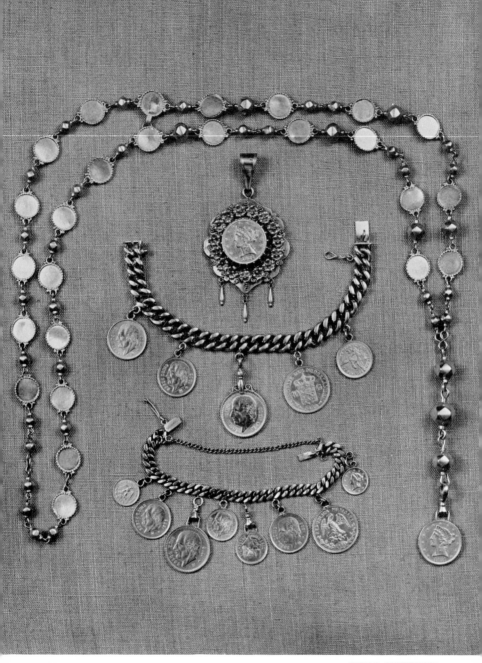

PLATE 67. Gold from Tehuantepec. The necklace is made of small
gold disks called *espejitos*, little mirrors, rather than of coins.

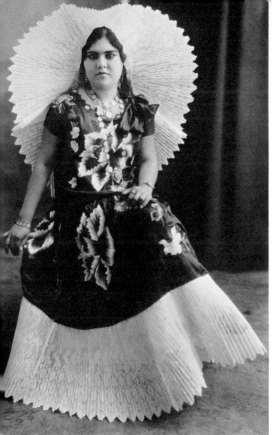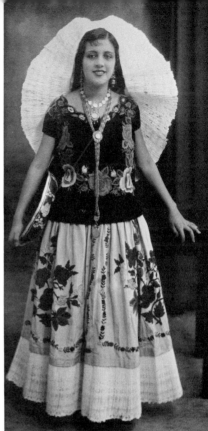

PLATE 68. Two Tehuanas in the regional costume, wearing their coin jewelry.

in circulation but can be bought at the banks or from reputable money changers. Although at the present time it is possible to exchange a U.S. 10-dollar bill for 125 paper pesos, it takes more than the same 10-dollar bill to buy a 10-peso gold coin. The 10- and 5-peso coins carry the head of Hidalgo and are called respectively an *Hidalgo* and a *medio Hidalgo*. On the 20-peso coin is the Aztec Calendar Stone and it is called an *Azteca*. On the 50-peso coin is the full-length figure of Hidalgo, called a *Centenario*.

Many of the coins, both Mexican and U.S., are dated from

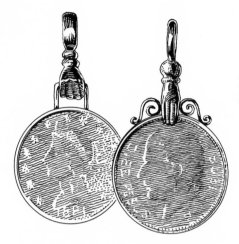

PLATE 69. Small hands hold many of the coins.

1850 to 1882 and must have been spent at that time by sailors and "forty-niners" whose ships stopped on the way from California at a nearby port and who traveled to Tehuantepec to see the beautiful girls, or by the railroad workers who came to the Isthmus when American companies were surveying for a railroad. In those days there was a burro road across the Isthmus with ships unloading at Acapulco or Salina Cruz, from where the loads were carried across the mountains to be reloaded on ships at the Gulf ports.

The beautiful girls of Tehuantepec are written about in every mention of the Isthmus, the descriptions varying in enthusiasm from the factual words in the guide books to the lyrical poems of many Mexican writers. A festive dance in the plaza, lit with paper lanterns and garlanded with paper flowers and banners, the *señoritas* in their finest embroidered dresses, ribbons and flowers in their hair, and glittering with gold, is a picture of tropical beauty that will never be forgotten. For such an occasion the family necklaces are fastened to the dresses so that every coin shows, the girls' fingers are

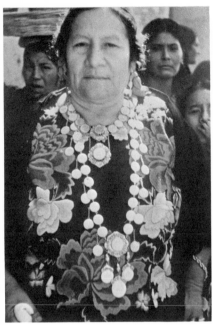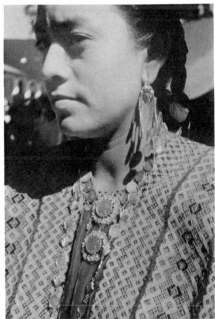

PLATE 70. Tehuanas wearing coin jewelry. The older woman was photographed in the market in Juchitán.

covered with wide gold rings and coins hang from their bracelets, for they are exhibiting their dowries.

The coins are used on bracelets, pendants, slides on long chains, brooches, and earrings, but the most important use is on necklaces. The coins, never mutilated or pierced, are often set, like precious stones, in pronged bezels with the Mexican eagle side up or, if a U.S. coin, with the Liberty head showing. Single coins to be worn as pendants are usually held in a little gold hand meticulously carved even to the finger nails.

The Tehuanas who can afford it wear two necklaces, one at

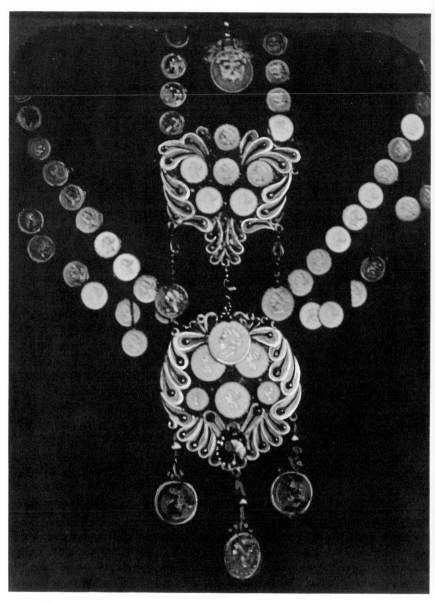

PLATE 71. The necklace of Señora Santibáñez of Tehuantepec.

PLATE 72. Some of the beads used in the coin necklaces of Tehuantepec.

the neck close set with coins ending in front with a pendant of larger coins, and the other a long chain reaching to the waist. The long one may be a heavy chain with a coin slide and a pendant at the waistline, or it may be of beads interspersed with coin units, or a chain full of coins dangling along its entire length. All the jewelry is of high grade yellow gold, the color seldom broken by stone settings. In the necklace of one Juchiteca we counted forty U.S. ten-dollar coins, five larger coins, and a number of smaller ones.

We had the privilege of seeing the gold jewels of Sra. Lucia W. Santibáñez, a lady of position in Tehuantepec. There were hundreds of gold coins set in two necklaces, the longer one reaching to the waist. Both necklaces have large filigree pendants about six inches across embellished with pearls and small pearly shells as a setting for the larger coins. Worn together as one necklace they make a lovely shining ornament from throat to waist. They were made for the mother of Sra. Santibáñez who also has her grandmother's hair ornaments, a heavy crescent of gold and a golden filigree butterfly. The butterfly was copied recently by a Tehuantepec goldsmith for Sra. López Mateos, the wife of the President. Our amateur photograph on Plate 71 does not begin to do justice to these splendid jewels with their intricate filigree.

Many of the women go about barefoot—by preference and not from poverty—but they all wear gold. It is said that the family fortune is worn around a woman's neck even though

PLATE 73. Gold earrings from the coast near Tehuantepec.

it is only one coin on a thin chain. In the center of the market building is a booth where imitation gold jewelry is sold, jewelry of the typical style but very light in weight because it is made of gold-washed copper with crude imitation coins. We have read that the women wear these imitations for every day and save their gold for festive occasions only, but we have never seen any of the imitation gold being worn.

The general store of Estefan & Cia. has a tempting collection of the good gold for sale; the case where it is displayed is always crowded with women examining and pricing it. It is sold by weight, each article being carefully weighed in the presence of the purchaser before a price is quoted.

At present, in the cities, coin bracelets are very high style with fashionable women who wear either a heavy link bracelet with one big *centenario* or smaller chains with lots of coins, gypsy style. And those who have them still wear the brace-

PLATE 74. Three filigree lockets, a chain, and earrings from Tuxtla Gutiérrez.

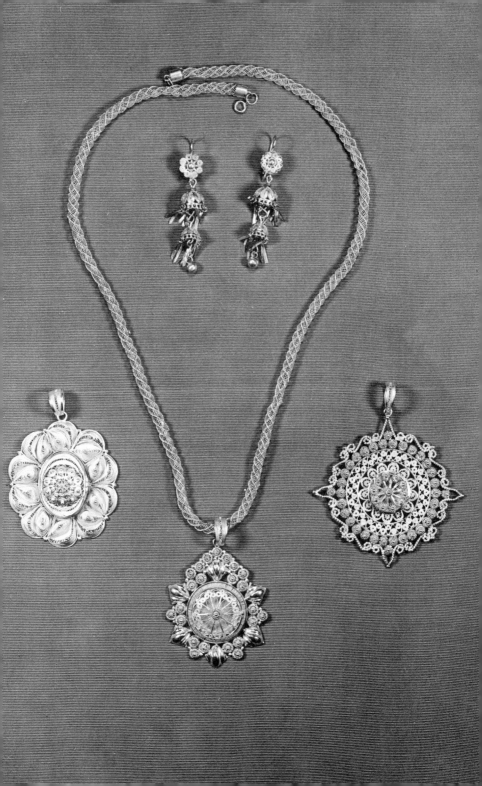

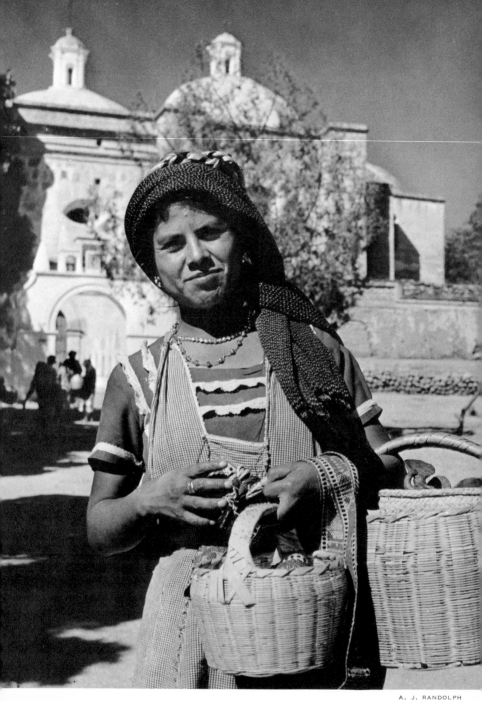

PLATE 75. A young woman from Mitla wearing the faceted gold beads of the Isthmus.

lets of little coins which were given to them when they were young girls.

Chiapas Gold

East of Tehuantepec, in the state of Chiapas, fine gold filigree is made in Tuxtla Gutiérrez, Chiapa de Corzo and Comitán. This filigree is made of orange-colored 18 Karat gold, drawn to a very fine wire. One goldsmith showed us the hole in his drawplate which he uses for pulling the wire, a hole so small that we had difficulty in finding it. With this fine wire they build up solid looking designs which, combined with polished *repoussé* units, give an effect different from any other filigree we have seen. A popular piece is a pendant containing a small locket.

In both Chiapas and Oaxaca they make an interesting chain of fine wire woven into an openwork rope. We watched a girl in Oaxaca making this chain and were reminded of the ropes we used to make by putting pins in the end of a spool and weaving yarn around the pins. These ropes are made both in Oaxaca and Chiapas but in Tuxtla Gutiérrez we were assured that they originated in Chiapas.

In Chiapa de Corzo, an old town near Tuxtla Gutiérrez they are making necklaces of big, 14 Karat red gold, faceted beads in graduated strands. The women of the town were wearing these beads but we suspected that they were being made largely for tourist consumption as the road to the town was new and the people seemed very tourist-conscious. But the beads are beautiful and well made and, coppery as they look, they do not tarnish.

In a small shop we watched the finishing touches being put on a strand of beads we had ordered. The maestro showed us the dies with which he stamps out the halves to be soldered into whole beads. He had five sets of homemade dies in different sizes, each die with twelve facets. The soldering was done with a mouth torch and a kerosene flame, the polishing with a buffer rigged to an old sewing machine frame with a

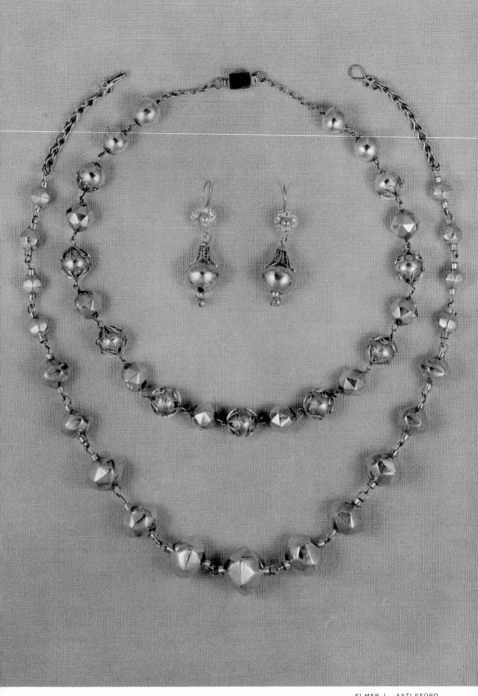

PLATE 76. Gold beads and earrings from Chiapas.

PLATE 77. Trinkets from the Isthmus showing the use of indigenous materials: the earrings are shells hanging from gold flowers; a good luck charm for a baby may be an alligator tooth or a piece of crudely carved amber.

foot treadle. Two apprentices were collaborating on the repair of a broken locket. The Señora was the business manager, and she raised the price considerably higher than the price the maestro had quoted us when we ordered them. Oh, well— we wanted the beads.

The goldsmith told us he had learned to make the beads when he was an apprentice many years ago and that they are an old style of beads. Similar beads come from Italy and faceted beads are also made in Tehuantepec, but none as large and imposing as those made in Chiapa de Corzo.

Donald and Dorothy Cordry, in their book, *The Costumes*

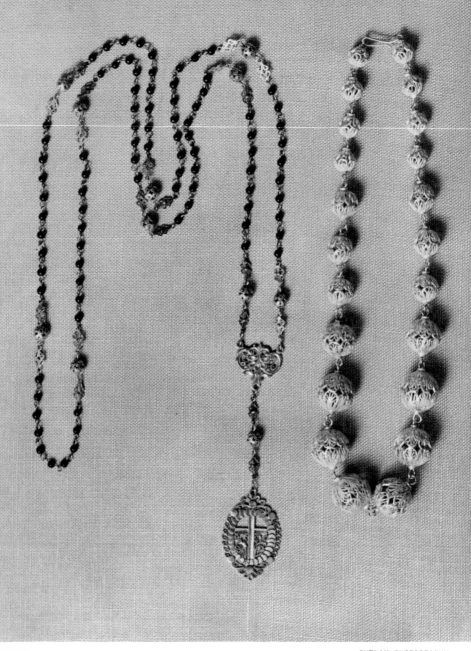

PLATE 78. Jewelry from Yucatán: a rosary of gold filigree and jet beads with a carved gold cross; a string of gold filigree beads.

PLATE 79. Alma Reed in the typical *mestiza* costume and the large gold rosary which is always part of the costume for fiestas. Miss Reed was a *protagonista* in a famous romance. She was engaged to Felipe Carillo Puerto, the governor of Yucatán, but while she was in New York preparing for the wedding her fiancé was killed in one of the struggles of the Mexican Revolution. Miss Reed has devoted her life to Mexico, and is the only living American woman to possess the government's recognition for distinguished service, symbolized by the Aztec Eagle.

and Weaving of the Zoque Indians of Chiapas, describe the gold rosaries worn by both men and women with fiesta costumes. The rosaries are made of gold filigree beads with corals interspersed with the small gold coins, little gold animals, and birds, ending in a filigree cross, very much like the necklaces of other mountain places except that they are of gold. These rosaries are prized as heirlooms and much sought after by collectors and so are becoming rare.

This part of the country is the home of amber jewelry, amber with silver or gold beads, pale amber earrings like the ones shown on Plate 55. In the market at San Cristóbal las Casas an old woman sold us little chunks of amber crudely carved in the shape of a heart and flowers to be tied on the baby's wrist for luck. In Iguala they were selling little pieces of jet for the same purpose, and in Tehuantepec small alligator teeth mounted in gold.

Every part of the country where filigree is made claims to do the best work. Without having made a specialized study of the subject, we felt that the work from Chiapas seems to be the most inventive and varied in design, and the Oaxaca work the most elegant because of all the pearls. In Yucatán they use very fine wire which gives their work an extremely lacy appearance.

Of the filigree made in Yucatán the handsomest piece, and the best known, is a long rosary of filigree beads combined with coral or other stones, ending in a filigree cross of distinctive design. When the Yucatán women wear the festive *mestiza* costume, the rosary is always an important part of the costume. The little rosary on Plate 79 is from Yucatán and, while not the typical rosary, it is interesting for the delicacy of the hand carving.

The flower and butterflies on Plate 82 are of silver wire used ingeniously to produce the form and pattern. They are from a collection picked up in shops and markets in various towns and their provenance is not known to us.

PLATE 80. Delores del Rio wearing Yucatán jewelry, as she appeared in the film *Deseada*, which was made in Yucatán.

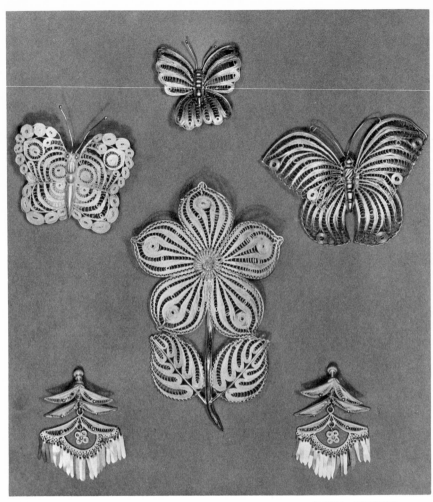

PLATE 81. Popular silver filigree from here and there.

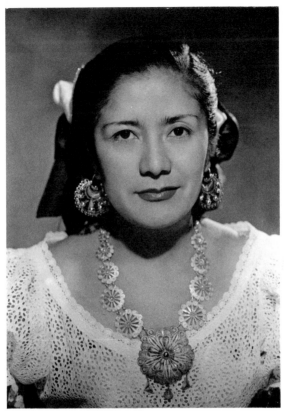

PLATE 82. Margaritá Figueroa wearing a gold filigree necklace from Iguala.

Gold from Iguala

Iguala in the state of Guerrero has been a center of jewelry making for generations. At one time the town was known for an individual kind of jewelry in floral and fruit designs, the flowers or fruit in red gold with green-gold leaves on a base or frame of polished yellow gold. At present the gold-work in Iguala is mostly filigree, but the traditional floral de-

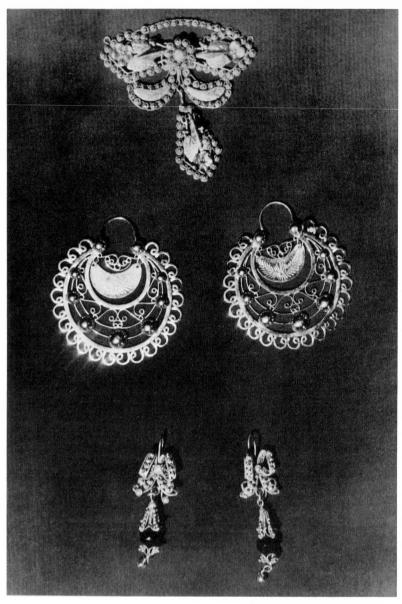

PLATE 83. Some Iguala jewelry in the collection of Margaritá Figueroa.

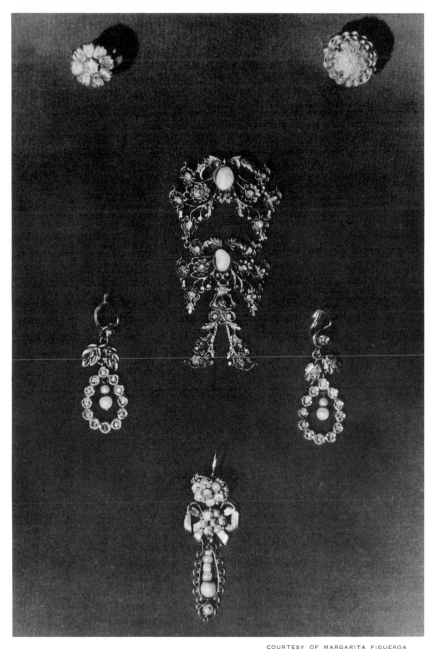

PLATE 84. More Iguala jewelry in the collection of Margaritá Figueroa.

signs are made in the old towns off the main highway, in Huetamo and the small villages to the west of Iguala in the hot country. On market day in Iguala there is always a little stand where this jewelry can be found, and travelers into the hot country have told us that the old-fashioned earrings and brooches and the bulky rings for men are sold in the market place in Huetamo.

Popular in that part of the country and similar to the Huetamo jewelry but more Victorian in feeling are the pieces made in Guanajuato, pieces whose design may have been influenced by the Churrigueresque ornament of the churches of that region. With different shades of gold and many small stones the brooches and earrings are built up on several planes. A typical piece is designed with red-gold flowers and green-gold leaves, the surfaces all naturalistically tooled and all held together with wire tendrils. On this flowery mass a small bird perches, its wings incrusted with turquoise and its eye a ruby-red stone. Here and there are clusters of turquoise and pearls, making the piece very colorful with the three shades of metal and three kinds of stones. The floral design is then riveted to an architectural framework of scrolls and broken curves with tear shaped drops, for all the world like a fragment from Valenciana looked at under a diminishing glass (See Plate 85).

We have seen similar pieces in the antique stores in Mexico set with precious stones instead of turquoise and pearls.

Tótonac Gold from Papantla

We knew that the Tótonac women from north of Vera Cruz wear gold jewelry but we did not know about their picturesque costumes. As we neared Papantla we saw the white-clothed men and women walking along the highway. The women's dresses appeared to be embroidered and they were very white; but we were wholly unprepared for the plaza in Papantla full of women in white lace and

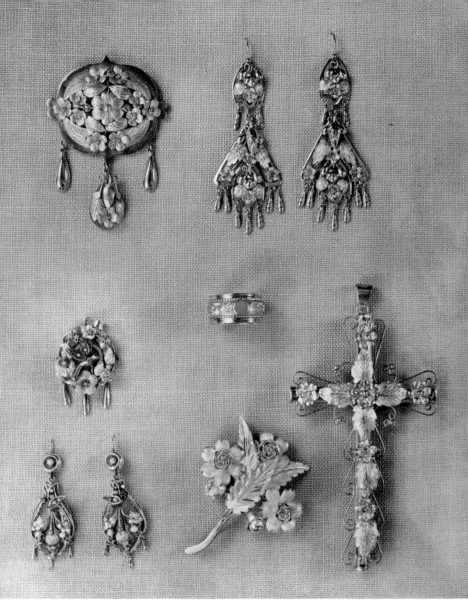

PLATE 85. Jewelry from Guerrero: the brooch at the top, from Iguala, is in three hues of gold; the earrings at the top and the man's ring, both from Huetamo, are also of three hues; the matching brooch and earrings, from Guanajuato, at the lower left, use not only several colors of gold but also small turquoise and pearls; the two pieces in the lower right are silver from Iguala.

137

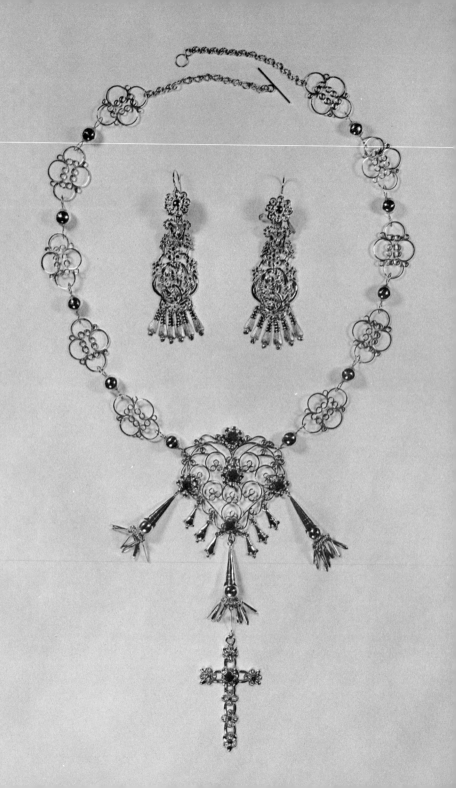

PLATE 87. A bride and groom from Papantla. She is wearing a wedding necklace and earrings similar to the one shown in Plate 86.

PLATE 86. A gold wedding necklace and earrings made by Sr. Genaro Vargas of Papantla.

Swiss embroidery. There did not seem to be any fiesta taking place. They simply had come to town dressed in white organdy and net. Their hair was caught with all sorts of trinkets and bright-colored combs, ribbons, rosettes, and flowers, around their necks and in their ears was shining gold, and in their mouths pale brown cigars.

A nice boy led us to the shop where the jewelry is made, a shop called "La Bola de Oro," the golden ball. The goldsmith, Sr. Genaro Vargas, brought forth a folding case and, to our admiring oh's and ah's, displayed necklace after necklace of lacy goldwork and beautiful sparkling gold earrings. The jewels had not been made for outsiders but for the Tótonac women themselves. They were of delicate goldwork, beautifully designed and done with great skill. The necklaces, much alike but each a little different, had crosses suspended from them set with red, blue, or green glass. Sr. Vargas explained that the Totonacas love bright, sparkling stones and are as happy with glass as with real stones. It would be a simple matter to replace the glass with real stones if one wished. The necklaces are expensive but the Indians earn enough for their work in the vanilla industry to be able to buy fine jewels.

Sr. Vargas works, with his son as assistant, in his shop adjoining his house. His workbench is well equipped and professional looking. He has made his own dies to stamp out the ornaments with which he designs his product. An earring may start with a small animal or bird to be worn alone or hanging from a little hand, which in turn may be suspended from a golden bowknot, and the bowknot may be attached to a flower, making a long, dangling ear drop. He uses only high grade yellow gold which he buys in bars, doing his own stretching and wire pulling. For stamping, the gold is necessarily thin.

The Tótonac women gaze at the jewelry from outside the gate which is opened to welcome visitors. We smoked a cigar with one of the women but could not talk jewelry with her because we did not know the Tótonac language. The white

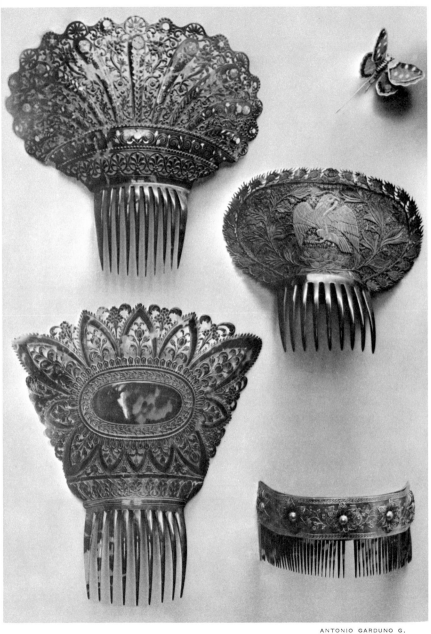

ANTONIO GARDUNO G.

PLATE 88. Nineteenth-century tortoise-shell combs in the Museo Nacional de Historia, Chapultepec.

dresses which so interested us were of fine Swiss organdy covered with silk or rayon embroidery. The shawls were either of the embroidery or of hand-worked lace on white net. The Totonacas used to wear dresses embroidered in color in native designs but these have been largely supplanted by the commercially embroidered organdy.

Commentators for a hundred years have mentioned the gold ornaments of the Tótonac women, and even further back in history the records tell of the Tótonac men decked in gold who met the Spaniards when they landed.

Tortoise Shell

In the Chapultepec Museo Nacional de Historia, there is a case of carved tortoise-shell combs made in the eighteenth and nineteenth centuries: the high *peinetas* over which the ladies used to drape their mantillas, and the jeweled *cachirulos* which are the favorites of the women of Vera Cruz.

In Mexico City there is very little tortoise shell to be seen today; the place to find it is in Vera Cruz. Along the waterfront, on the Malecón, are shops where one can find shells, mother-of-pearl, and coral from Italy, shell jewelry, cameos, and all the trinkets and knickknacks made from the products of the sea which abound in port cities. To us the most interesting articles are those of tortoise shell: combs, boxes, jewelry.

Every store has little tortoise-shell animals, fish, scorpions, turtles, dragons, and such, made into brooches. There are necklaces and bracelets of carved units linked together, and many kinds of earrings. Some have long tear-shaped drops and some are flat drops intricately pierced and carved. The finest ones are incrusted with silver and gold, mother-of-pearl, and iridescent shell. It is possible to buy heavy band bracelets or plain combs to be embellished to one's order either with incrustations or with ornaments riveted to them. Fine line designs can be incrusted with a name, a monogram, or a sentiment. Although very little fine carving is now being done,

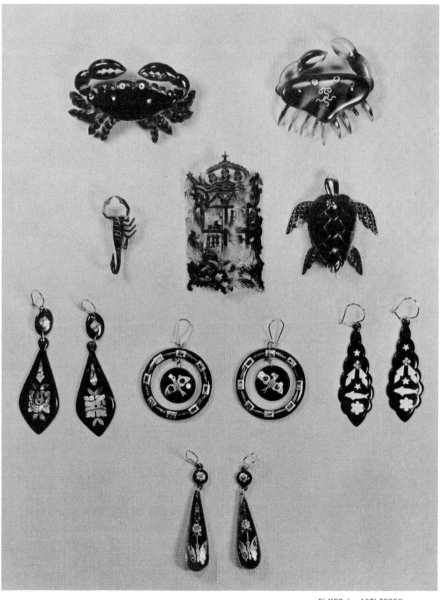

PLATE 89—Brooches and earrings of tortoise shell from Vera Cruz, some carved, some incrusted with gold and shell.

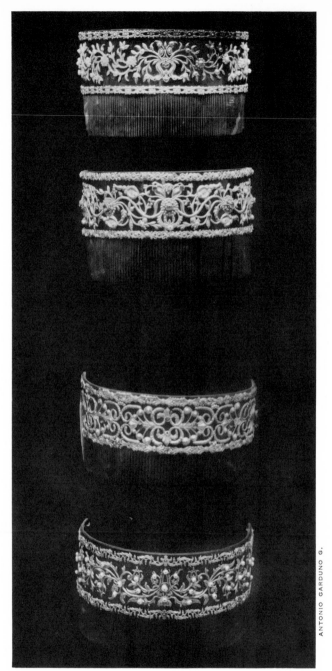

PLATE 90. *Cachirulos* of tortoise shell decorated with gold, in the Museo Nacional de Historia, Chapultepec.

there are goldsmiths in the city who do the incrusting. But special orders take months to be executed and so our bracelets are still plain bands. Most of the shell is mottled but small pieces can be made all dark or all light.

The best work is from Campeche, across the Gulf from Vera Cruz, but a few Campechanos live in Vera Cruz and have workshops there. The big turtles are caught in the Gulf, the only kind used for the shell being the *carey,* and as only eight of the thirteen scales on the outer back are choice, each big turtle yields only about four pounds of good shell. When heated the plates are pliable, but high heat darkens the shell. Thin layers can be pressed together to make a heavier layer which will have a perfect union when it cools.

The regional costume of the Vera Cruz ladies, worn now only for special occasions, is the *jarocha* dress, a dainty, elegant costume of white ruffles with a black, embroidered, lace-trimmed apron and a lace fichu caught in front with brooches of filigree or cameo. With this dress they wear gold necklaces and long earrings. But the crowning glory of the costume is the *cachirulo,* a semicircular comb with a band two or three inches wide, jeweled and gold trimmed, which encircles the back of the head.

The *cachirulos* are family heirlooms and now impossible to buy unless some old family falls into dire need of money. For fiesta wear cheap ones can be purchased, although the one we bought set with thin, gold-colored ornaments and imitation stones cost ten American dollars. There are said to be many of the fine old ones in Tlacotalpan, but a three hour boat trip up the river to that interesting town and a diligent search failed to reveal *cachirulos* as they are not for sale and we did not have the entree to any of the old houses. So we were fortunate and pleased to be able to examine an old one belonging to a family in Alvarado, a town not far from Vera Cruz.

Sra. Lola Tejeda de Rivera graciously brought her *cachirulo* into her *sala* to show to us, in a casket specially made to hold it. The comb was beautifully decorated with fine, carved-gold

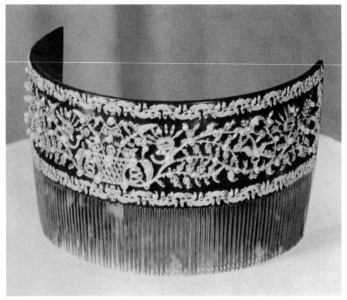

PLATE 91. *Cachirulo* of tortoise shell, gold, pearls, and rubies, belonging to Señora Lola Tejada de Rivera of Alvarado, Vera Cruz.

tracery riveted to the tortoise shell and set with pearls and small rubies (Plate 91). It had been made for her family "many years ago" in Campeche and will be passed on to her daughter. Unlike the carved *peinetas,* the shell of the *cachirulos* is uncarved, their beauty being in the exquisite goldwork and jewels.

El Museo Nacional de Artes e Industrias Populares in Mexico City, a government museum, shows fine exhibitions of popular folk art and jewelry carefully selected from different parts of the country. This jewelry, as well as the work of a few of the good contemporary commercial designers, can be purchased in the Museum salesroom. In 1952 an exhibition in their galleries was all of silver and jewelry, a comprehensive and

informative exhibition which made available for study many articles from private collections and interesting objects from several government museums. Such exhibitions cannot help but improve the quality of jewelry making throughout the country, being an inspiration not only for craftsmen but for the purchaser as well.

The local museums found in a number of craft centers usually show examples of the work of the region. Good exhibits can be seen in the regional museums of Toluca, Pátzcuaro, and Oaxaca. And every year new museums are being opened.

CHARRO ADORNOS

THE *charro* IS SOMETIMES DESCRIBED as the Mexican counterpart of the American cowboy, a description falling far short of the truth. Although the *charro* and the cowboy are both direct descendants of the Mexican herdsman, the modern *charro* is the prototype of the Mexican gentleman as he likes to think of himself, aggressive, brave, patriotic, completely the master of his horse, and above all very Mexican. The *charro* has been so linked with Mexican history that he is a part of it and shares many of its finest traditions. He appears here only because of the typical *adornos* with which his handsome suits and riding gear are trimmed.

The tradition of beautiful trappings and clothing for riding started with the Spanish colonists who brought with them their decorated saddles and big iron stirrups, a style of accouterment which they had inherited from the Moors. The large, heavy stirrups were decorated with Mudejar or Plateresque openwork designs, or with damascene work in silver or gold. As soon as ironworking was started in Mexico, there were Mexican variations of the Spanish designs for harness fittings and stirrups and spurs. The seventeenth century saddles were works of art. The fittings of the Mexican horseman were said to be finer than anything of the kind in Europe at that time, trimmed with gold and silver and precious stones, with saddle covers of velvet, gold brocades, and heavy Chinese silk lavishly enriched with pearls. Riding boots were embroidered with gold and silver and fastened with gold buckles. Little bells jingled on the harness.

However, the *charro* stems more directly from the ranchero, the working ranch owner, than from his elegant Spanish ancestors. The style of his hat and clothing originated in Spain, to be modified by the weather and working conditions in Mexico as well as by the Mexican taste in wearing apparel. The eighteenth-century *mestizo* who lived on the ranch and worked with the herds was the original *charro*. He spent most of his time in the saddle and, as he became affluent, he spent his profits on horses, saddles, and riding clothes trimmed with buttons, buckles, and embroidery. Then, as a reaction to this display, the rich rancheros adopted more elegant and sober clothing, dark gray or blue woolen suits with trousers closed at the sides by a row of silver buttons, short kidskin jackets fastened with silver buckles and trimmed with a little embroidery or silver braid. Their wide felt hats had low crowns, silver ropes as hat bands and silver ornaments at either side where the chin-cords were attached. In the Museo Nacional de Historia, Chapultepec, is a suit which is of this elegant but restrained style.

Later many of the rancheros became officers in the War of

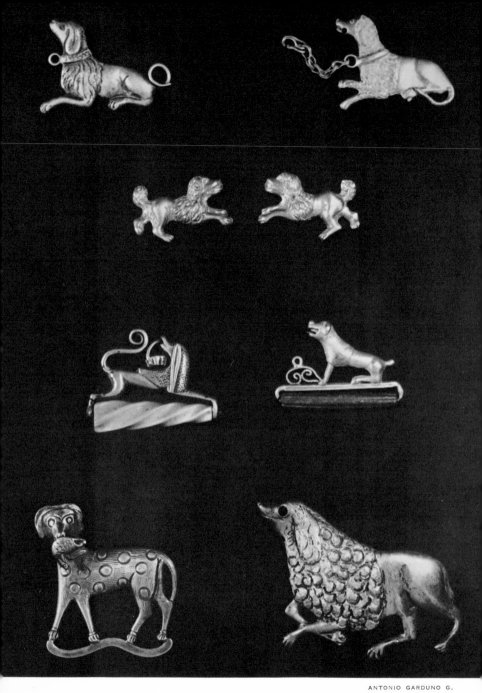

PLATE 92. *Charro adornos:* small dogs of cast and carved silver. Except for the two flint lighters, they are all hat ornaments and come in pairs.

Independence, and to distinguish themselves from the plain soldiers who also dressed in *charro* clothing, they ornamented themselves with silver and gold braid which they were loath to discard when the war was won. They were a class which became politically and economically powerful and, although no longer living on their ranches, they dressed in exaggerated ranchero style, with more buttons, larger and fancier hat ornaments, and spurs jingling as they walked about the city streets. Their suits were covered with heavy silver embroidery, their hats with gold and pearl trimmings. The outfit represented importance either social or economic.

These elaborate suits are worn now mostly on the stage and in the movies, by professional rodeo performers, and musicians in *mariachi* orchestras. For this reason some people who have not visited Mexico visualize a place where all the men wear such suits, or the baggy cotton of the Indian sitting asleep in the sun. Both of these conceptions are equally false.

The suit has been the uniform of rancheros, soldiers, bandits, and aristocrats at various times. Emiliano Zapata and Pancho Villa wore *charro* clothing, and so also did the Emperor Maximilian in his unhappy attempt to be a true Mexican. His costume was of dark blue cloth embroidered in silver, and if we can believe the equestrian portraits, he made a dashing and handsome figure in it. To accompany him on journeys he had a coachman, footmen, and guards dressed in chamois *charro* uniforms trimmed in silver. His carriage drawn by twelve white mules, with its *charro* outriders excited the admiration and wonder of the country people as he traveled about.

The present-day *charros* wear comparatively plain suits but they still wear wide hats, short leather jackets, bow neckties and tight riding trousers. They limit their silver decorations to a buckle on the jacket, small ornaments on the hat and buttons on the trousers. The group in Mexico City, made up largely of business and professional men, has a fine clubhouse, open to the public on Sunday mornings, where they perform the old

PLATE 93. *Chapetas:* the ornaments worn in pairs on the *charros'* big felt hats.

ranch skills of roping and throwing the bull. They are favorites of the Mexican crowds as they ride in patriotic parades on their fine horses with beautiful saddles, dressed in their picturesque clothing.

Originally the silver *adornos* were symbols of the ranch: horseshoes, bulls heads, pistols, spurs, hoofs, dogs. The first hat ornaments, the *chapetas,* were silver monograms which were followed by larger, fancier designs. The butterflies on Plate 94 are a sample of the ornate style, beautifully done in silver and gold with movable wings. One can imagine them fluttering on the crown of a big, silver-embroidered felt sombrero.

Buckles for the jackets come in the form of shells, roses, baroque scrolls, and heavy filigree. The silver buttons which fasten the trousers are from three-eighths of an inch to an inch and a half in diameter and they vary in design from horseflies to roses. Fastened together in pairs by silver chains, they are worn in sets of from ten to forty pairs, according to the size, buttoning the trousers at the sides from the belt to the boots, or at least to the knee-opening. A full set is called a *botonadura.* A distinguishing feature of *charro adornos* are the *puntas,* the long, thin drops which dangle from many of the silver pieces. They take their name and shape from the metal tips of cords or lacings, once functional but now only ornamental.

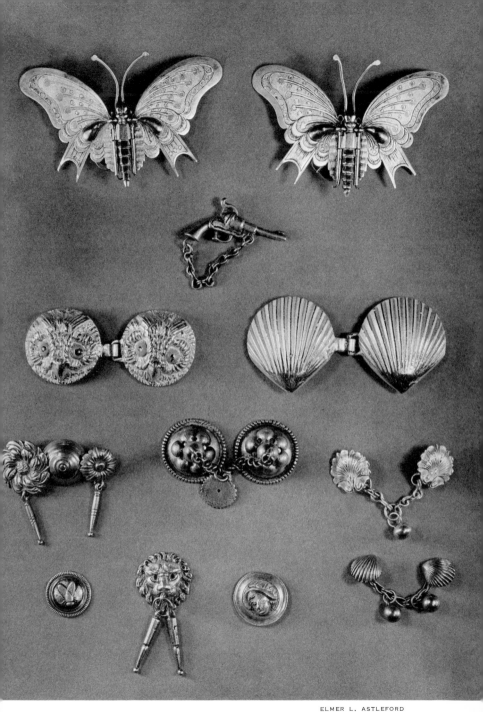

ELMER L. ASTLEFORD

PLATE 94. *Charro adornos:* the butterfly hat ornaments are of silver and
gold, the buttons and buckles of cast silver.

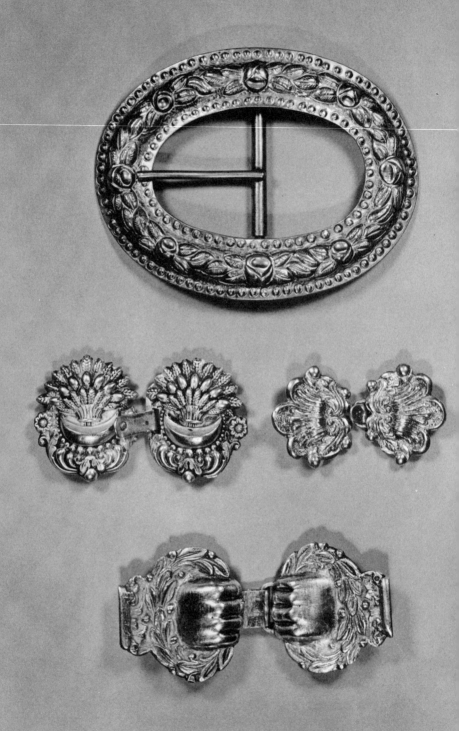

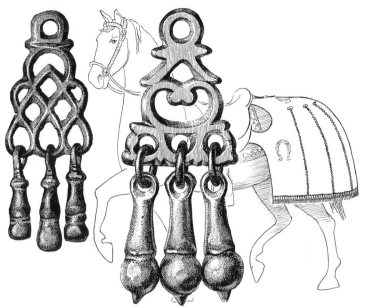

PLATE 96. The *anquera*, a useful part of the accouterment of the early rancheros, is now only occasionally seen on the horses of the city *charros*. From it hang little iron or brass drops which jingle with the movement of the horse.

The wide, decorated leather belts have silver, or silver-incrusted, buckles and holsters for the revolvers which are part of the *charro* fittings. Some of the young *charros* prefer the horn, leather, or bone buttons of the ranch rather than silver. In Mexico City there are a number of shops which sell nothing but *charro* fittings and clothing, and every city has at least one such store.

One piece of harness which is seen only in Mexico—and lately not often there—is the *anquera* which resembles a skirt of leather fastened to the saddle at the back and falling over

PLATE 95. *Charro* buckles of cast or *repoussé* silver.

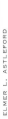

PLATE 97. *Charro* buckles and buttons of blued steel incrusted in silver, from Amazoc.

the horse's hindquarters. It is made of heavy leather gores laced together to fit the horse, falling well above the bend of the leg at the back. At the bottom edge is a fringe of little dangles of iron or bronze which jingle as the horse moves. The dangles are so interesting in design that they became the motif for a typical and lovely necklace which is shown on Plate 100.

In the Museo Nacional de Historia are some old *anqueras*, embroidered and tooled, unlike the plain ones now in use. Also there are many of the spurs and stirrups made in Colonial days. The Bello Museum in Puebla also has a fine collection of old iron trappings.

In Amozoc, a small town near Puebla, beautiful ironwork for saddle fittings has been made for over four hundred years. The specialty of the town is the well known blue steel incrusted in silver and gold.

The rough castings for the stirrups and spurs are done in a foundry. Then the silversmith files and polishes them into shape, incises the design in the steel with a cold chisel and fills in the incised spots with silver which is pounded and sweated into place. The silver is then carved and engraved and the steel goes through the blueing process, ending an iridescent peacock blue. The result is rich and sparkling on the saddles and harnesses. Some of the silversmiths make buttons and buckles of the same steel as well as knife handles and other articles for *charro* use. Being made in larger quantities than formerly, most of the incrusted steel does not compare well with the beautiful old work which we can see in the museums, but it is well made and effective.

PRESENT-DAY JEWELRY

Silver Jewelry

AT THE PRESENT TIME a prodigious amount
of silver jewelry is being produced in Mexi-
co and sold at a relatively low price considering the high
quality of design and the skilled workmanship which goes into
its making. As the appreciation of silver jewelry has grown,
the industry has kept pace with the increasing demand by
tourists and sophisticated Mexican women—or perhaps it is
the other way around and the beauty of the product has cre-
ated the demand.

Taste in jewelry is bound to be very personal. Many women prefer silver. The gray tones are becoming to brunettes and to women with high color as the cool gray complements their warm coloring, and when it repeats the color of gray or white hair it is always pleasing. It can be used in large jewelry for street or informal wear when the same piece in gold would be showy and unsuitable because of the brilliance and obvious intrinsic value of the metal.

Silver is a malleable metal which can be worked in many techniques. It can be given a variety of hues, from its own light pearly gray to almost black, from a blue to a yellow gray, and even to a bronzelike color. It can be polished to a high brilliance almost like chromium, or brushed to a soft, velvety texture. In the Mexican work all the possibilities of silver have been realized. Gold, being impervious to oxidation, cannot be given the same depth of coloring and, because of its brilliance, it is better when used in fine designs rather than in large masses.

Looking back to the 1920's when the Mexicans were starting to produce fine silver jewelry, we remember the handmade jewelry being made in the United States. Some of it was still under the influence of the Art Nouveau style with its fantastic flowing curves and leaves. In a notable group of master craftsmen in Boston the outstanding designer probably was Mr. Edward Oakes who worked in the traditional English style of design in silver and gold and precious stones, building up delicate settings of small flowers, leaves, and wirework. This group had many followers. Then, after 1925 the Art Moderne movement had its vogue. In the early twenties the work of the Danish silversmith, Georg Jensen, commenced to be seen in the United States. Done almost altogether in *repoussé* silver in compact, sculptural designs, his jewelry was sensational in contrast to the intricate work being done in so many of the workshops, and it had a deserved and continuing influence on the American craftsman.

No trends or schools, however, were followed by the men

in Mexico who started making silver jewelry at that time. Their designs were an outgrowth of Mexican traditional decoration, either pre-Hispanic Indian or Baroque. The popular art of the Indians was beginning to be recognized and appreciated as, following the Revolution, the Indian himself was much in the minds of thoughtful Mexicans. The pioneers in the industry were men of imagination and creative artistic ability who were able to reconcile the traditional forms with their own individual taste, and the artisans who worked out their designs were men accustomed to making table silver and ecclesiastical trays and vessels, and who had the feeling for the metal and its correct use. Much of the first silver jewelry was without stones, or with the native obsidian and amethyst quartz. Gradually the style has changed as other materials have become available, but much of the design is still characteristically Mexican without being affected by foreign design.

Of course the same costly jewelry which is found in every big city in America and Europe is also found in the larger Mexican cities, the precious stones set in gold and platinum in conventional designs to display the sparkle and color of the stones. The jewelry about which we are writing is the handmade work which is the creation of craftsmen-designers. Among the leaders of this craft we can only mention a few men and women who are outstanding and whose individuality has contributed to the craft as a whole.

Frederick Davis

Closely connected with the beginning of the industry is Mr. Frederick Davis, who employed a group of silversmiths to carry out his designs in silver at a time when Mexican women were still wearing gold almost exclusively. The fact that Mr. Davis, an American, more or less started this important movement and is also responsi-

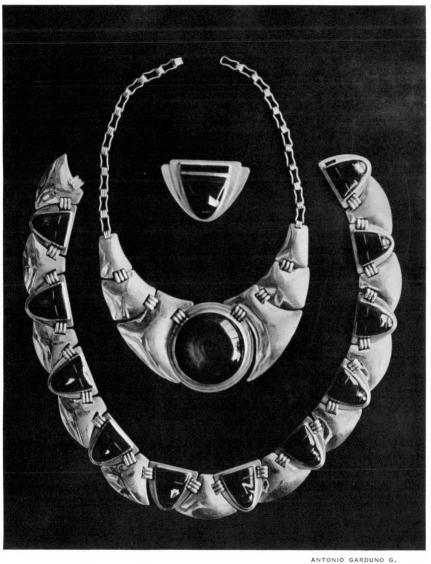

ANTONIO GARDUNO G.

PLATE 98. Two necklaces and a brooch of carved obsidian set in silver, from Frederick Davis.

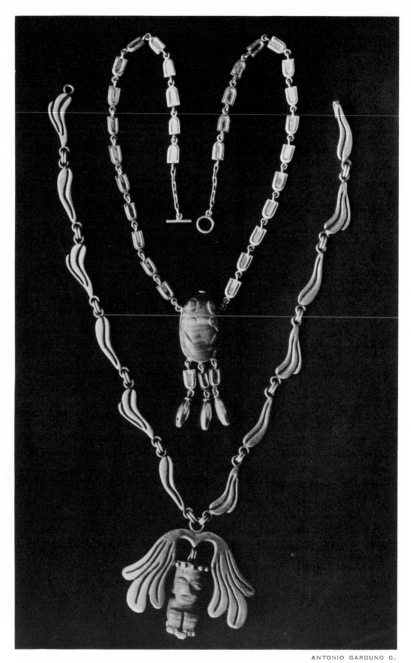

PLATE 99. Two necklaces of silver with pendants set with old stones, from Frederick Davis.

ble for much of the appreciation of native Mexican crafts, is so interesting that it merits more elaboration.

In 1910, because of family circumstances, young Fred Davis gave up his studies at Rush Medical School in Chicago, left his home in Illinois, and went to Mexico to seek his fortune. A friend, the owner of the Sonora News Company, offered him a position contingent on his promise to stay in Mexico and behave himself, both of which conditions he met very successfully.

The Sonora News Company had the concession as news agent for all the railroads in Mexico with agencies in thirteen cities scattered from Sonora to Oaxaca and from Vera Cruz to Guadalajara. For some time the sandy-haired young American traveled around wherever the trains went from one end of the country to the other in his capacity as assistant manager of the news agencies and later as traveling auditor. At every station the country people would crowd around the train with flowers, fruit, and food, and with the things which they made to sell to the passengers. In this way he became acquainted with the indigenous crafts and began to collect them. When he became manager of the Mexico City branch of the business he started selling Mexican handcrafts and popular art, antiques, and paintings in the store of the Sonora News Company in the Iturbide Hotel. In the galleries of the shop were shown the paintings of many of the artists who have since become world famous. He sent scouts about the country hunting interesting objects, not only for the store but for his own growing collection of folk art. One of these assistants was Rene d'Harnoncourt who has become a leading authority in many fields of art. Some of the best collections, both in Mexico and the United States, were started with purchases made in Mr. Davis's shop and many fine pieces of antique jewelry and other crafts passed through his hands, but no other collection of folk art could compare with his own priceless one which recently was broken up to settle his estate, parts of it to be bought by

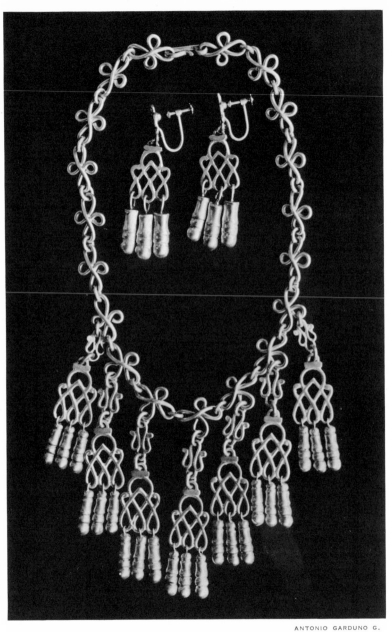

PLATE 100. Necklace and earrings of silver inspired by the little iron pendants which hang from the *charro anqueras,* from Frederick Davis.

the government for the National Museums and part going to private collections.

One of his projects was the production of silver jewelry which would be of such high quality that it would be prized by Mexican women as well as by the tourists who were beginning to come to Mexico after the Revolution. With a lively imagination and a knowledge of all forms of artistic expression, he was full of ideas and was fortunate to have them carried out by fine craftsmen. He used obsidian for his jewelry and had obsidian heads carved in a semiabstract style to make a fine black and white design when combined with the silver. He set as jewels the little old stone carvings which were still being dug up from the fields and were plentiful at that time. He used as motifs old seals and symbols. One lovely necklace was inspired by the iron drops which hung from the *charro anqueras* (Plate 100). Employing silversmiths skillful in doing *repoussé,* he produced wide bracelets with embossed designs. He was the first to make many of the now popular pieces. The "Fred Davis" silver and jewelry has always been unmistakably Mexican and definitely a quality product because of its fine finish. Over the years many expert silversmiths have carried out his designs, among them the master craftsmen, Abraham Paz and Ezequiel Gómez.

Across the *avenida* from the Sonora News Shop, Mr. Frank Sanborn had been selling silver articles made by his own silversmiths. In 1933 Mr. Davis moved his shop across the Avenida Madero to Sanborn's and took over the management of the antiques and fine crafts in the Sanborn shop. It was a felicitous move as both Mr. Sanborn and Mr. Davis were men of taste and vision, and they were able to enlarge the line of silver and jewelry. Craftsmen from all over the country brought their best work to show to Mr. Davis, and he had the opportunity to assemble for exhibition and sale the finest work that was being done, work with which the tourists, as well as many Mexicans, were unfamiliar.

After Mr. Sanborn retired and sold his interest in the famous

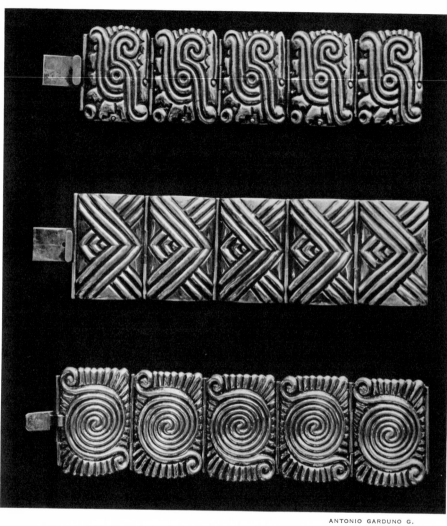

PLATE 101. Bracelets of *repoussé* silver from pre-Hispanic motifs, from Frederick Davis.

Sanborn store, Mr. Davis remained for a time on the Board of Directors of the new organization, and then he too retired. Mr. Davis died in 1961. His designs are still being reproduced by his silversmiths and some of them are usually on display in the Museo Nacional de Artes e Industrias Populares of which he was a director from its opening. From time to time parts of his collection of folk art are on exhibition in the Museum.

Mr. Davis extended his interest in the native arts to include houses and gardens. Several times he bought an old house for his own use, remodeled and restored it and then, his imagination being roused by another house, his creative energy would not allow him to repose peacefully in the already remodeled house, so he would buy another one to restore. The "Morrow House" in Cuernavaca was one of these. His own house in Cuernavaca was once the Black Cat Cantina in a crowded block in the center of town. By adding to the property he created a secluded *finca* where he grew his own coffee and where garden after garden stretched down the hillside. In all he remade ten houses, six in Cuernavaca, one in Taxco, one in San Angel, and two in Mexico City. His collection of antiques, paintings, and folk art was housed in his Mexico City residence.

The Mexican jewelry industry has grown so fast that it is difficult to trace its history or predict its future, but one certainty is that the enthusiasm and vision of Frederick Davis are largely responsible for its beginning and for many of the design trends of the present producers.

Taxco

The center of the jewelry industry is now in Taxco, and no story of modern jewelry in Mexico is complete without something about that lovely place. From a small mining settlement it has grown into an important town because of its enormous production of jewelry and silverware.

The history of the town goes back to not long after the

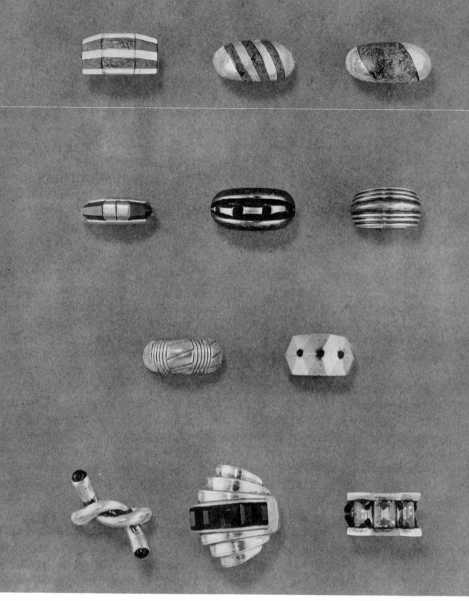

PLATE 102. Rings from Taxco: the three at the top, by Felipe Martínez of Piedra y Plata, are set with malachite or lapis lazuli; the five in the center, by William Spratling, are of silver, except for the dark one which seems to be of gun metal set with spots of bright silver; the three lower rings are by Antonio Pineda and are set with amethysts.

Conquest when Cortés heard of rich mineral deposits in the mountains south of the capital and started mining operations. From near Taxco the first silver was shipped to Spain, and a small village was established on the mountainside. For the next two hundred years the mines in the region produced quantities of silver which was packed by burros to Vera Cruz for shipment to Europe or to Acapulco for shipment to Manila. Gradually there was a decline in the output of silver, partly because of richer discoveries elsewhere and partly because the Spanish settlers considered mining an occupation less dignified than agriculture.

In 1716 José de la Borda, a young Spaniard of French parentage, came to Taxco to join his brother who had been mining there without much success. Before long they discovered a bonanza vein of silver, and to this and other mining activities de la Borda owed his fame and fortune. He was not only interested in mining, but he had what today we would call public spirit and civic pride. He also had a fine appreciation of beauty, as shown in the exquisite parish church which he not only paid for but which he personally planned and whose construction he supervised.

He built roads, aqueducts, and houses in the town, all in the Spanish style of the period, so well suited to the setting and the climate. The houses were of pink, white, or cream-colored stucco with tiled roofs. The narrow, winding streets were paved with cobblestones in patterns of black and white, and many small plazas were leveled to break the steep ascent, all beautified with flowers and fountains.

Then José de la Borda, who had so generously given his wealth, lost most of it and sold his mines. He took back some of the treasures he had given to the Church and opened mines in the northern mountains where he was successful in winning another fortune. He did not return to Taxco but his presence is still felt in the town which is itself his monument.

The mines were worked continuously until the War of Independence when the predominantly Spanish community was

attacked, the mines destroyed, the houses sacked, and valuable property stolen. Mining was resumed during the French occupation, but in the following years unrest and revolution tore the country apart and it was not until President Díaz adopted a policy of welcoming foreign capital that the mines were reopened, only to be closed again from 1913 to 1919 during the Revolution.

When, in 1927, the National Automobile Highway finally linked Taxco with Mexico City there was danger that the eighteenth-century town, when opened to the outside world, might become commercialized and modernized. Interest in preserving the town was aroused and laws were passed making it a National Monument. Now it is illegal to make any changes in its outward appearance. Any new building or remodeling must be approved for exterior style, all roofs must be tiled, the streets must remain cobbled, and no neon signs or gas stations are allowed inside the town limits. To eliminate some of the traffic in the narrow streets the highway skirts the town.

Before the road came through, Iguala was the jewelry center of the region, and in Taxco the only jewelry maker worked in gold in the traditional Guerrero style. In 1929 William Spratling conceived the idea of making silver jewelry in the old silver town and a year or so later started a little workshop with a few local boys. This fast-growing group developed into hundreds of craftsmen who became independent workers and opened their own shops. A large part of the town's income now comes from silversmithing and jewelry and it is the main production center for those products. It is estimated that today there are over three hundred shops turning out silver products in Taxco. In 1952 thirty-five tons of silver jewelry and even more hollow silverware were made. Much of this is sold to the tourists who pour into the town every day, but the Taxco product is sold all over Mexico and the United States.

Of the hundreds of silversmiths in Taxco, many are no more than artisans who do the same few pieces over and over,

working in their own homes and supplying the commercial shops around the Plaza. A few do good, original work and may develop into the creative designers of tomorrow. Every time we visit Taxco, new shops have opened and new designers have appeared. A trip to Taxco is always an exciting experience to anyone interested in the jewelry craft.

The town absorbs the daily stream of visitors unspoiled by all the commerce which has invaded it. The old church still serenely presides over the Plaza Borda with its great laurel trees, and transitory doings seem of small importance in the old setting.

Every year in June, on the anniversary of the opening of the original Spratling shop, Taxco has a silver fiesta with fireworks and all the trimmings. Started as a local fiesta to give recognition to the best work done during the year, it is now a big affair with prizes given by national organizations, and visitors from all parts of the country. The most valuable medal is for general high quality in all classes of work, a medal which is greatly prized and which has on it a bas-relief portrait of William Spratling.

William Spratling

In spite of the number of jewelry makers who have developed in the thirty years since he opened his first shop, William Spratling keeps his leadership in the craft. Stories about him have appeared in many magazines, naming him as a benefactor of Taxco or an ambassador of good will. He himself emphatically denies trying to be a benefactor or ambassador of any kind and insists that everything he has done has been for the purpose of making a living for himself in a place he likes, and that what has happened to Taxco has been simply a by-product. The result, however, of the combination of an artist, a craft, and a

PLATE 103. Two heavy silver buckles made in the Spratling shop in the early days of the silver industry (1934). They were inspired by ranch jewelry and, although these designs have not been made for a long time, they are in the good silver tradition and are interesting as samples of the beginning of Taxco silver work.

congenial environment can be seen in his workshop where some of the most beautiful and unusual jewelry in the country is made.

A teacher in the Department of Architecture at Tulane University, William Spratling came to Mexico on a vacation to study Spanish Colonial architecture. This was in 1925 before the road from Cuernavaca to Taxco was passable for automobiles. He saw the old Spanish town, unchanged since Colonial days and decided to make it his home. In 1929 he settled in Taxco and wrote illustrated stories about Mexico for the American magazines. At this time he also wrote a book, *Little Mexico*, which was published in 1932 and through successive printings has become a classic on the subject of life in a small Mexican town.

Meanwhile, he started a shop to make and sell the traditional crafts of the region. To this enterprise he brought taste and training as a designer, a knowledge of Spanish-Indian design, the enthusiasm of a pioneer, and a respect and liking

172

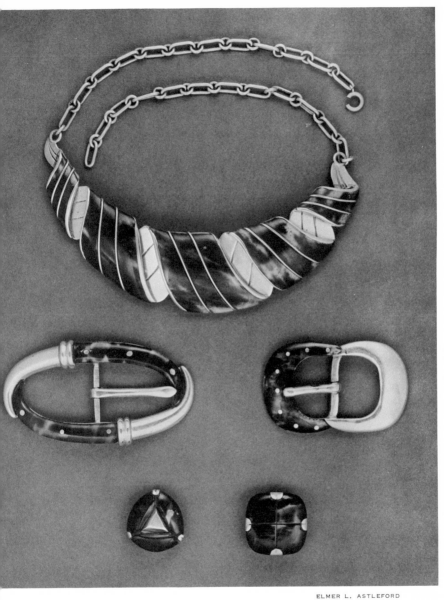

PLATE 104. Necklace, buckles, and buttons of silver and tortoise shell, from William Spratling.

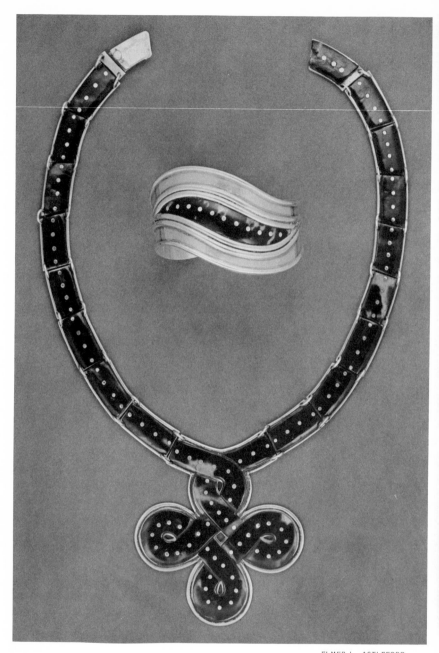

PLATE 105. A necklace and bracelet of silver and tortoise shell, from William Spratling.

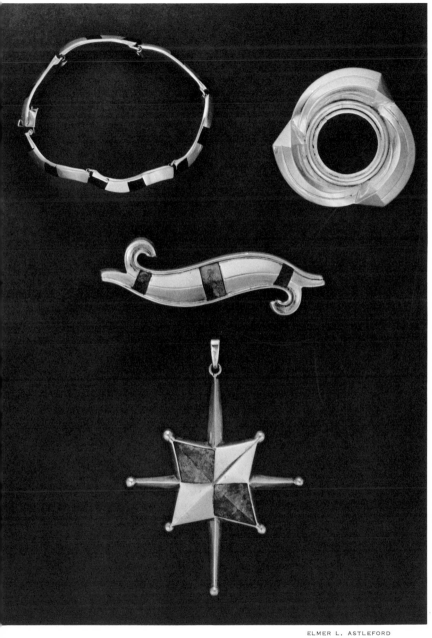

PLATE 106. Two brooches, a bracelet, and a pendant set with obsidian or malachite, from William Spratling. The "North Star" pendant may also be made of gold and ivory.

for his Mexican neighbors. He started with six boys working in a small shop. Silver had not been used for jewelry in Taxco and it was necessary to train the boys and to set high standards. As the road was improved tourists started coming, and when it was paved, they came in car- and busloads, and the Spratling shop, up a steep cobbled street, became the next stop after the church had been viewed. In 1935 he moved into a larger shop near the plaza which he called "Taller de las Delicias," and made furniture, rugs, wood and tin articles, as well as silver and jewelry. The shop grew and prospered and in 1946, when he admitted outside capital for necessary expansion, there were 422 workers for "Spratling y Artisanos," an organization which no longer exists. In the meantime hundreds of smaller shops had been started by men trained in the Spratling workshops, or in the Spratling tradition. This was inevitable as the workers had been encouraged to experiment with original designs as well as to perfect their craftsmanship. Today a great many of the best designers and craftsmen are graduates of the "Spratling school."

In 1944 the United States Department of the Interior, through Governor Gruening, asked Mr. Spratling to go to Alaska to suggest ways of improving the Indian crafts and developing for Alaska the kind of a craft industry with which he had had so much experience in Taxco. Piloting his own plane he flew to Alaska and the Arctic, investigating the sources of supply, the native design, and possible ways of training the Indians, and building a tourist trade in the Alaska crafts, specially in jewelry. For this project he made two hundred designs based on Alaskan Indian motifs, designs which were later exhibited in Washington and at The Museum of Modern Art in New York. For the production of models, he brought a group of Alaskan Indians to Taxco for training in silverwork, men who might return to Alaska and instruct others.

The experience in Alaska had a definite influence on the Spratling style. A number of his designs for flat silver and some of the jewelry designs are based on rhythms, lines, or motifs

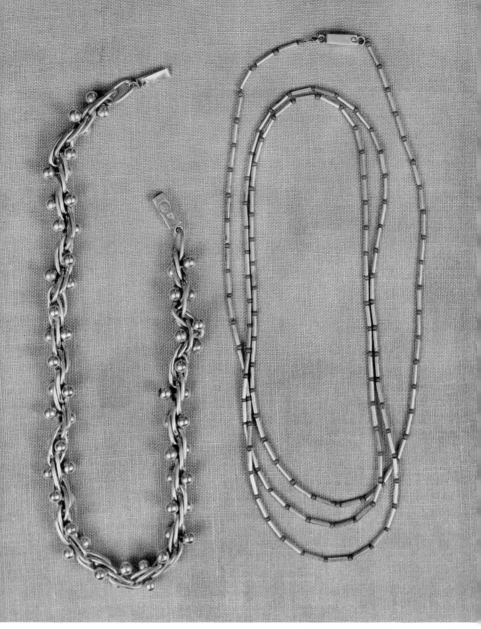

PLATE 107. Two chains, the heavy one of silver (sometimes made with the balls of obsidian), the delicate one with small coral beads. Both are from William Spratling.

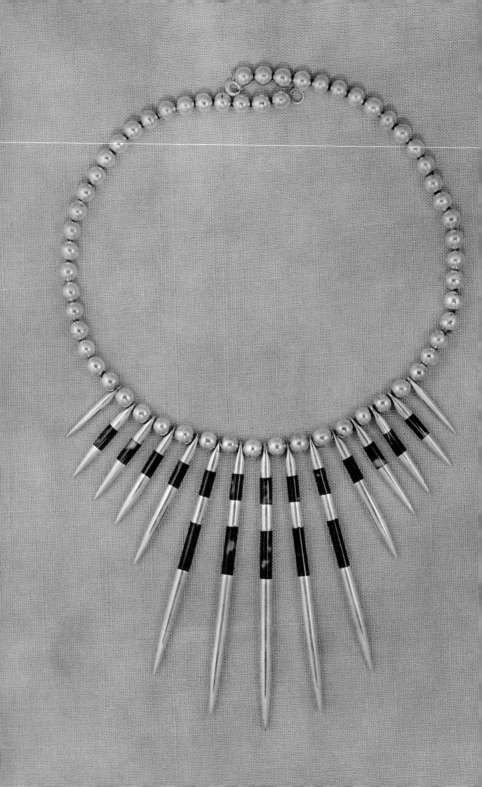

with which he had become familiar while working on the Alaska project. His beautiful "North Star" pendant in gold, ivory and baleen is a result of his interest in the North.

To go back, the earliest Spratling jewelry was simple in design, often using the motifs of the ranches: ropes and straps and balls. Some were inspired by pre-Hispanic designs, and all were of heavy silver. The traditional designs have now disappeared and he is working for greater simplicity and a more refined line and as a consequence his designs have become more individual in character, more distinguished. He believes that designing is not an occupation in itself but is the result of meeting and solving a creative problem. He develops his design on paper to a certain point, when it is turned over to one of the craftsmen in his home workshop to be made up. When it is complete in silver a design is often changed and refined until Mr. Spratling is satisfied that it is the best that can be done with his original idea. Thus the proportions of an apparently simple ring may be changed four or five times before it is put into production.

The Spratling designs are unmistakable among the thousands of pieces being turned out in Taxco. They have a clean, classic quality due to the absence of trivial decoration, and a fine feeling for the native materials which he uses in great variety. He cuts and polishes his own stones, as do a number of Taxco jewelry makers. Of his many beautiful pieces in which silver and tortoise shell are combined, three necklaces are shown on Plates 104, 105, and 108. He was the first to combine wood with metal for jewelry and still uses a great deal of rosewood and ebony. For one not familiar with rosewood it is interesting to see the pale tan sticks, piled like firewood in the corner of the shop, become a deep purple-red with

PLATE 108. A necklace of silver and tortoise shell, from William Spratling. The same design is also made in gold set with ebony or ivory.

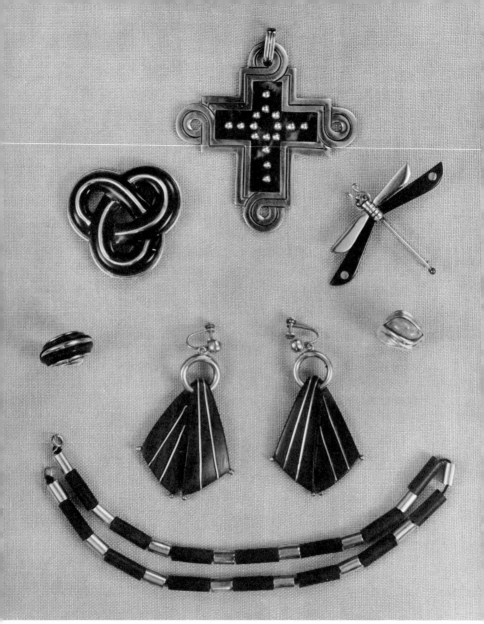

PLATE 109. Jewelry of wood and tortoise shell, from William Spratling. The brooch on the left is of an almost black tortoise shell; one ring is of gold and ebony and the other of a light yellow tortoise shell and silver; the beads are made either of gold and ebony or silver and rosewood.

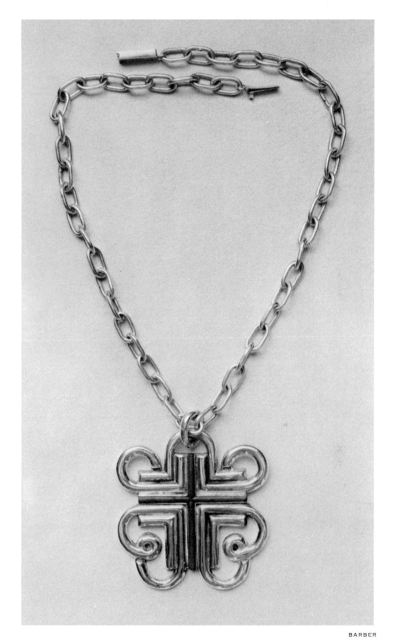

PLATE 110. A pendant of silver and yellow jasper, from William Spratling.

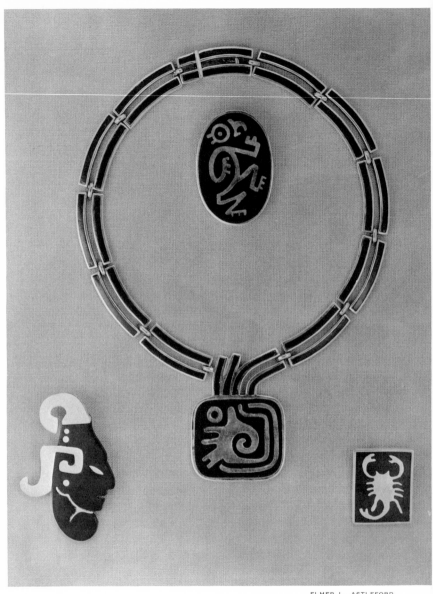

PLATE 111. A necklace and three brooches of black onyx incrusted in silver, from Los Castillo.

exposure to the sun, and then become jewelry or parts of boxes, or spoon handles. Recently the discovery of yellow jasper in the mountains near Taxco has added that golden yellow color to his silver and gold pieces.

Like others who make a study of Mexican art, he has found himself going back into the past and collecting archeological stones, large and small. Recently he has been assembling the small ones in jewelry, combining them with gold. His gold room is a breath-taking place with the beautiful necklaces, each in its lighted niche. He has given a valuable group of Remojadas clay sculpture (200 B.C. to 600 A.D.) to the National University of Mexico and in 1960, in collaboration with the University he published *More Human Than Divine*, a book about the Remojadas culture written from the artist's point of view rather than from the archeologist's.

As an architect, Mr. Spratling is responsible for building and remodeling a number of the houses in Taxco which have been made comfortable for modern living. The planning and decoration of the Hotel Rancho Telva was done by him twenty-five years ago. And it is largely due to him that Taxco still looks like an eighteenth century town, for he was the moving spirit back of the law which made the place a national monument.

Los Castillo

One of the largest workshops in Taxco is that of Los Castillo, operated by members of the Castillo family headed by Sr. Antonio Castillo Terán, known in Taxco as Tony. The Castillo brothers were trained in the Spratling shop, and are the second generation of silver workers.

Their workshop is one of the oldest in Taxco where no jewelry shop is more than thirty years old. It has grown so fast that, as new workshops had to be added, it has spread out of the original building and up the mountainside and

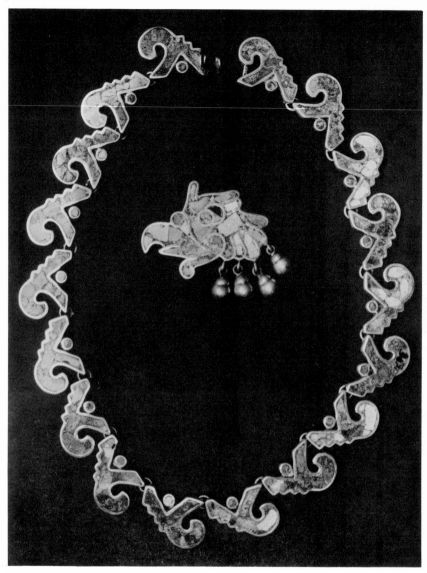

PLATE 112. A necklace and brooch of turquoise inlay on silver, from Los Castillo. In the collection of Ethel Comstock.

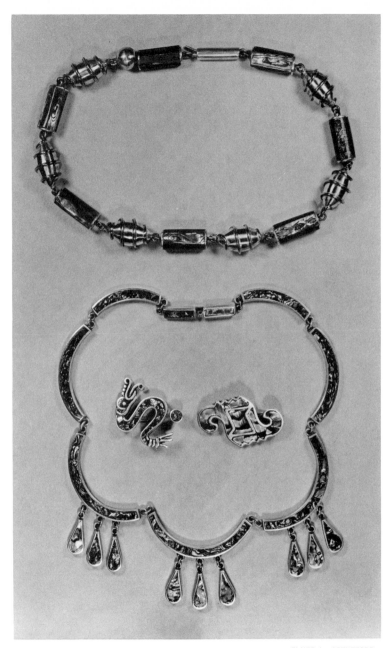

PLATE 113. Necklaces and brooches of *concha* inlay, from Los Castillo.

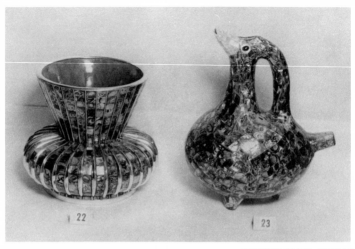

PLATE 114. *Concha* inlay used as a mosaic to surface two vases, from Los Castillo.

across the street. High rooms have had balconies built in them to make a place for more workers. In addition to their two sales rooms in Taxco they have two shops in Mexico City.

They always have, in addition to Antonio Castillo himself, a staff of fine designers. Their standards of craftsmanship are high and they constantly experiment with new materials and designs. Their early designs were based largely on Spanish-Colonial ornament and were lavish with the scrolls and flourishes of that period, the naturalistic fish, flowers, and feathers which were popular at that time. As taste has changed and new techniques and materials are being used, the style of design has changed and the Castillos have acquired great variety in their product.

In the use of new materials and the revival of old and complicated techniques they are outstanding. Their turquoise inlay is made just as the ancient Indians made it and as it is

PLATE 115. Little brooches from Los Castillo showing three of the processes which they originated and perfected: married metals, onyx incrusted with silver, and *concha* inlay.

described in the early records. It is done on a silver base, the outlines of the design being of silver, the spaces filled in with a cement-pitch in which are imbedded carefully cut pieces of turquoise, malachite, or chrysoprase to give a vibrant color. For this work they use flat designs, often from simplified pre-Hispanic motifs. The same kind of inlay is done with *concha*, the iridescent abalone shell, a native product which also was used by the ancient masters of the craft. It comes in many colors—pink, violet, blue, green. For the shell inlay they use simple, geometric designs which emphasize the pattern of the shell itself. Recently they have been making larger objects of the *concha*, using it more as a mosaic on a metal base, fitting carefully cut pieces to bring out the contours of a mask, the effect of plumage on an abstract bird form, or the shape of a vase. Their craftsmanship in this kind of work is perfect. Following in their footsteps, other shops now make inlaid jewelry but not with the clean accuracy of Los Castillo.

In their search for new ways to use old methods and materials they have mastered the art of making what they call *"metales casados,"* married metals, an ancient way of combin-

ing several metals which was in use when the Spaniards came to Mexico. In this technique silver, brass, copper, and what is known as dark silver (an alloy of silver with nickel and brass) are combined in designs in such a way that the metals are joined with little or no solder. When such a piece is highly polished the effect is one of shimmering color changes in the metal but when it is given a brushed finish to eliminate the highlights on the metal the various colors are seen. Sometimes to the four metals they add black onyx and turquoise inlay, giving them a palette of six colors with which to design. As an example of this Plate 116 shows a brooch for which they received the first prize in the Silver Fiesta of 1953. They also make a few pieces of blued steel inlaid with other metals, silver, brass, or copper. The trays, boxes, and vases made by this method are truly collectors' items as some of them are one of a kind.

From the start the youngest of the Castillos, Chato, was responsible for the development of the married metals. He worked out new alloys and new techniques in using them in large wall decorations, "paintings in metal," which combine a number of colors in dramatic designs.

The speed of this organization in the mastery of new techniques is remarkable. At one time they experimented with designs in baked enamel and in a very short time they had ten different necklaces in production and a roomful of girls trained to do this meticulous work. The enamel pieces were done in fine Moorish style designs with the colored enamels filling in depressions on heavy, polished silver backgrounds. We watched the development of the silver-incrusted black onyx from the day that it was discovered that the onyx could

PLATE 116. Jewelry of married metals from Los Castillo. The brooch at the top is a prize-winning piece which is made of four different metals and two stones.

PLATE 117. Pendants and brooches from Los Castillo, showing their ingenuity and versatility in the combining of metal and stones. The two large pendants both have a center layer of black onyx faced and backed with silver and inlaid with stones. In the upper one the stones are edged with gold, in the lower the blue inlay is edged with black. One brooch is of blued steel with the design of fireworks in copper and brass. The other is of dark silver with a background of blue and red feathers.

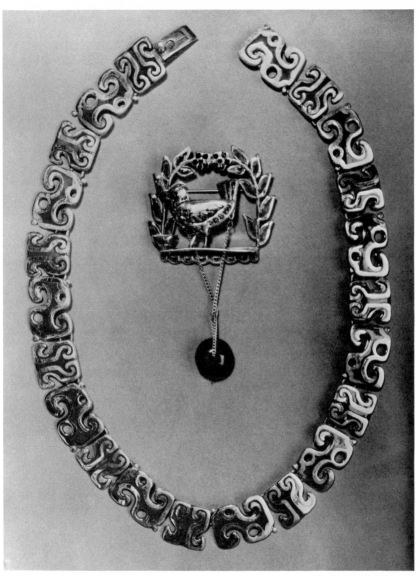

PLATE 118. A necklace and brooch of champlevé enamel on silver, from Los Castillo.

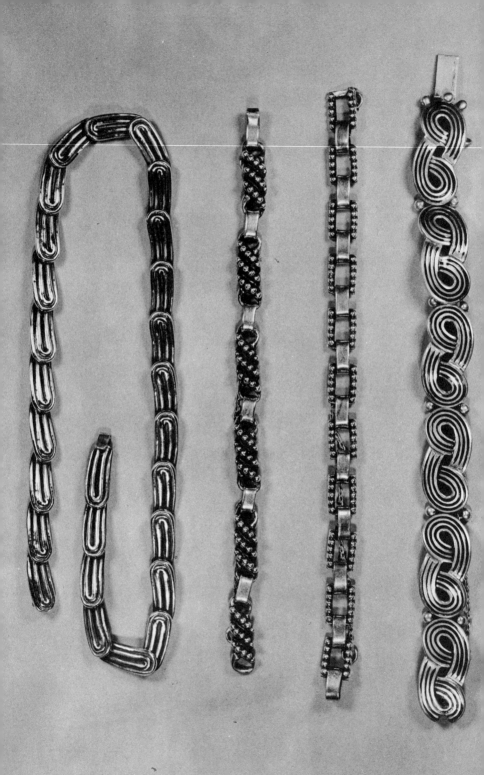

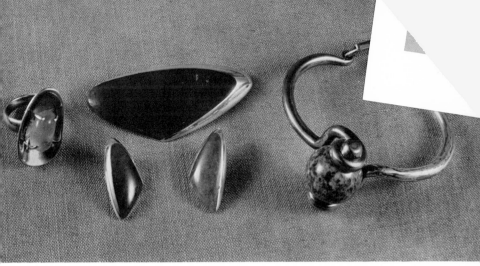

PLATE 120. A ring of silver with a pale green translucent stone, and a bracelet of silver and lacquered brass and copper with a jadeite bead, both from Los Castillo. The large stone brooch (aventurine) and earrings are by Enrique Ledesma.

be carved to receive incrustations of silver to the time it was produced in many designs—it seemed no time at all. For this line the striking black and white designs are necessarily simple.

Los Castillo's shops are open to the public and are interesting to see. They have their own rolling mill for sheet silver, their tool and die makers, and both experts and apprentices working in all the various processes. If the presence of some modern machinery might lead one to think that their jewelry is not handmade, the sight of over a hundred men, boys, and girls working with hand tools and hand processes will refute the impression.

In his shop in Mexico City, Jorge, "Chato," Castillo is now doing large work, murals and decorations in metals. His "paintings in metal" are done in blued steel and married

PLATE 119. Chain necklace and three bracelets, from Los Castillo.

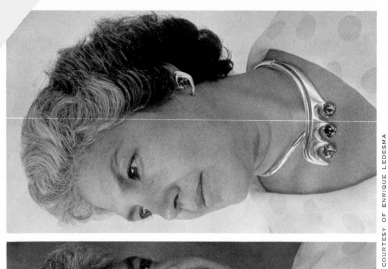

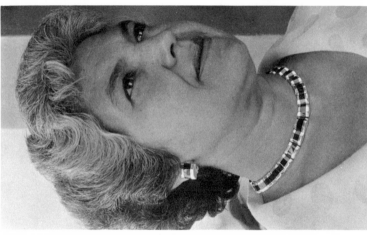

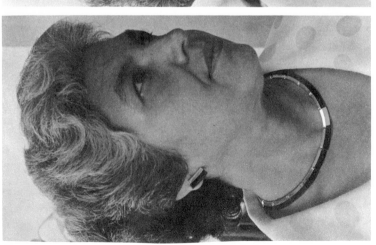

PLATE 121. Three necklaces by Enrique Ledesma: the first is of obsidian, the second of turquoise, and the third is set with alexandrite.

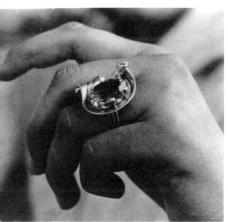
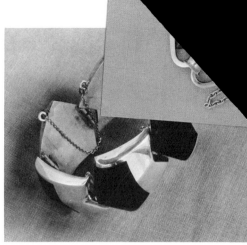

PLATE 122. A ring with an amethyst set and a bracelet of obsidian, by Enrique Ledesma.

metals. Like many other imaginative Mexican artists, he is inspired by pre-Spanish art and, at the other extreme, by modern abstract art, two styles which are more alike than different. In the few jewelry objects which he makes he gives his modern designs a pre-Spanish feeling by incorporating in them old stones and jade. His pieces are all one-of-a-kind in contrast to the large production of the big Castillo shop in Taxco.

Enrique Ledesma

A jewelry maker "by inheritance," Enrique Ledesma grew up helping in his father's shop in Mexico City. Later, while he was still a student of painting and sculpture at the San Carlos Academy of Art, he began his career as an apprentice in a large silver shop. After coming to Taxco and working for both Spratling and Castillo he started his own shop in 1950 and has perfected an original and individual style. His training in sculpture enables him to do bas-relief figures and portraits in silver and

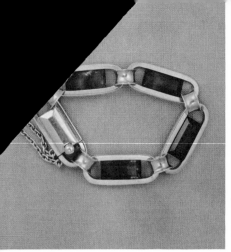
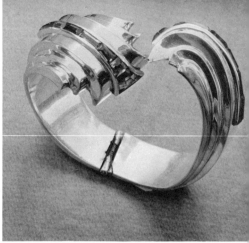

PLATE 123. Bracelets by Antonio Pineda, both of silver and amethysts. The large bracelet was a prize-winning piece.

his apprenticeship in large silver work gives him a complete command of the metal.

In his most characteristic work he uses the stone and the metal as a single unit, first making the silver shape and incrusting in it the stone and then polishing and refining the silver and stone as a single unit. These units are combined in necklaces and bracelets or made into separate pieces. He uses rather large semiprecious stones of clear color to contrast with the silver and keeps his designs simple to emphasize the color and texture of the stones; and, as is necessary with very simple designs, his craftsmanship is perfect.

Antonio Pineda

In 1934 when we first visited the Spratling shop, there were six young men working at the benches and learning the craft of jewelry making. One of these was Antonio Pineda Gómez, now one of the important silversmiths in Taxco, whose shop on the Plaza Borda is called "Antonio."

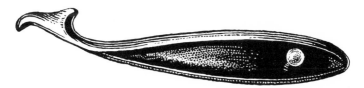

PLATE 124. A brooch, by Antonio Pineda, made of darkened silver with a pearl set.

Sr. Pineda is a native of Taxco, a member of the large family of a former *Presidente* of the town. As a boy he studied painting with Kitigawa, a fine Japanese painter who at that time was guiding the talent of the Taxco children, and while still very young with Siqueiros, working in between at the Spratling shop. Then for a few years he was in Mexico City working while he was getting his education. When he finished in the Technical School and was ready to start doing professional work he began in the silver shop of Valentín Vidaurreta whose style of design probably influenced him in his liking for large jewelry as Valentín was doing massive pieces at that time. Working large and with simple lines he has developed an individual style.

One's first impression of his jewelry is that it is "high style" because of its size and dramatic design. But the big pieces are not heavy because they are hollow. The bracelet on Plate 123 is made of over thirty pieces carefully fitted together. Even his rings which appear heavy are light and easy to wear. Only a skilled technician and designer can get the effect of mass without weight.

His work is also distinguished by the imaginative use of stones. No other jeweler in Taxco uses so many of the more costly stones and no one sets them with as much ingenuity and variety as Sr. Pineda. He is apt to set them with as little metal touching them as is possible to hold them firmly in place, giving the stones a free or floating look. Stones are embedded, or rows of stones are set close together to emphasize the struc-

PLATE 125. A prize-winning knife by Antonio Pineda.

PLATE 126. Silver *repoussé* brooches and bracelet. The feather brooch is by Héctor Aguilar and the other two pieces were made some twenty-five years ago by Valentín Vidaurreta.

tural lines of a design, or stones are cut to fit irregularly shaped spots in a design. He uses many clear, faceted stones, mainly gem amethysts or topaz combined with brilliants.

He opened his shop in 1941 and has been successful from the start. His work receives many prizes. The bracelet on Plate 123 was the winner of the first prize in the Silver Fiesta of 1949, and the knife on Plate 125 which was done by a number of processes and contains gold and silver, turquoise, jade, pearls, and a star sapphire won the prize in 1959. A few years ago he set a number of fine Oriental stones for Gump's of San Francisco, which resulted in an exhibition of his work in the Palace of Fine Arts in that city. For a number of years he has admitted to his shop as apprentice students a group from Syracuse University who come to Taxco to learn about Mexico and jewelry making at the same time.

Héctor Aguilar

 An important shop on the Plaza Borda is that of Sr. Héctor Aguilar Ricketson. Like so many others, he started as an assistant in the Spratling shop and opened his own workshop some twenty years ago. His large silver pieces, flat and hollow-ware, frames, candlesticks, and vases are exceptionally beautiful and well made. The larger copper pieces are outstanding. He does not concentrate on jewelry, but that which he does is characterized by fine taste and workmanship.

The construction of his jewelry is always interesting. A good example is the bracelet of alternating balls and flat units with concealed swivel hinges, a bracelet which has been copied many times by other silversmiths but which originated in the Aguilar shop. Another of his bracelets, also shown on Plate 127, is made of hollow tubes hinged in an ingenious way. The technical problems of the metal and its construction into jewelry are of great interest to Sr. Aguilar, and his successful solution of these problems insures a durable product.

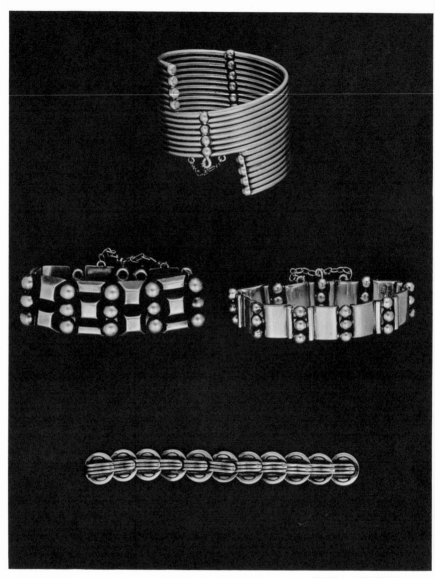

PLATE 127. Bracelets by Héctor Aguilar.

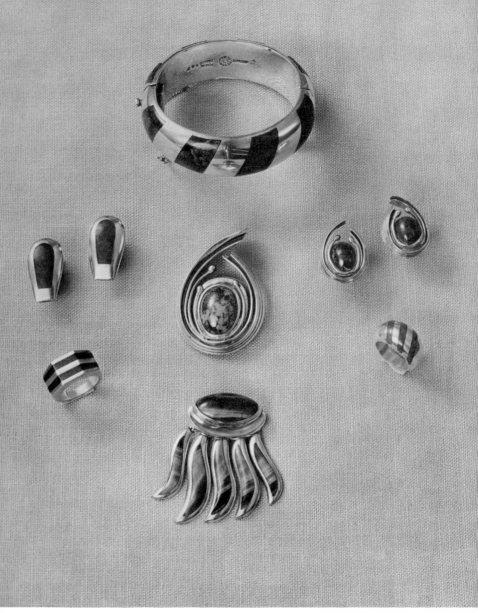

PLATE 128. Silver pieces set with stone, from Piedra y Plata: the bracelet is of malachite, the center brooch and earrings of turquoise, the lower brooch of tiger-eye.

His workshop as well as his sales shop is in the house which Borda built for his own use over two hundred years ago.

Felipe Martínez

"Piedra y Plata" is the name of an interesting shop, opened in 1950, by Sr. Felipe Martínez H. Before opening his workshop he was an expert sculptor of small heads and figures, and these are one of the main attractions of his exhibition room where lighted niches in the walls contain his carvings done in native stones. A few of the smaller carvings are set in jewelry.

As might be expected of a designer whose main interest has been in stones, his jewelry is simple in design and the stones are set in unexpected ways, long, flat stones set between bands of silver, diagonal rope effects of alternating bands of silver and malachite, stones cut in unusual shapes in settings obviously designed by a sculptor. An interesting brooch made of tiger-eye, shown on Plate 128, is an illustration of this.

Ysidro García

In Mexico City and in Taxco we had seen some brooches made of free, foliated scrolls which seemed to us to be a fine expression of the Mexican liking for flourishes of all kinds. In this case the flourishes had the restraint imposed by good taste, and a simplicity of design suitable for silver. In the small shop of Sr. Ysidro García Piña in Taxco we found the source of these brooches.

Sr. García's shop is called "Maricela." His trademark and greatest pride is a naturalistic silver orchid which he makes with the skill of a master, reminding us of the gold and silver flowers made by the early craftsmen to decorate the altars in the churches.

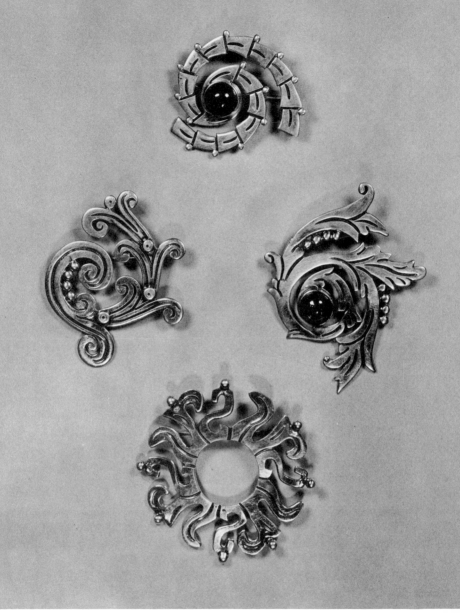

PLATE 129. Silver scroll brooches by Ysidro García ("Maricela"), and a sunburst by Bernice Goodspeed.

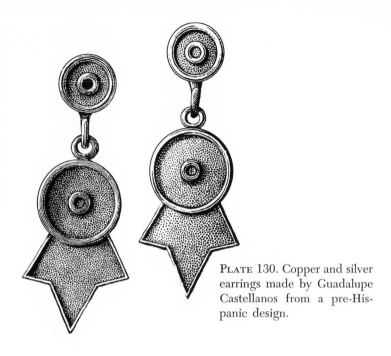

PLATE 130. Copper and silver earrings made by Guadalupe Castellanos from a pre-Hispanic design.

He makes several variations of the scrolls we like, some with stones and some without, and he fills many orders for these popular brooches for dealers in Mexico.

Guadalupe Castellanos

In 1938, writing for a Mexican art magazine, William Spratling told of the men in Taxco and Iguala who were making jewelry and silverware when he first came to Taxco, mentioning five men. One of these was Sr. Guadalupe Castellanos who lives in Iguala but sells his work through a few dealers in Taxco and Acapulco. Old-timers in Taxco tell us that twenty-five years ago Sr. Castellanos did the usual kind of work that comes to a small town jewelry maker: gold beads and silver spoons, wedding rings, and earrings. It seems re-

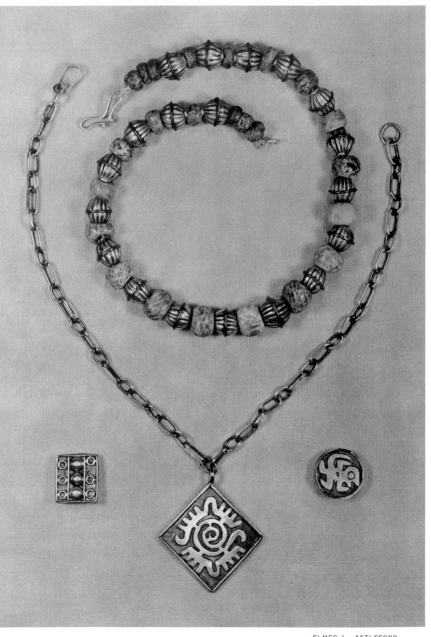

PLATE 131. Beads, pendant, and buttons by Guadalupe Castellanos. The beads are used with old jadeite. All are of silver and copper combined.

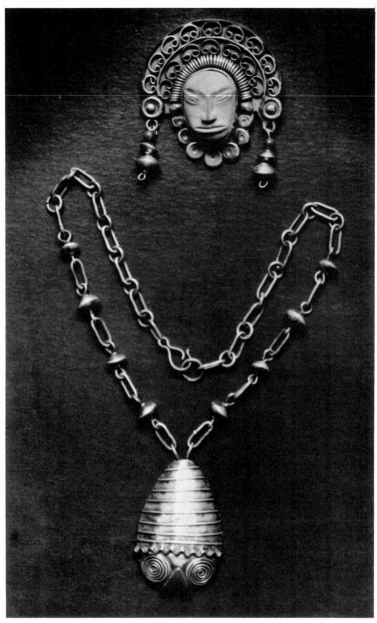

PLATE 132. Grotesque silver and copper brooch and pendant by Guadalupe Castellanos. The head in the brooch is of wood, hand carved.

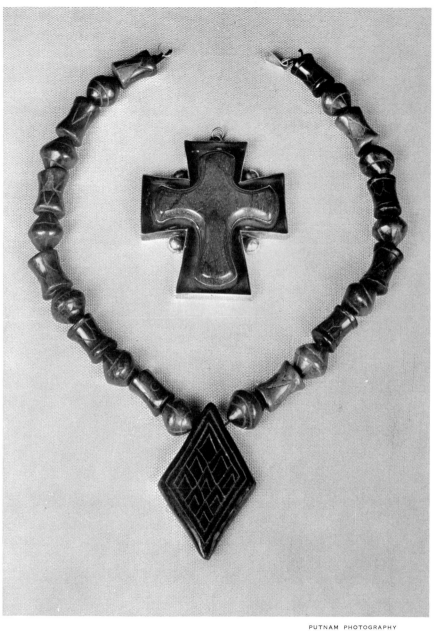

PLATE 133. A cross of walnut set in dark silver and copper by Guadalupe Castellanos, and black pottery beads whose maker is unknown.

markable, that being the case, that he now does large, primitive-looking pieces. Of all the modern "primitive" jewelry we have seen, his seems to have the most feeling and the most authentic look.

He darkens all his silver and often combines it with copper, leaving only a few spots burnished. The chains for his necklaces are heavy and the beads are never just balls, but are the flattened Iguala type, or they are fluted, or melon shaped, or decorated. And with them he often uses old jadeite beads.

Here we might mention the present and growing appreciation for necklaces made up of old jadeite beads and silver, and bead necklaces made of unusual materials (Plates 20 and 133). Sr. Víctor Fosada, an authority on folk jewelry, who has a shop in Mexico City, has had made for him some heavy silver beads which look as if they might have been found in some tomb along with the old worn stone beads.

A number of jewelers are making so-called "primitive" jewelry and occasionally it is well done. We have seen a few pieces done by Ken Belden, an American living in Tenancingo, which were interesting in color, being mainly of copper and brass with a little white metal. He is the custodian of a collection of archeological stones and it is from these he derives his motifs.

Margot de Taxco

Several American women who have lived for a number of years in Mexico have been successful as jewelry producers. Few of them are actually jewelry makers but they sell jewelry made for them exclusively, either in their own workshops or by silversmiths who work closely with them and carry out their designs.

Margot de Taxco has had a large and successful shop for

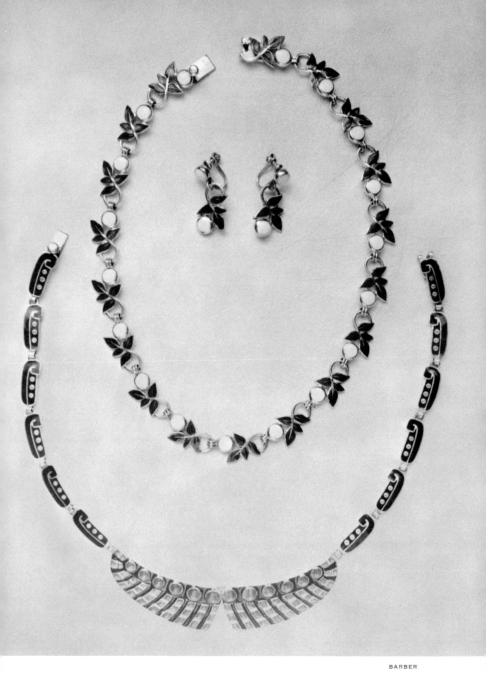

PLATE 134. Two necklaces of champlevé enamel by Margot de Taxco. The upper one is of leaf green and white, the lower of a transparent emerald green.

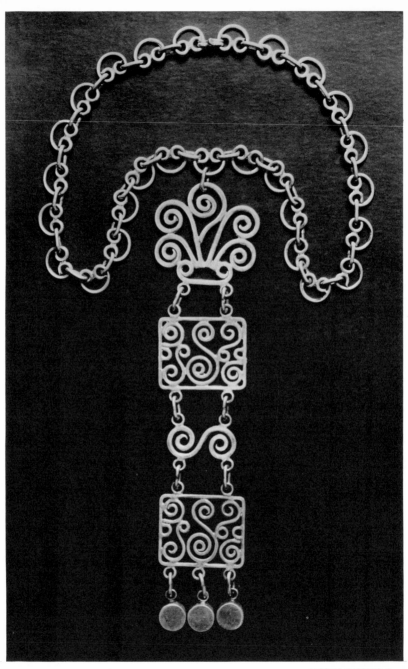

ANTONIO GARDUNO G.

PLATE 135. A necklace by Bernice Goodspeed from a pre-Hispanic motif.

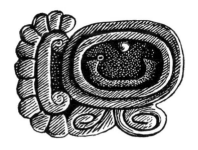

PLATE 136. A small brooch designed by Bernice Goodspeed from a pre-Hispanic hieroglyph.

a number of years. Her designs, drawn with great skill and understanding of the craft and carried out in her own shop, are apt to be rather ornate and sumptuous, perhaps because she has traveled considerably and has great admiration for the design of the Orient.

Recently she has been doing some beautiful work with champlevé enamels, using opaque and transparent enamel in intricate designs and placing small spots of color like precious gems. Her jewelry with its masses of color is in dramatic contrast to the silver jewelry so prevalent in Taxco.

Bernice Goodspeed

Bernice Goodspeed, the author of several good books on Mexican subjects, also has a shop in Taxco. She is a student of archeology and with great imagination has based her designs not only on the motifs of ancient Mexico but on the rhythms and symbols of the Coclé region of Panama and the goldwork of Costa Rica. The necklace on Plate 135 is in-

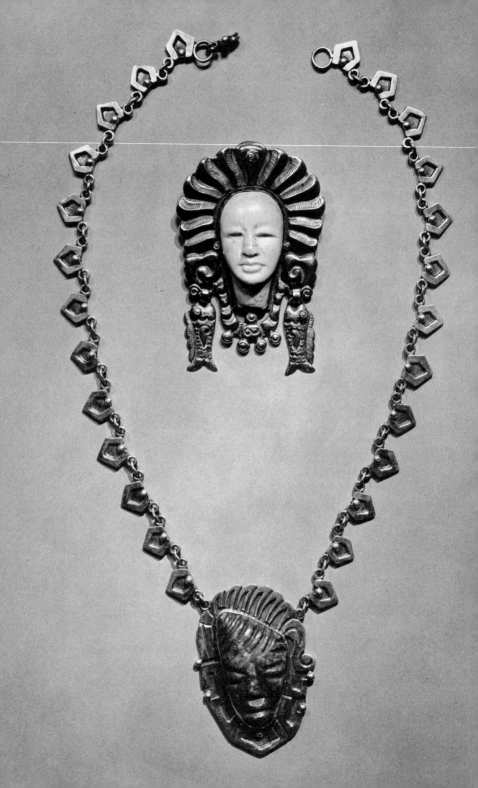

spired by the spirals which are characteristic of the Coclé Indians. She works with a fine silversmith who carries out her ideas. And she often incorporates in her jewelry the old carved stones which she collects with great discrimination.

Salvador Terán

After long association with his cousins, Los Castillo of Taxco, Sr. Salvador Terán opened his own workshop in Mexico City in 1952. Although well known among jewelry craftsmen, he had designed anonymously for the big shop in Taxco and so had the problem of establishing his own identity as a designer. But he is original, inventive, and versatile and in a short time his jewelry had won recognition in the city. His work is known under the name "Salvador."

Some of his most interesting silver work is jewelry built up in two separate planes joined invisibly, the upper one pierced with a cut-out geometric design which seems to float above the lower plane of darkened silver. The effect of the brilliantly polished design against the shadowy background is dramatic.

Always interested in new materials and both new and old techniques, Sr. Terán is combining metal with mosaic and has a large workshop busy turning out boxes, trays, and other decorative objects in the technique so in demand at the present time. He has also done interesting mosaic wall decorations and murals in abstract design made to fit the rooms for which they are designed.

PLATE 137. A silver brooch designed around an old carved ivory head, by Ricardo Salas, and a necklace designed around an old stone head by Bernice Goodspeed.

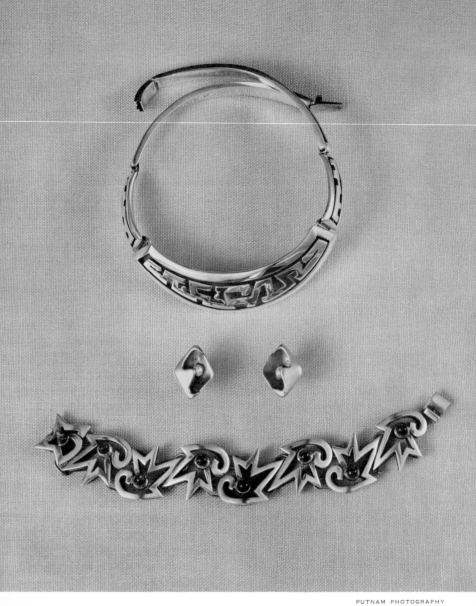

PLATE 138. A silver bracelet, necklace, and earrings, by Salvador Terán.

Matilde Poulat

Jewelry making in Mexico is usually a man's craft but one of the finest producing designers of the past thirty years was a woman, Srta. Matilde Eugenia Poulat, whose work is quite different from any other. All her designs have a subtle Mexican feeling without recourse to any definite Mexican motifs. The products of her workshop were signed "Matl." This gifted designer died in 1960 but some of her designs are still being made by her nephew who was closely associated with her for many years.

Srta. Poulat was a student at the San Carlos Academy of Art when a number of now famous students were there, among them Diego Rivera, and her art education was based on the usual figure study of the academic schools. However, she was never able to confine herself to the literal rendition of the figure and the classically composed landscape. She started her professional career as a painter and designer at the time when realism was very important but soon found that imaginative designing was the work she liked best. For some time she did decorative designing with an occasional chance to do a piece of jewelry, and when jewelry making became such an important craft she began to work entirely in that medium.

In 1934 she started her own shop and, when a nephew, Ricardo Salas Poulat, had grown proficient enough to assist in the shop, she was able to produce work to sell to dealers, and in 1950 she started her own sales room on the street floor of her residence with her workshop there also.

The effect of her jewelry is rich and precious, with designs based on floral and bird forms, *cascabeles,* and shells. The Mixtec jewels were the inspiration for many of her pieces, designed with heavy wire, whole surfaces decorated with ap-

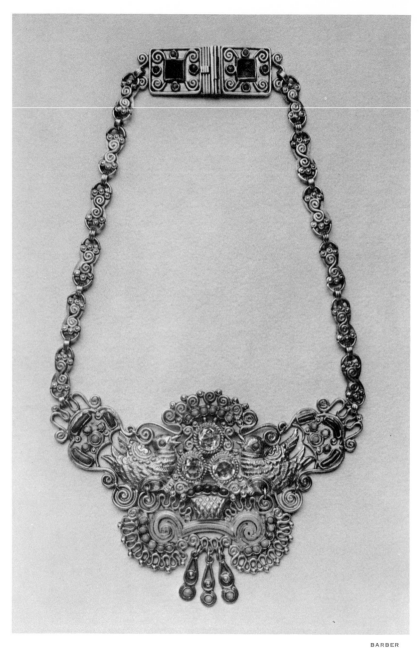

PLATE 139. A silver necklace set with topaz, coral, and turquoise by Matilde Poulat.

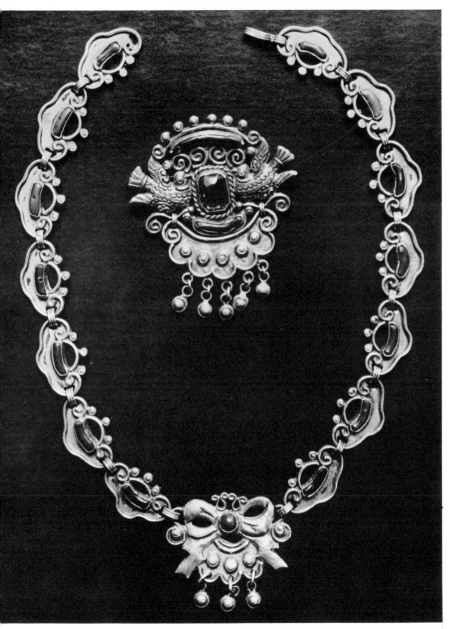

PLATE 140. Two pieces by Matilde Poulat: a brooch of silver with a
dark gray transparent stone and long pieces of coral; a necklace set
with branch coral and turquoise.

217

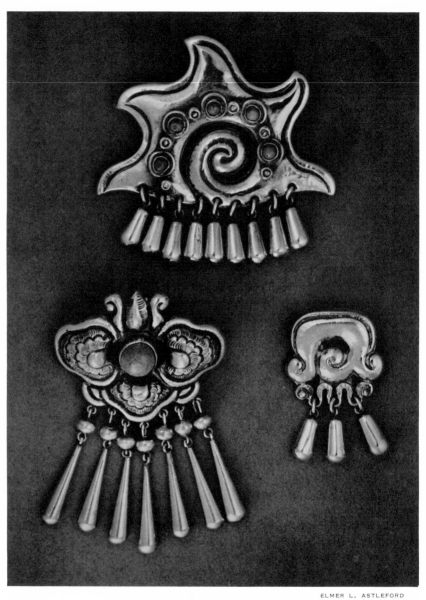

PLATE 141. *Repoussé* silver brooches by Matilde Poulat.

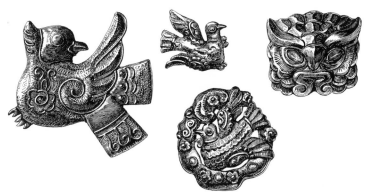

PLATE 142. Silver *repoussé* birds, from Matilde Poulat, showing the skill of the workers in her shop.

plied wire designs, and with coils and loops on the edges. Large simple shapes are made interesting by pattern and detail. Many pieces are done in *repoussé* with heavy, embossed surfaces to give a Baroque effect of mass and modeling. The use of colored stones adds to the Baroque feeling. This imaginative combination of motifs, methods, and color adds up to an original and personal style.

Since she used a limited number of motifs, it is surprising that she obtained so much variety in her work as a whole. By contrasting heavy *repoussé* with filigree, using differences in texture and polish, and setting stones in many ways she avoided monotony. For color she used coral and turquoise, amethyst quartz, amethysts, and topaz, all feminine colors. Some pieces are a mass of stones and some have no more than one small blue eye in a bird. Her use of coral fragments is unusual with the decoration built around the irregular shapes of the coral branches.

She made many religious and devotional pieces, crucifixes, *santos*, and figures of the Virgin. These vary from six inches in height to two feet and are designed like her jewels. Ricardo

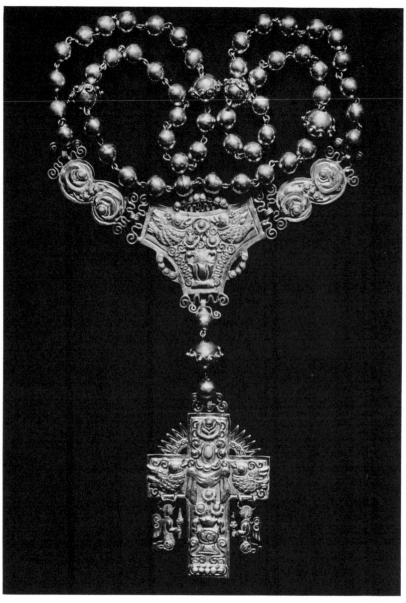

PLATE 143. A rosary set with turquoise and coral by Matilde Poulat, from the collection of Isabel Kelly.

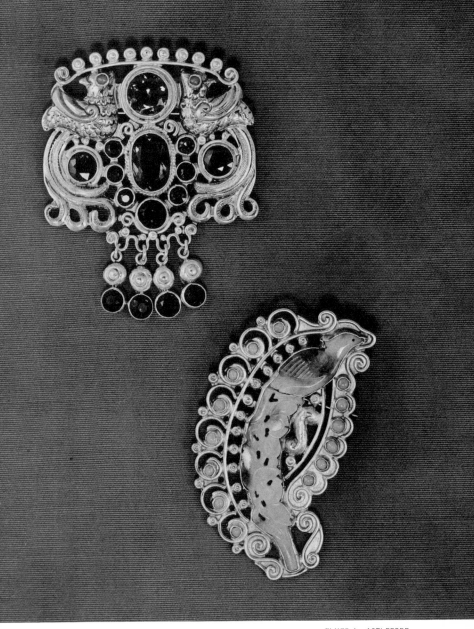

PLATE 144. Brooches designed by Ricardo Salas and made in the "Matl" shop. The upper one is of silver with gold quetzal birds, set with amethysts and garnets. The lower uses a fragment of Chinese jade and pale pink coral.

became adept in carving the heads for the figures from ivory, as well as the little ivory doves and cherubs which adorn these beautiful pieces, now collectors' items.

Her work was always popular with Mexican artists and connoisseurs. We have heard archeologists praise it as being expressive of the pre-Hispanic feeling. To us it seems Churrigueresque. And it is very wearable.

Ricardo Salas Poulat

After Matilde Poulat died her nephew, Ricardo Salas Poulat, who had worked so closely with her, opened his own shop. He designs, as he has for so long, in the Matl style even producing some of the Matl designs which are marked Matl Salas. Gradually his own individuality is becoming more noticeable, the jewelry being a little flatter without so much *repoussé*, a little less decorated. It is hard to see, in a case like this, where one artist's designs leave off and another's become predominant. Matilde's designs were her own very personal expression and Ricardo is of another generation. He has been on his own as a designer for only a short time and it will be interesting to see how his style develops.

Conclusions

A piece of jewelry, to have aesthetic value, must be designed as an ornamental accessory whose purpose is to add beauty or interest to the personality of the wearer. The designer, whether trained or untrained, should know the materials and techniques with which a jeweler works so that his design, when carried out will be durable and wearable. The more original and imaginative the designer, the more interesting the jewel will be. Technique is almost inseparable from the design but its importance is secondary. Sometimes a jewel is more beautiful in an unfinished stage

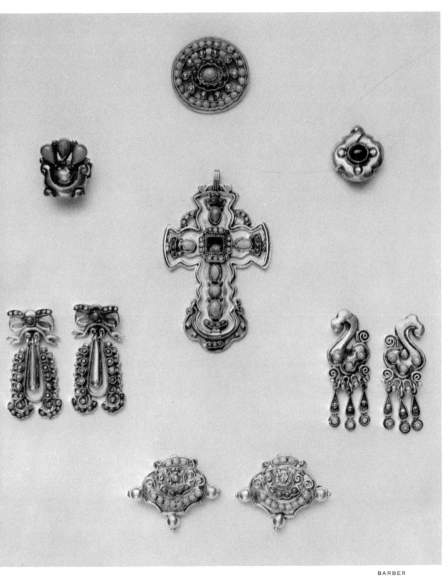

PLATE 145. Jewelry by Ricardo Salas: the ring on the left is of silver and gold set with jade and a pearl; the *repoussé* ring is set with obsidian; all other pieces are set with coral and turquoise.

than after it has been refined, cleaned, and polished. And, again, the beauty of a design may be lost by being poorly or roughly carried out.

The jewelry of the past is interesting to us not only from the aesthetic point of view but because it helps to interpret the feeling of the period in which it was made. Contemporary jewelry should do the same; but Mexican design will not show the same response to contemporary life that one finds in the United States where there are hundreds of high schools, art schools, and colleges teaching design and jewelry making compared to one such school in Mexico. This makes a different artistic atmosphere.

The startling motifs with which some of the American jewelry craftsmen are so preoccupied at present, the skeletons, claws and bones, architectural rhythms, and machine parts, the boomerangs, and fetishes, have not occurred to the Mexicans as motifs for jewelry. With a few exceptions the Mexican designer has not been influenced by cave paintings, African sculpture, Modigliani, or Picasso. When he looks to the primitive it is to his own rich inheritance; when he designs with fish forms it is because fish are familiar and important to him. The fish jewelry of Pátzcuaro as well as the pottery of Tzintzuntzán decorated with fish drawings are indigenous.

A number of American designers are in Mexico making jewelry, drawn there by various reasons: the abundance of materials available, or an enthusiasm for life in Mexico, the large market for jewelry, or a desire to earn a living working with their own hands. These are all legitimate reasons. But unless their work meets the Mexican standards of workmanship which is partly inherent and partly the result of apprenticeship under master craftsmen, their work can not be classed as Mexican. The Americans who stimulated the growth of the craft in the early part of the century were men who were moved by their love of Mexican native crafts, and their influence can not be questioned.

Handmade jewelry in Mexico is an industry by which thou-

sands of Mexicans earn their living, not a means of self-expression. In the United States it is the product of individual craftsmen made for the sophisticated few. This must be remembered when judging the work seen in the shops. Looking at the work as a whole it seems to us to meet exceptionally well the requirements of beautiful and original design, wearability and durability.

NOTES ON JEWELRY MAKING

Gold and Silver

OVERHEARING A CONVERSATION in Taxco in which one man enthusiastically described to a group his trip behind the scenes in one of the shops made us realize that many people are interested in how jewelry is made, and they do not know that some of the processes which the craftsman uses as a matter of course have been used in practically the same way for thousands of years. These notes concerning methods and materials, as used in Mexico, are for anyone who may be interested in the technical details we have mentioned elsewhere.

The term used to designate pure gold or pure silver is Fine. In this state both metals are soft and ductile and can be drawn into thin wire. As gold always retains its brilliance and does not rust or decay or tarnish, the wire can be made into lace, or wound on silk threads to be used in fabrics, embroideries or tapestry.

There are, however, few uses for gold and silver in their pure state and other metal must be added to strengthen them. The color and amount of other metal used as an alloy changes the color and often the brilliance of the metal.

The standard of measuring Fine gold is by Karat (*quilate* in Spanish), designated by the letter K, Fine gold being 24K. Eighteen Karat yellow gold is an alloy of eighteen parts Fine gold, four parts Fine silver and two parts copper. This is the alloy most used and the color we think of as gold. Eighteen Karat green gold is eighteen parts Fine gold and six parts Fine silver. Eighteen Karat red gold is made of eighteen parts Fine gold alloyed with six parts copper; the more copper added to the gold the redder the alloy.

One of the earliest ways of working gold was to beat it into thin sheets by hand. In primitive times this was done between two stones. This process held an important place in the art of the goldsmith in ancient Mexico. The sheets, sometimes as thin as vellum—for gold leaf can be made 1/250,000 of an inch thick—were made into crowns, leg-bands, bracelets, and rings, and very thin sheets were attached and formed over metal, wood, stone, or clay. In many of the old Mexican churches there are fine examples of this use of gold. The details were carved in wood after which the thin gold sheets were modeled over the carving, resulting in the glowing, sparkling interiors which we see today. During the wars and the Revolution many of the churches were robbed. of the gold up as high as a man could reach to scrape it off.

The metal used to strengthen silver is usually copper as the two metals mix well in the molten state and produce an alloy which is at the same time tough and ductile, but inclined to

oxidize. This was not a great problem before the use of coal when there was very little sulphur in the air, and now other metals are sometimes added to take care of the problem of tarnishing. Many craftsmen make their own alloys. The law requires that an article stamped Sterling contain 925 parts of Fine silver to 75 parts of other metal in 1000 parts of Sterling. As some of the alloys used in Mexico have a very high content of Fine silver, many articles are stamped with a number showing the amount of Fine silver they contain instead of the Sterling stamp. Some are stamped as high as 980 showing that the piece has only 20 parts in 1000 of the alloy metal, the rest being Fine silver. This high percentage of silver gives a softer patina which is more resistant to tarnish.

Fine metal can be purchased, the alloy added, the two melted together and poured into bar molds, after which it is rolled between the steel rollers of a rolling mill to the desired thickness. Wire is made by drawing strips of the metal through tapered holes in a steel plate to any gauge or shape.

Gold is one of the rare metals, and the demand for it is always greater than the supply. At the time of the Conquest gold was ten times as valuable as silver but in the world today, as the production of silver has increased, gold has become about one hundred times as valuable as silver. Mexico produces a third of the silver in use in the world.

Coloring of Metals

Silver jewelry is sometimes oxidized to give depth to recessed parts, then polished to its true color. A warm solution of potassium sulphide is often used for this purpose, and there are several other methods of oxidizing silver. A glossy blue-black finish can be given to the article after it is oxidized by buffing it with a fine brass buffing wheel on a slow lathe.

The brilliant blue color which is given to steel or iron is called "*pavón,*" the Spanish name for peacock color. In Amozoc we inquired about the method they use to blue their steel

and were told that it is a secret, so we do not know which of two well-known methods they use or whether they really have a secret method. By the Nitre Bath, the first of these methods, the polished article receives a thin coating of oil, after which it is immersed in a hot nitre bath, then is quenched in cold water and then dipped in boiling water and finally in hot oil. The simpler charcoal method consists of burying the polished steel in a bed of very hot charcoal and afterwards rubbing the surface with sperm oil. The color is caused by the formation of iron oxide on the surface, a color which will remain the same under most conditions.

Casting

There are several ways of casting metal objects, all of which require molds into which the molten metal is poured or is thrown.

Some of the finest examples of pre-Hispanic goldwork were made by the cire-perdue or lost-wax process. For many years after their discovery the wire decorations on these pieces were thought to have been soldered on, but now it has been decided that they were made of wax threads applied to the model and cast by the lost-wax process. The best of this work came from southern Mexico where it reached a high state of perfection. In the lands to the south, now Costa Rica and Panama, beautiful casting was done and those people may have originated the process in the Americas. Specimens of this work are rare, but the treasure taken from Tomb 7 in Monte Albán has added greatly to the small collection of beautiful gold castings which exist in the world today.

Although the principle of the lost-wax process was the same in the pre-Hispanic period as it is today, the equipment at that time was primitive. The models and molds were made of clay and charcoal, the wax of the wild bee was used and the pitch was gathered from the trees around the countryside. The description of the process is given here in some detail for

those who may become interested in the old pieces in the museums, and for jewelry craftsmen who may wish to compare the Indian way of casting with the process as it is used in modern jewelry workshops.

First, the material for the core was made of clay and finely ground charcoal mixed and kneaded into a mass. Small pieces of this mass were laid in the sun to dry for several days. A rough core, the approximate size of the article to be made, was cut from one of these dried pieces and then modeled, carved and refined with a small copper scraper into a model of the finished piece. Beeswax was melted and mixed with copal and strained to remove impurities, and, on a smooth flat stone, was rolled with a wooden cylinder into very thin sheets. Small pieces of the thin wax sheet were pressed over the modeled core and additions of wax wires were added for decorative purposes. Over this wax-covered core a thick coating of very finely ground charcoal was applied and the core was then enclosed in a shell of clay mixed with coarse charcoal; but before the shell was sealed a small roll of wax was placed to connect the core with the outside of the shell to form a channel into which the molten metal could be poured.

The shell was sealed and allowed to dry thoroughly. Then heat was applied to melt the wax which flowed out leaving the mold and channel free to receive the molten metal which was poured in through the channel. When it cooled the shell was opened to release the casting which was then tooled and burnished. The filigree was probably made of waxed threads which were burned out in the heating.

Sometimes the model was made by dipping fine threads in melted wax and winding them around a prepared core of clay, either smoothing them out or leaving them as fine lines in the finished casting. Much of the casting from Guerrero and Michoacán seems to have been done in this way. Many of the castings from that region are of *tumbago*, a mixture of copper and gold with a high copper content. Cast beads must have been made from individual models as they are not uniform

in shape and size. The *cascabeles* which are uniform in size may have been made in a master mold into which each clay core was pressed.

Fine reproductions of the Monte Albán jewelry are being made in Oaxaca using the cire-perdue process. A wax pattern is encased in plaster and the wax is then melted leaving a mold into which molten metal is forced. By the earlier method the metal was poured but now the casting is done by centrifugal force, often with homemade tools, perhaps a tin can with a wire fastened to it to whirl it.

Some jewelry casting is done in sand, an inexpensive process, but limited because undercuts and intricate designs must be avoided. However, if the model is cast in several parts and soldered together most designs can be cast and, if well joined, are perfectly satisfactory.

For sand casting two iron frames are packed with casting sand. The model is made of some material which can be carved or modeled easily, such as wood or soft metal. The model is placed between the two sand filled frames and the frames are pressed together. When the frames are separated and the model is removed the impression of the mold is left in the sand. A channel is cut in the sand, the frames are clamped together and the molten metal is poured in. The rough casting is finished by hand. In sand casting the model can be used indefinitely but a new mold must be made for each casting. In cuttlebone casting the same procedure is followed, the mold being impressed on the soft, porous sides of two pieces of the cuttlebone.

We watched sand casting being done in a small shop. The silversmith was engraving surface decorations on some lead models. A number of these models were to be cast at the same time with a central channel in the sand connecting all the impressions. The finished castings were fine.

The Navajo Indians, who learned silverworking methods from the Mexicans, do their casting in a special kind of stone which is found in the southwestern part of the United States,

a tuff which is light in weight and easy to carve. The mold has to be carved out of the stone by hand. Two pieces of stone are used and the process after the mold is made is the same as in other casting.

Repoussé

Repoussé is another old technique for working metals, the process being to raise the design from the reverse side by the use of punches. Much of the early work stopped after the first stage of the process, but later, modeling and refining the embossed surface became the custom. The pre-Hispanic work was done on thin sheets of gold alloy containing a small amount of silver and copper, but not enough to destroy the malleable quality of the gold.

The early work in repoussé needed few tools, the thin sheets of gold being laid face down on a yielding surface, such as lead or leather, and the design punched from the back. The tool marks were sometimes left, giving an irregular texture to the finished piece. The pre-Hispanic repoussé was done on very light weight sheets, the design pressed into the metal with a blunt tool to give an embossed line design in primitive craftsmanship. Another early method was to press the thin sheets of metal into incised stone or wooden molds.

In the eighteenth century, when the taste in all kinds of decoration demanded richly modeled surfaces, repoussé became a highly developed technique. The process then was much the same as it is today. The first step was to prepare a mixture of black pitch combined with brick dust and candle wax into a flexible mass to use as a bed on which the metal was to be worked. The mixture was melted over a slow fire and poured into a clay bowl which was broken and removed when the pitch had cooled. The pitch retained the form of the bowl. It was put in a holder which allowed it to turn easily at any angle while the work was being done, and the metal was pressed firmly into the pitch so that it could not move.

The drawing for the design was made on paper and the out-

line was pricked at close intervals with a needle. The paper was secured on the metal and the design was transferred through the small holes with a pounce bag filled with powdered carbon. Following the carbon outline the design was scratched on the metal so that a small, blunt tool, lightly hammered, could follow the scratched outline with a chased line. The metal, when released from the pitch, showed the raised outline of the design on the reverse side.

Then the metal was returned to the pitch with the reverse side up and the areas to be raised were hammered with various sized punches. Again the metal was returned to the first position, warmed, and pressed onto the pitch which would fill the hollow spaces and support the metal for modeling. With occasional annealing this process could be repeated over and over again, working from the back and from the front until the desired effect in high relief was obtained. Tooling and texturing could be added and, by his way of doing the modeling and the surface finish, each craftsman could express his individuality.

Repoussé done in this manner by a skillful craftsman is one of the most difficult of the jewelry-making processes, demanding as it does both a fine feeling for the design and a complete understanding of the metal. It seems a more legitimate way to obtain the effect of bulk in metal than by casting. In casting the whole design is made in another material, while in *repoussé* the effect of bulk is obtained in molding and working the metal itself.

Interested in some *repoussé* jewelry in a store in downtown Mexico City we visited the shop where it had been made. Among the workmen in the shop, one was finishing a fine piece of *repoussé* with the same kind of tools and pitch block which were described in the record of two hundred years ago. This shop does lovely brooches and necklaces which, in their richness and bulk, reminded us of Churrigueresque ornament, a style which would be hard to follow in any other technique.

Filigree

Filigree is the technique by which a design is carried out with wire. In different countries and at different times wirework was applied as decoration on solid backgrounds, but ever since it has been done in Mexico it has been an open, lacy wirework supported by a more rigid frame. This delicate work requires a knowledge of construction, technical skill, and a feeling for design on the part of the craftsman. The gauge of the wire which frames the design and the wire which forms the filigree pattern must be in the right proportion, the combination of the filigree with other elements and textures must be sensitively done, and it all must be meticulously executed.

The best filigree is made of gold or silver wire, but skillful work is also done in copper wire which is then plated with gold or silver at a much smaller cost than that of pure gold or silver. While the craftsmanship and the lacy effect are almost the same in the cheaper material, the color and texture are not as fine.

We watched this work being done in a small shop where they were working in copper wire. First the frame was made of wire heavy enough to keep its shape and give strength to the whole piece. When the frame—an inch wide circle with a smaller circle inside it attached to the top—had been soldered it was laid on the charcoal block and the wire design was built up inside it. A fine, flat wire with a serrated edge was used for this. The units of wire were coiled and formed with small pliers. The designs in this shop have been made over and over again, and what seemed to be extremely intricate work to us appeared to be easy to these men. When all the loops and coils had been combined into a rhythmic design it was painted with a paste of solder and flux, a mouth torch was turned on it and it was soldered in no time at all.

Then a spiral of fine, round wire was opened and laid in

overlapping loops around the edge. When all the wirework had been soldered to the frame it was a little warped and so it was given a single light blow with a flat-faced steel hammer to flatten it without destroying the serrated edge of the wire which gives lightness and texture to the filigree in contrast to the smooth frame. Several little domed disks were soldered on at strategic spots and the circle was finished. Some little rosettes or flowers were made of the wire, about forty little pieces of thin copper (about a quarter of an inch long), were cut for a fringe, an equal number of small wire rings were made for attaching the fringe to the frame, and the piece was assembled, ready to be plated, a delicate, lacy earring.

The filigree of each region differs a little from that made elsewhere. Sometimes the wirework is subordinate to other kinds of work on the design; the weight of the wire used makes a great difference, as heavy wire gives one effect; round wire and flat wire give different results altogether; the wire may be used for an open or a solid design, or it may be combined with balls or *repoussé* units for contrast. Many of these variations are shown in the photographs of regional jewelry.

Plating

The early Mexicans did their plating by the amalgam process. The article to be plated was cleaned in acid to remove grease, corrosion, and tarnish. In pre-Hispanic times plants containing citric acid were crushed and heated as a bath for cleaning metals. When the piece was clean it was spread with an amalgam paste made of powdered gold and mercury. The amalgam would adhere to the surface of the copper and, when heat was applied, the mercury would evaporate leaving a coating of gold on the article. Silver plating was done in the same way.

Today electroplating has largely taken the place of amalgam plating. The article is deposited in a bath containing gold

or silver and a current generated by a dynamo is sent through the solution, and the gold or silver is deposited on the article by electrolysis.

Married Metals

"Married metals," *metales casados,* as the name implies, results from the joining of different metals so closely that the piece seems like one metal. When the surface of a piece made by this process is polished, the color of some of the metals is so much the same that to see the design it is necessary to put a piece of tissue paper over it to eliminate the shine on the metal. The effect of the changeable color is very interesting.

The metals used are silver, copper, brass, and an alloy, called "dark silver," composed of silver, nickel, and iron. This alloy is a soft, gun-metal gray, a foil to the silver which is lighter in hue and more brilliant. Silver is usually the predominating metal, although blued steel is sometimes used as a background for the lighter hued metals.

The design is drawn on the background metal and the parts which are to be of a different metal are sawed out and pieces the exact size and shape of those sawed out are cut from the other metal and inserted with the use of as little solder as possible—theoretically the metals are sweated together and a perfect piece would have no solder—and the metal becomes one piece and can be treated as such, molded by *repoussé* for instance. The inlay goes through to the back of the metal and can be seen on larger pieces such as trays or boxes, but a backing of silver is usually added to the jewelry.

The skill needed for this work is astonishing, for which reason only a few craftsmen do it. We have seen a brooch in the form of a jaguar covered with little spots no larger than a pin head of another metal, a tray inlaid with an intricate serpent design all done in outline with spots of brass outlined with a copper line less than one thirty-second of an inch wide.

Enamels

There is no record of the first use of enamel to decorate metal but examples exist of work done in ancient Egypt. Although the pre-Hispanic Indians had mastered so many of the jewelry techniques they never did enameling. The Spaniards, however, soon introduced the technique in Mexico and it was often used to enrich the goldwork of the early Colonial period. Later, when colored jewels ceased to be the fashion, it was used so little that it was almost forgotten and only recently it has been added to the list of old processes which have been revived in Taxco.

Enamels are composed of several ingredients which melt under heat and form a glazed surface either on a metal background or in small open frames of wire. When fired the enamels are transparent, translucent, or opaque and when they are used in jewelry in small areas they simulate stones. There are several styles of enamel work, among the most frequently used being Champlevé, Cloisonné, and Limoges.

The method being used in Taxco today is the Champlevé. The design is sunk in the metal by carving, stamping, etching, and piercing, and the enamel is introduced into the sunken surfaces. Limoges enameling is popular in the United States at the present time and is being produced in profusion. It is done by painting a very finely ground enamel onto a fused enamel surface on a metal base. Originally done as fine paintings for use in jewelry and religious pieces, recently it has been used more for such items as trays and boxes. Cloisonné enamels are made by outlining all parts of the design with a network of thin wire held to a backing. Different colors of enamels are fused into the little areas of the design. The most beautiful work of this kind has been done in China.

The various techniques of enameling are too complicated to describe here. Baked or fused enamels as used for jewelry are not to be confused with the commercial enamels used for

painting household articles, nor with the lacquer so beautifully used by the Mexicans in decorating trays, boxes, and masks.

Stones

Although none of the precious gem stones (diamonds, rubies, emeralds, and sapphires) are found in Mexico, the lapidary craftsmen have always had a wealth of native material to work with, and have excelled in carving and polishing the stones which are found in many parts of the country, the amethysts, garnets, and opals, the crystal, obsidian, and onyx. The source of the precious jade, from which many fine jewels were made in pre-Hispanic times, has never been discovered, nor have any large deposits of turquoise been found although quantities of it were used by the men who made the stone mosaics in the past.

The jade which the ancients prized so highly is a nephrite which differs considerably from the Chinese and Burmese jade. It is slightly softer and not as bright in color, coming in grayer greens, leaf green, spinach green, and mottled black and green.

There are many green stones found in Mexico which are incorrectly called "Mexican jade." That which is found in the cheap jewelry is a common mineral, usually calcite, dyed green. This name has also been used more correctly for the mineral mayaite or diopside jadeite. Jasper, plasma, and serpentine are a fine green in color and could be mistaken for jade, the jasper and serpentine being a grayish yellow-green and the plasma a bright emerald color.

The turquoise which the ancient Indians used may have come from the mountains of what is now New Mexico, although the old records show that three Aztec villages paid tribute in turquoise. Within the last few years some turquoise has been found in the silver mines of Zacatecas.

The so-called "Mexican onyx" is not onyx but a variety of marble or calcite. When pure it is white but it is sometimes

clouded or streaked with color. It is not a gem stone but has beauty and durability and comes in various degrees of hardness. In the states of Puebla and Oaxaca there are deposits of this stone which the natives call *tecali*. Large slabs are used architecturally and for table tops as well as for the hundred and one little objects and carved ornaments found in the shops and sold by the vendors in the plaza. Most of the beads are made in Puebla. They are interesting for their color which varies from the translucent greenish white to the dyed greens and reds and grays (which are not altogether permanent). They have a slight irregularity, due to the fact that they are polished by hand in dozens of little "factories," but this does not detract from their appeal to the bead fancier.

Obsidian is a form of glass, molten lava which has cooled rapidly, solidifying without crystalizing. It is found in places where there has been volcanic activity. Usually black, it is sometimes cloudy or shows a greenish tint in some lights or when ground very thin. It is brittle and hard to carve or polish.

Opals have always been plentiful, coming from the mountains around Querétaro. The rock from that part of the country is so full of veins of opal that traces of it appear in the building stone. Opals are divided into two groups by the gem dealers, black opals which are dark blue or gray shot with brilliant lights of blue-green or red, and white opals which are pale in tone with green, yellow, and orange lights. Water opals are semitransparent with flashes of red, green, and blue coming from a base which has the appearance of water. When of fine quality they are beautiful and rare. The yellow and orange stones known as fire opals are the most common and are known as "Mexican opals."

Opals are seldom cut faceted but come in all shapes and sizes of cabochons. Thin slices of opal are sometimes cemented to an onyx base resulting in an opal doublet.

The city of Querétaro has become a receiving center for gem minerals, and the art of the lapidary has grown into a

home industry employing hundreds of workers to cut and polish the stones. Many shops sell beautiful gem stones for jewelry settings and also gem-set jewelry. There are vendors on the streets with stones for sale, but the unwary buyer should be warned that the lapidaries of Querétaro also cut and polish the beautiful Mexican colored glass with the same care they lavish on the gem stones.

Gems are valued according to their scarcity, color, and hardness. The hardness refers only to the scratchability of the stone. This quality is important in jewelry because a soft stone soon loses its polish and for this reason requires a protective setting. Transparent stones are usually cut in facets to bring out the sparkle which comes from the reflections and the refraction of light. Opaque and translucent stones are usually cut cabochon (convex in shape) and polished or carved. The hardest stones are not found in Mexico, but a few stones which are found, such as quartz and topaz, are above average in hardness.

Quartz is a fairly hard (7 in the scale of hardness as compared to the diamond, which is 10), transparent stone which comes in many colors and under many names. Rock crystal, clear and colorless, is quartz as are also amethyst, citrine, and rose-quartz. Beautiful amethysts are found in the northern mountains, varying in hue from pale violet to deep purple. While the most beautiful dark topaz come from Brazil, a few of the pale yellow stones are mined in the mountains in the northern part of Mexico. Jasper is an opaque quartz found in many parts of the world. It comes in many different colors: red, brown, yellow, green, and gray. It has been used ornamentally for centuries. Examples of engraved rings made of this stone have been uncovered in many ancient sites.

Pearl, coral, and amber are organic matter but are used as stones and are generally classed as such. Many of the pearls used in Mexico come from the Orient, the larger ones being sold individually and the smaller ones pierced and sold in

strings. However there has always been an abundant supply of Mexican pearls from the Pacific coast. "Black pearls" of a soft gray hue and baroque pearls with only slight irregularities are obtainable in graded strands or as single gems. Small, irregular branches of coral are found off the Mexican coast but the larger and better polished corals come from Italy.

Amber is a resin fossil of coniferous trees many thousands of years old, usually found washed up along the sea coasts in many parts of the world. It is either opaque or transparent and varies in color from pale yellow to a reddish brown. The Chiapas amber is a pale clear yellow, a land amber mined near Simojovel de Allende, not far north of San Cristóbal las Casas. It is probably a relic of the era when the mountains pushed up and enclosed a salt lake in the center of the land now called Chiapas. There is very little of it available but a few men in the market at San Cristóbal had little pieces molded into forms for earrings or crudely cut into hearts or other simple shapes. Jet is also a fossilized vegetable, like coal but harder. We were told in Iguala that it comes from a lake south of there, but can not vouch for this as it may be only Indian hearsay.

Stone Mosaic

Stone mosaic is a surface decoration made by fitting together small pieces of stone which are held in place by a tenacious pitch on a surface of metal, wood, clay, or stone. A high degree of perfection in this technique was attained by the pre-Hispanic Indians in decorating their jewelry, shields, helmets, masks, and images. Turquoise, malachite, obsidian, coral, gold pyrites, white and pink shell, and mother-of-pearl provided a palette of many colors and textures for the composition of the designs. When turquoise alone was used, the beauty of the work depended on the brilliance of the color and the gradations of blue. There are only a few of the

ancient stone mosaics in existence today as those which were mounted on wood have disintegrated with time, leaving only a mass of thin stone fragments. The Yanhuitlán brooch (See Plate 19) is one of the few mosaics which were done on metal and which are, therefore, still in existence.

The inlaid jewelry of today is a revival of the old technique, the stones being set in an adhesive on a metal base and then polished down to a flat surface. Recently an easier, but not more beautiful, kind of "mosaic" has appeared, one by which the various stones are powdered and impressed on the adhesive instead of being cut and fitted in a design.

Tortoise Shell

The hawksbill turtle, from which tortoise shell is obtained, inhabits the waters of tropical and semi-tropical seas the world over. The shell has been used ornamentally from the era of ancient Rome and Egypt to the present day. Mexican tortoise shell comes from the Gulf.

Of the thirteen plates, or blades, on the big turtles, only the eight lateral plates are choice. They are sometimes as large as 8"x14" and weigh about 9 ounces each. The shell is tough and pliable, so much so that the men who sell shell combs on the streets of Vera Cruz throw them down on the sidewalk to prove their toughness. The plates are softened in boiling water to be formed or joined by pressure. As the heat softens the film a perfect union of two parts can be made.

The shell takes a high polish. It is mottled brown and yellow, some spots entirely dark and others a pale yellow. It can be carved and incrusted with metal. Outside of Vera Cruz and Campeche very few jewelry makers have had the imagination and inclination to use it. But some beautiful pieces are being made, unusual in design and in the use of the shell.

In the past it was much used by cabinet makers to decorate

furniture, frames, and boxes, and also by the men who carved and decorated the big combs. Occasionally one of these articles can be found in an antique store, a real prize.

BIBLIOGRAPHY

GENERAL

Anderson, Lawrence. *El Arte de la-Platería en México, 1519 to 1936.* New York: Oxford University Press. 1937.

—. *The Art of the Silversmith in Mexico: 1519–1936.* 2 vols. New York: Oxford University Press, 1941.

Benítez, José R. *El traje y el adorno en México, 1500 to 1910.* Guadalajara: Imprenta Universitaria, 1946.

Cali, François. *The Spanish Arts of Latin America.* New York: The Viking Press, Inc., 1961.

Calvillo Madrigal, S. *Platería mexicana.* Vol. 9 of *Colección Anahuac de Arte Mexicano.* México: Ediciones de Arte, 1948.

De Kertesz, M. Wagner. *Historia universal de las joyas.* Buenos Aires: Ediciones Centurión, 1947.

Evans, Joan. *A History of Jewelry, 1100–1870.* New York: Pitman Publishing Corporation, 1953.

Johnson, Ada Marshall. *Hispanic Silverwork.* New York: Hispanic Society of America, 1944.

McCarthy, James Remington. *Rings Through the Ages.* New York: Harper and Brothers, 1945.

Museo Nacional de Artes e Industrias Populares. *Mexican Silverwork.* México: Museo Nacional de Artes e Industrias Populares, 1952.

Museum of Modern Art. *Twenty Centuries of Mexican Art.* New York: Museum of Modern Art, 1940.

Oved, Sah. *The Book of Necklaces.* London: Arthur Barker, 1953.

Spratling, William. "25 años de platería moderna," in *Artes de México,* Vol. III, No. 10 (1955).

—. "The True Color of Silver Is White," in *Mexico This Month,* Vol. II, No. 6 (1956).

Sutherland, C. H. V. *Gold: Its Beauty, Power and Allure.* London: Thames and Hudson, 1959.

Valle-Arizpe, Artemio de. *Notas de platería.* México: Editorial Polis, 1941.

Weismann, Elizabeth Wilder. *Mexico in Sculpture, 1521 to 1821.* Cambridge, Massachusetts: Harvard University Press, 1950.

Pre-Hispanic Jewelry

Aguilar, Carlos H. *La orfebrería en el México prescortesiano.* Acta Antropologico #2. México: Escuela Nacional de Antropología e Historia, 1946.

Carli, Enzo. *Pre-Conquest Goldsmiths' Work of Colombia.* London: William Heinemann, Ltd., 1957.

Borbolla, Daniel F. Rubín de la. *Tarascan Jewelry.* México: Quadernos Americanos No. 3.

Burland, Cottie A. *Art and Life in Ancient Mexico.* Oxford: Bruno Cassirer, 1948.

Caso, Alfonso. "Monte Albán: Richest Archeological Find in America," in *National Geographic Magazine,* Vol. LXII, No. 4 (October, 1932).

Covarrubias, Miguel. *Indian Art of Mexico and Central America.* New York: Alfred A. Knopf, Inc., 1957.

Díaz del Castillo, Bernal. *The Discovery and Conquest of Mexico.* New York: Farrar, Straus and Cudahy, Inc., 1956.

Disselhoff, H. D. and S. Linné. *The Art of Ancient America.* New York: Crown Publishers, Inc., 1960.

Enciso, Jorge. *Sellos de antiguo México.* México: n.p., 1947.

—. *Design Motifs of Ancient Mexico.* New York: Dover Publications, 1953.

Joyce, Thomas A. *Maya and Mexican Art.* London: The Studio, 1927.

Naranjo, García. *México: leyendas y costumbres, trajes y danzas.* México: Editorial Layac, 1945.

Orchard, William C. *Beads and Beadwork of the American Indians.* New York: Museum of the American Indian, Heye Foundation, 1929.

Sahagún, Fr. Bernardino de. *Los cantares a los Dioses y la orfebrería,* in *Historia general de las cosas de Nueva Espania.* México: Editorial Pedro Robledo, 1938.

Saville, Marshall H. *The Goldsmith's Art in Ancient Mexico.* New York: Museum of the American Indian, Heye Foundation, 1920.

—. *Turquoise Mosaic Art in Ancient Mexico*. New York: Museum of the American Indian, Heye Foundation, 1922.

Spinden, Herbert J. *Maya Art*. Cambridge, Massachusetts: Peabody Museum, 1913.

—. *Maya Art and Civilization*. Indian Hills, Colorado, Falcon's Wing Press, 1947.

Solier, W. du. *Ancient Mexican Costume*. México: Instituto Nacional de Antropología e Historia, 1950.

Vaillant, George C. *Artists and Craftsmen in Ancient Central America*. New York: American Museum of Natural History, 1935.

Jewelry of the Past and Religious Jewelry

Calderón de la Barca, Frances. *Life in Mexico*. London: J. M. Dent & Sons Ltd.; New York: E. P. Dutton & Co., Inc., 1954.

Carrillo y Gariel, A. *Indumentaria colonial*. Vol. 5 of *Colección Anahuac de Arte Mexicano*, México: Ediciones de Arte, 1948.

Géo-Charles. *Arte Baroque en Amerique Latine*. Paris: Librairie Plon, 1954.

Keleman, Pal. *Baroque and Rococo in Latin America*. New York: The Macmillan Company, 1951.

Hernández Serrano, Federico. *Colección en el Museo de Arte Religioso*. México: Colección Anahuac, 1950.

Laver, James. *17th and 18th Century Costume*. London: Victoria and Albert Museum, 1951.

Reade, Brian. *The Dominance of Spain*. Vol. III, No. 4 of *Costume of the Western World*. London: George G. Harrap & Co. Ltd., 1951.

Romero de Terreros, Manuel. *Las artes industriales en la Nueva España*. México: Librería de Pedro Robredo, 1928.

—. *El arte en México durante el virreinato*. México: Editorial Porrua, S.A., 1951.

Toussaint, Manuel. *Arte colonial en México*. México: Universidad Nacional Autónoma de México, 1948.

Folk and Regional Jewelry

Adair, John. *The Navajo and Pueblo Silversmiths*. Norman: University of Oklahoma Press, 1944.

Auger, Helen. *Zapotec.* Garden City, New York: Doubleday, Doran & Company, Inc., 1954.

Cordry, Donald Bush and Dorothy. *Costume and Weaving of the Zoque Indians of Chiapas, Mexico.* Los Angeles: Southwest Museum, 1941.

—. *Costume and Textiles of the Aztec Indians of Quetzalan Region, Puebla, Mexico.* Los Angeles: Southwest Museum, 1940.

Covarrubias, Miguel. *Mexico South.* New York: Alfred A. Knopf, Inc., 1946.

Fernández, Justino. *Mexican Folklore.* (A volume of pictures.) México: Eugenio Fischgrund, n.d.

Langner, Alberto Cajigas. *Monografía de Tehuantepec.* México: Imprenta Manuel León Sánchez, 1954.

Museo Nacional de Artes e Industrias Populares. *Los Huicholes.* México: Museo Nacional de Artes e Industrias Populares, 1954.

Toor, Frances. *Mexican Popular Arts.* México: Frances Toor Studio, 1939.

—. *A Treasury of Mexican Folkways.* New York: Crown Publishers, Inc., 1947.

Woodward, Arthur. *Navajo Silver.* Flagstaff: Museum of Northern Arizona, 1938.

Charros

Alvarez del Villar, José. *Historia de la charrería.* México: Imprenta Londres, 1941.

Rincón Gallardo, Carlos y Manuel Romero de Terreros. *El libro del charro mexicano.* México: Imprenta Regis, 1946.

Taxco

Azcona, Héctor Sánchez. *Tasco.* México: Imprenta Mundial, 1935.

Foscue, Edwin J. *Taxco: Mexico's Silver City.* Dallas: Southern Methodist University Press, 1947.

Jewelry Making

Abbott, D. Tucker. *American Sea Shells.* Princeton, New Jersey: D. Van Nostrand Company, Inc., 1954.

Bates, Kenneth F. *Enameling Principles and Practice.* Cleveland: The World Publishing Company, 1951.

Bergsoe, Paul. *The Gilding Process and the Metallurgy of Copper*

and Lead Among the Pre-Columbian Indians. Copenhagen: 1938.

Jones, W. R. *Minerals in Industry.* London: Penguin Press, 1950.

Kraft, James Lewis. *Adventures in Jade.* New York: Henry Holt and Company, Inc., 1947.

Kraus, E. H. and C. B. Slawson. *Gems and Gem Materials.* New York: McGraw-Hill Publishing Company, Inc., 1947.

Morris, Percy A. *Field Guide to Shells of the Pacific and Hawaii.* Boston: Houghton Mifflin Company, 1952.

Neuman, Robert von. *The Design and Creation of Jewelry.* Philadelphia: Chilton Company, 1961.

Pack, Greta. *Jewelry and Enameling.* (3rd edition). Princeton, New Jersey: D. Van Nostrand Company, Inc., 1961.

Rivet, Paul and H. Arsandaux. *La Metallurgie en Amerique Precolumbienne.* Paris: L'Institut d'Ethnologie, 1946.

Sinkankas, John. *Gem Stones of North America.* Princeton, New Jersey: D. Van Nostrand Company, Inc., 1959.

Sperisen, Francis J. *The Art of the Lapidary.* Milwaukee: The Bruce Publishing Company, 1953.

Weinstein, Michael. *The World of Jewel Stones.* New York: Sheridan House, 1958.

Wienebrenner, D. Kenneth. *Jewelry Making as an Art Expression.* Scranton, New Jersey: Scranton International Text Book Company, 1953.

Winter, Edward. *Enamel Art on Metal.* New York: Watson Guptil Publishing Company, 1958.

INDEX

bracelets: pearls in, 55, 56; coins in, 116, 122, 125; of *repoussé* silver, 166; contemporary styles of, 174, 175, 192, 193, 195, 196, 200, 201, 214

British Museum: 31, 45

brooches: filigree in, 132; regional variations in, 136, 137; of tortoise shell, 142, 143, 180; with stones, 175, 201, 217, 221, 223; of stone inlay, 182, 184, 185, 187; of married metals, 187, 188; of steel, 190; of silver, 191, 197, 198, 203, 211, 218; with carved heads, 206, 212

—, pre-Hispanic: 39, 40, 41

buckles: for *charro* suits, 152, 154, 156; of silver, 172; of tortoise shell and silver, 173

butterflies: as motif, 10, 12; examples of, 11, 30, 93, 121, 130, 132, 152; on pre-Hispanic stone, 30; of filigree, 121, 130, 132; as *charro* hat ornament, 152

buttons: in eighteenth century, 58, 61; on *charro* suits, 151, 152, 156; materials used for, 155, 173, 205

Calderón de la Barca, Madam: 60, 61, 62

Calle de los Plateros: 52, 60

carey. See tortoise shell

Carr, Mrs. See "Margot de Taxco"

cascabeles: for movement in design, 7; on pre-Hispanic jewels, 17, 18

Caso, Alfonso: at Monte Albán, 38

Castellanos, Guadalupe: 204, 208; examples of work of, 42, 204, 205, 206, 207

Castillo, Jorge "Chato": 189, 193–195. See also Castillo, Los

Castillo, Los: techniques developed by, 86, 87, 93; examples of work of, 182, 184, 185, 186, 187, 188, 190, 191, 192, 193; workshops of, 183, 186, 193. See also Castillo Terán, Antonio; Castillo, Jorge "Chato"

Castillo Terán, Antonio: 183, 186. See also Castillo, Los

casting: in pre-Hispanic period, 32, 34; by cire-perdue method, 32, 34, 113, 229–231; of earrings, 93, 94, 95, 97, 99; example of, 106; in sand, 231; in stone, 231–232

Cazares, Herminio: 99. See also Pátzcuaro

Cazares, Jesús: jewelry by, 96, 98, 99, 100, 101; workshop of, 99, 101

chains: for *conquistadores*, 36; worn by officials, 53; for weddings, 100, 138, 139; from Oaxaca, 112, 113; from Chiapas, 123, 125; contemporary styles of, 177, 192

charros: 148, 149; costume of, 148, 149, 151; *adornos* of, 150–156; hat ornaments *(chapetas)* of, 150, 152, 153; *anqueras* of, 155, 157; steel fittings for, 156, 157

Chiapas: woven chain from, 123, 125; gold filigree from, 123, 125; gold beads from, 125, 126, 127; Zoque rosary from, 127, 130; amber from, 130

Chinese: influence of, on design, 58

Churrigueresque style: influence of, on design, 8, 136; of "Matl," 222

Coclé Indians: 210, 211, 213

coins: in necklaces, 83, 88, 118; in Toluca earrings, 99; in Tehuantepec jewelry, 115–122

Colonial jewelry: early conditions of, 48, 52; examples of, 49, 51, 53, 54, 61, 63; filigree in, 51, 63, 95; in costume, 52, 53, 57, 60, 61; pearls in, 55–56, 57, 58, 61; corals in, 56, 58, 61; silver in, 60; in Monte de Piedad, 64. SEE ALSO Cortés, Hernan; costume; eighteenth century; Maximilian, Emperor; nineteenth century; sixteenth century

coloring of metals: by heat and chemicals, 157, 229; by alloys, 189, 227; by oxidation, 197, 228

combs, tortoise-shell: 141, 144, 145, 146

concha. SEE shell

copper: pre-Hispanic use of, 32; for filigree, 91; in married metals, 189; in jewelry, 204, 207, 208

coral: in Colonial jewelry, 56, 58, 61; examples of, in jewelry, 61, 102, 216, 217, 220, 223; imitations of, 88; use of, by "Matl," 219; source of, 240, 241

Cortés, Hernan: as *conquistador*, 35, 36; *ex-voto* of, 48, 49, 50

Cortés Domingues, Jorge: reproduction of Monte Albán jewels by, 113

costume: of pre-Hispanic Indians, 28, 29; in sixteenth century, 52; early laws regarding, 52, 53; in seventeenth and eighteenth centuries, 52, 53, 55, 57, 58; in nineteenth century, 60, 61, 62; of Tehuanas, 84, 115, 117, 118, 119; of Oaxaca, 114; of Yucatán, 129, 130; of Tótonac women, 136, 139, 142; of Vera Cruz, 145; of *charros*, 148, 149, 151

craftsmanship: of pre-Hispanic Indians, 28, 29, 32, 33, 38, 39; of

Mexicans, 31, 48; in jade carving, 43, 44; in meticulous work, 70; of contemporary men, 78, 186. SEE ALSO craftsmen

craftsmen: as designers, 8; inherent talent of, 31, 48; Colonial conditions of, 52; contemporary workers as, 158, 170, 171. SEE ALSO craftsmanship

crosses: as symbols, 18; with engraving, 19, 20; in design, 74, 76; of mother-of-pearl, 75; contemporary designs of, 76, 78; by Benedictine brothers, 77, 78, 80; from Yalalag, 79, 103, 104, 105, 106; of silver, 79; from Yucatán, 128, 129, 130; of wood, 207

crowns for the Virgin: for Soledad in Oaxaca, 68, 69; in Museo de Arte Religioso, 69; contemporary examples of, 76, 78

Davis, Frederick Walter: collection of folk art of, 70, 74; *santo* in collection of, 70, 71, 74; *matracas* in collection of, 74; life of, 160, 163, 165, 167; obsidian first used by, 161, 165; old stones used by, 162, 165; as businessman, 165, 167; as house and garden planner, 167

de la Borda, José: 169

design: Mexican style of, 3, 4, 5, 7, 8, 47, 58; Churrigueresque influence on, 8, 160; pre-Hispanic *sellos* in, 15; pre-Hispanic style of, 31, 32; Chinese influence on, 58

diamonds: cutting and setting of, 55; on eighteenth-century buttons, 58, 61; profusion of, 60, 61; in Oaxaca filigree, 112

Díaz del Castillo, Bernal: on jewelry, 36; on jade, 46

Domínguez, Rafael: examples of work by, 13, 15

earrings: from eighteenth and nineteenth century, 56; of filigree, 90, 91, 110, 111, 112, 234, 235; from Súltapec, 93, 95, 97; from Toluca, 94, 97, 99; from Pátzcuaro, 101; of gold, 102; from Yalalag, 106, 107; from Oaxaca, 111, 112; from Tehuantepec, 122, 127; from Chiapas, 123, 126; from Guanajuato, 137; from Papantla, 138, 140; of tortoise shell, 142, 143; contemporary styles of, 164, 180, 193, 201, 204, 214, 223

eighteenth century: jewels and filigree of, 51, 56, 58, 63; wealth and elegance of, 55, 57, 58; use of pearls in, 55, 56, 57, 58; coral jewelry of, 56, 58; Chinese influence during, 58; use of silver during, 60; Monte de Piedad established during, 63, 64

enamels: sixteenth-century example of, 49; and pre-Hispanic Indians, 50; contemporary examples of, 191, 209; facts about, 237, 238

Enciso, Jorge: book on *sellos* by, 15
ex-votos. SEE *milagros*

feathers: pre-Hispanic use of, 28, 32, 35; mosaics of, 32; as edge of shield, 41; as motif, 190; as background, 198
fiesta, Silver: in Taxco, 171
filigree: Colonial use of, 51, 63, 95; origin of, 90, 93, 95; of plated copper, 91; technique for making of, 91, 234, 235; of wrought iron, 92; by pre-Hispanic Indians, 95; from Oaxaca, 108, 110, 111, 112, 114; from Chiapas, 123, 125, 130; from Yucatán, 128, 129, 130, 131; of silver, 130, 132; from Iguala, 133
fish: as motif, 9, 10; in Pátzcuaro jewelry, 96, 99; in contemporary design, 197
Fosada, Víctor: as producer of reproductions, 6; as authority on folk jewelry, 208; heavy beads by, 208

García Piña, Ysidro: 202, 203
glass: miniature objects of, 21, 22; in Cortés' necklace, 35; in jewelry, 83, 88, 89, 97, 140, 240
gold: source of, 32, 107, 109; techniques used in working, 32, 33, 34, 35, 66, 227, 229, 230, 231, 232; Spanish love of, 32, 35, 36, 109; in Montezuma's treasure, 36, 37, 38; early workers in, 48, 52; in Monte Albán, 95, 109; coloring of, 111, 227, 228; in filigree, 111; texturing of, 111; in coins, 114, 117, 118, 119, 121; Karet as standard for, 227
Goodspeed, Bernice: 211, 213; examples of work of, 13, 16, 40, 203, 210, 212
grotesque figures: examples of, 13, 17, 206; as motifs, 17, 18
Guanajuato: jewelry from, 136, 137

handmade jewelry: 4, 25, 193
hands: as motif, 20, 21, 102, 118, 119, 140
hearts: as motif, 20, 78
hieroglyphs: as motif, 13, 14, 211
horn: as used in San Juan de la Isla, 7, 10; for *charro* buttons, 155
Huetamo: jewelry from, 136, 137
Huicholes: beadwork of, 84, 86, 88

Oaxaca; Museo Regional de Pátzcuaro; Museo Regional de
Toluca; National Museum, Washington

National Museum, Washington: 44

Navajos: taught by Mexicans, 3, 4; method of casting used by, 231,
232

necklaces, historical: of pre-Hispanic Indians, 33, 35, 39; with pre-
Hispanic motifs, 42, 161, 162, 184; of Colonial period, 54; of
nineteenth century, 61

—, folk and regional: 83, 84, 85, 87, 88, 89; from Pátzcuaro, 96,
98, 99, 100; from Oaxaca, 108; from Tehuantepec, 116, 119, 120,
121; from Papantla, 138, 139

—, modern: of silver, 59, 164, 182, 210, 214; with obsidian, 161,
194; with old stones, 162, 212; with tortoise shell, 173, 174,
178; of onyx, 182; of turquoise inlay, 184; of shell inlay, 185;
with stone sets, 194, 216, 217; of enamel, 209

nineteenth century: opulence of, 60, 61, 62; diamonds during, 60,
61; collection of jewels from, 62, 63

Oaxaca: regional museum of, 39, 113; filigree from, 108, 110, 111,
112; fine craftsmanship in, 110, 111, 113; typical chain from,
112

obsidian: from Monte Albán, 38, 39; in modern jewelry, 161, 165,
175, 194, 195; properties of, 239; sources of, 239

onyx: incrusted with silver, 182, 187, 189, 193; from Puebla, 238,
239

opals: 239

Ortiz, José: 110, 111; crown for Soledad by, 68, 70

Papantla: costumes from, 81, 136, 139, 140, 142; gold jewelry
from, 138, 140, 142

Pátzcuaro: jewelry from, 82, 96, 98, 99, 100, 101; workshop in, 99,
101

pearls: as used in the past, 55, 56, 57, 58, 61; for the Virgin, 66,
68, 69, 70; in Oaxaca jewelry, 102, 108, 110, 111, 112, 113;
modern use of, 197; sources of, 240, 241; color of, 240, 241

pendants: from pre-Hispanic motifs, 16; pre-Hispanic pectorals
as, 30, 34; religious *relicarios* as, 51, 52, 53; from Colonial period,
54, 58; of gold filigree, 108, 110, 123; of coins, 116, 117, 119,

121; old stones set in, 162, 212, 213; from Taxco, 175, 181, 190, 205, 206

"Piedra y Plata." See Martínez H., Felipe

Pineda Gómez, Antonio: 196, 197, 199; examples of work of, 196, 197, 198

plating: by amalgam process, 235; by electrolysis, 235, 236

Poulat, Matilde Eugenia. See "Matl"

pre-Hispanic Indians: life, customs, and religion of, 27, 28, 29; costumes of, 28, 29, 35; designers and craftsmen among, 28, 29, 31, 32, 33; materials used by, 28, 29, 31, 32, 33; gold used by, 32, 33, 34, 35, 36, 38; stone mosaic technique of, 32, 39, 40, 41; conquest of, 35, 36; and Monte Albán tomb, 36, 37, 38, 39; jade used by, 41–46. See also Aztecs; Coclé Indians; Mayas; Mixtec Indians; Monte Albán; Montezuma; pre-Hispanic motifs; pre-Hispanic symbols; Tarascans; Tlaxcala Indians; Yanhuitlán Brooch; Zapotecs

pre-Hispanic motifs: 10, 12, 13, 14, 15, 16, 17, 18, 28, 30, 31, 33

pre-Hispanic symbols: 11, 18, 28, 30, 40, 41

"primitive jewelry": 205, 206, 208

quartz: rock crystal as, 32, 38, 66; amethyst as, 168, 195, 196, 221, 240; jasper as, 181, 183, 240; topaz as, 216, 240

Querétaro: as gem center, 239, 240

Quiatoni, San Pedro. See San Pedro Quiatoni

Quiroga, Vasca de: 82, 84

Quiroz, A.: 97, 99

ramillete: 66, 67

regional jewelry: reasons for, 81, 82, 84, 86

religious jewelry: crosses as, 18, 19, 20, 74, 76, 77, 78, 79, 80; rosaries as, 19, 99, 105, 128, 129, 130; motifs for, 20, 75, 78; milagros (ex-votos) as, 48, 49, 50, 70, 71, 72, 74; relicarios as, 51, 52, 53; development of, 65, 66; ramilletes as, 66, 67; in Museo de Arte Religioso, 66, 69, 78; for the Virgin, 66, 68, 69, 70, 76, 78; medals as, 73, 77; matracas as, 74; design of, 80

repoussé: pre-Hispanic use of, 38; in modern jewelry, 159, 165, 166, 198, 219, 223; the process of, 232; 233

reproductions: of old pendant, 6; of design by Spratling, 13, 14;

of Súltapec earrings, 95, 97; of Yalalag crosses, 106; of Monte Albán jewels, 113; of design by Aguilar, 199, 200

rings: with clasped hands, 21; pre-Hispanic designs for, 36, 113; in Colonial times, 57, 58, 61; for men, 137; modern designs for, 168, 180, 193, 195

rosaries: 19, 99, 105, 128, 129, 130

Sahagún, Fr. Bernardino de: on pre-Hispanic gold-work, 32

Salas Poulat, Ricardo: examples of work of, 212, 219, 221, 222, 223; as nephew of "Matl," 215

San Pedro Quiatoni: bead necklace from, 88, 89

scorpions: as motif, 11, 12; *milagros (ex-votos)* with, 48, 49, 50, 143

sellos: book about, 15; as motifs, 15, 166

serpent: as motif, 14, 16, 188; in pre-Hispanic design, 28, 31

shell: as motif, 14, 20; on *charro adornos,* 20, 152, 154; in mosaic, 185, 186, 187

silver: pre-Hispanic use of, 35; eighteenth-century use of, 60; qualities of, 159; alloys of, 189, 227, 228; techniques for working, 228–233

Silver Fiesta: in Taxco, 171

silver industry: 158, 159, 160

sixteenth century: craftsmen in, 48, 52; jewelry of, 48, 49, 50; Mexican style in, 52, 53, 54; *Casa de Moneda* in, 52; precious stones in, 55

Spratling, William: old bracelet by, 14; examples of work of, 168, 172, 173, 174, 175, 177, 178, 180, 181; as founder of Taxco group, 170, 171, 172, 176; style of, 172, 176, 179, 183; books by, 172, 183; Alaska project of, 176, 179; use of gold by, 179, 183; as architect, 183

stamped jewelry: from Chiapa de Corzo, 125, 126, 127; from Papantla, 138, 140

steel, blued: from Amozoc, 156, 157; incrusting of, 157; from Taxco, 190, 193; coloring of, 228, 229

stones: old carvings of, in jewelry, 14, 162, 165, 183, 195, 212, 213; used by pre-Hispanic Indians, 32, 36, 38, 39, 41, 43, 44, 46; cutting and setting of, 55, 197, 202; jewelry set with, 120, 128, 195, 196, 197, 201, 209; native to Mexico, 238–241; Querétaro as center for, 239, 240; value of, 240; in mosaic, 241. SEE ALSO amber; coral; glass; ivory, carved; jet; pearls

style, Mexican: 3, 4, 5, 7, 8, 48; beginnings of, 159, 160; of today, 224, 225

Súltapec: earrings from, 93, 95, 97

sun: as a symbol, 14, 15, 20, 28, 75; on gift for Cortés, 35; in jewelry, 203

Tarascans: 32, 84, 87, 99

Taxco: 167–171

Tehuantepec: coin jewelry from, 114, 115, 117, 118, 119, 120, 121, 122, 125; costume of, 115, 117, 118, 119; gold jewelry from, 116, 122; "beautiful girls" of, 118; imitation jewelry in, 122

Terán, Salvador: 213; examples of work of, 15, 214; stone mosaics of, 213

Tlaxcala Indians: 36

Toluca: regional museum in, 10, 97; earrings from, 22, 94, 97, 99

tools: of pre-Hispanic Indians, 33, 44, 230; for casting, 113, 231; for making filigree, 125, 228, 234, 235; for *repoussé*, 125, 232, 233, 235; for stamping, 125, 140; for working steel, 157; for married metals, 236

tortoise shell *(carey)*: 141–146; combs of, 141, 142, 144, 145, 146; jewelry set with, 173, 174, 178, 180; working of, 242, 243

Tótonacs: jewelry of, 10, 138, 139, 140, 142; costume of, 136, 139, 140, 142

tradition: Mexican regard for, 8, 82, 84; in design of crosses, 18, 20; in village shops, 24; in Oaxaca earrings, 112; of the *charro*, 149

Tula: stone carving from, 12, 15

turquoise: in inlay, 184, 186, 187, 241, 242; in jewelry, 216, 217, 220, 223; source of, 238

Vargas, Genaro: 138, 140, 142

Vera Cruz: tortoise-shell jewelry from, 141–146; *jarocha* costume of, 145

Vidaurreta, Valentín: 197, 198

wedding necklaces: from Pátzcuaro, 99, 100; from Yalalag, 106; from Papantla, 138, 139

wood: use of, in jewelry, 179, 180, 183, 206, 207

workshops: of present day, 24, 25, 183, 186, 193; in pre-Hispanic times, 29; in Colonial period, 48; of village jewelers, 99, 101, 125, 140

Xipe-Totec: as god of silversmiths, 226